Museums and Higher Education Working Together
Challenges and Opportunities

Edited by

ANNE BODDINGTON, JOS BOYS AND CATHERINE SPEIGHT

LONDON AND NEW YORK

First published 2013 by Ashgate Publishing

Published 2016 by Routledge
2 Park Square, Milton Park, Abingdon, Oxon OX14 4RN
711 Third Avenue, New York, NY 10017, USA

First issued in paperback 2017

Routledge is an imprint of the Taylor & Francis Group, an informa business

Copyright © 2013 Anne Boddington, Jos Boys and Catherine Speight

Anne Boddington, Jos Boys and Catherine Speight have asserted their rights under the Copyright, Designs and Patents Act, 1988, to be identified as the editors of this work.

All rights reserved. No part of this book may be reprinted or reproduced or utilised in any form or by any electronic, mechanical, or other means, now known or hereafter invented, including photocopying and recording, or in any information storage or retrieval system, without permission in writing from the publishers.

Notice:
Product or corporate names may be trademarks or registered trademarks, and are used only for identification and explanation without intent to infringe.

British Library Cataloguing in Publication Data
A catalogue record for this book is available from the British Library

The Library of Congress has cataloged the printed edition as follows:
Museums and higher education working together : challenges and opportunities / Anne Boddington, Jos Boys and Catherine Speight [editors].
 pages cm
 Includes bibliographical references and index.
 ISBN 978-1-4094-4876-1 (hardback)
1. Museums--Study and teaching (Higher) 2. Museum techniques--Study and teaching.
3. Museums--Educational aspects. I. Boddington, Anne.
II. Boys, Jos. III. Speight, Catherine.
 AM7.M8814 2014
 069.071'1--dc23
 2013020328

ISBN 13: 978-0-8153-9939-1 (pbk)
ISBN 13: 978-1-4094-4876-1 (hbk)

Contents

List of Figures	vii
List of Tables	xi
Notes on Editors and Contributors	xiii
Preface: Museums – Reaching Higher by Roy Clare CBE	xix
Acknowledgements	xxv

PART I POLICY, PEDAGOGIES AND POSSIBILITIES

Introduction 3
Catherine Speight, Anne Boddington and Jos Boys

PART II STRATEGIC ALLIANCES, KNOWLEDGE EXCHANGE AND OPPORTUNITIES

1 Learning Activities, Learning Outcomes and Learning Theory 27
Stephen Brown

2 Internships in Museum Studies: Learning at the Interface 39
Elizabeth A. Beckmann

3 Understanding the Distributed Museum: Mapping the Spaces of Museology in Contemporary Culture 55
Susana Smith Bautista and Anne Balsamo

4 Learning at the Interface: The Museum as Public Laboratory 71
Richard Watermeyer

PART III CURATING, COLLECTING AND CREATIVE PRACTICES

5 Keeping Good Company: Art Schools and Museums 83
Sarah Ganz Blythe

6 Curating Emerging Design Practice 91
Gareth Williams

| 7 | Artist-Led Curatorial Practice: Mediating Knowledge, Experience and Opinion
Tracy Mackenna and Edwin Janssen | 103 |

PART IV EXPECTATIONS, ASSUMPTIONS AND OBSTRUCTIONS

8	'Museums and Galleries? No Thanks, Not For Me.' A Critical Review of Attitudes to Museum and Gallery Visits among University Students on an Education Degree Programme *Carrie Winstanley*	123
9	Tales from the Coalface *Leanne Manfredi and Rebecca Reynolds*	135
10	Enhancing Observational Skills: A Case Study. Collaboration between a University Art Museum and Its Medical School *Linda K. Friedlaender*	147
11	Object-Based Learning: A Powerful Pedagogy for Higher Education *Leonie Hannan, Rosalind Duhs and Helen Chatterjee*	159
	Conclusion: Opportunities for the Future *Jos Boys, Anne Boddington and Catherine Speight*	169

Afterword by David Anderson *189*
Index *193*

List of Figures

1.1	Role brief for one of the characters in the simulation (© Emsource)	34
3.1	Where is the museum for the digital generation? (© Balsamo and Bautista 2011)	56
3.2	QR codes or Microsoft tags using HCCB (high capacity colour barcodes) Cantor Arts Center, Stanford University, Palo Alto, California (© Susana Bautista 2012)	63
3.3	A prototype of an interactive map of the concept of the distributed museum is available as a Prezi document: http://prezi.com/6j2kvs8tb_i0/mapping-the-distributed-museum/ (© Balsamo and Bautista 2011)	67
5.1	Hubert Robert, *View of the Grande Galerie of the Louvre*, 1796, Musée du Louvre; The Medieval Court, from 'Dickinsons Comprehensive Pictures of the Great Exhibition of 1851,' lithograph, pub. Dickinson Brothers, 1854, Victoria and Albert Museum; The Waterman Galleries, c.1915, courtesy of Museum of Art, Rhode Island School of Design; *Raid the Icebox I with Andy Warhol*, 1969, courtesy of Museum of Art, Rhode Island School of Design; Classical Gallery, 1939, courtesy of the Museum of Art, Rhode Island School of Design	83
6.1	Jen Hui Liao, *The Self-Portrait Machine*, variable dimensions, mixed media (© Royal College of Art 2009)	93
6.2	Unknown street artist, *Jen Hui Liao*, 2008 (© Jen Hui Liao)	94
6.3	Portrait of Jen Hui Liao drawn by *The Self-Portrait Machine*, ink on paper, 2009 (© Jen Hui Liao 2009)	95
6.4	Thomas Thwaites, *The Toaster Project*, mixed media, variable dimensions (© Nick Ballon 2009)	98
6.5	Thomas Thwaites, toaster from *The Toaster Project* (© Daniel Alexander 2009)	101
7.1	*Ed and Ellis in Schiedam*. Stedelijk Museum Schiedam and the streets of Schiedam, the Netherlands. Detail showing the alderman for culture announcing the election results in Lijst 0's headquarters,	

	in the Stedelijk Museum Schiedam (© Tracy Mackenna and Edwin Janssen 1998)	104
7.2	*Shotgun Wedding*, Scottish National Portrait Gallery, Edinburgh. Detail showing one of six video projections, 300 × 400 cm each, duration 20:00 each (© Tracy Mackenna and Edwin Janssen 2007)	104
7.3	*WAR AS EVER!*, Tracy Mackenna and Edwin Janssen. Nederlands Fotomuseum in collaboration with the Atlas Van Stolk, Rotterdam, 2012. Detail showing the slide projection *WAR AS EVER!: Eighty Years and One Day*, made up of a selection of prints from the Van Kittensteyn album and newspaper excerpts reporting the Iraq war, bought on 1 April 2003, the day the artists' daughter was born (© Tracy Mackenna and Edwin Janssen 2012)	105
7.4	*On Growth, & Forms of Meaning*, Tracy Mackenna and Edwin Janssen. Centrespace, Visual Research Centre, Duncan of Jordanstone College of Art and Design, University of Dundee, Scotland, 2011. In collaboration with The D'Arcy Thompson Zoology Museum, University of Dundee. Public studio for presentation, exchange and production. (© Tracy Mackenna and Edwin Janssen 2011)	106
7.5	*LIFE IS OVER! if you want it.* Cooper Gallery, Duncan of Jordanstone College of Art and Design, University of Dundee. Detail showing projections, wall drawings, historical artworks, public studio for presentation, exchange and production (© Tracy Mackenna and Edwin Janssen 2009)	108
7.6	*LIFE IS OVER! if you want it.* Cooper Gallery, Duncan of Jordanstone College of Art and Design, University of Dundee. Detail showing projections, wall drawings, historical artworks, public studio for presentation, exchange and production (© Tracy Mackenna and Edwin Janssen 2009)	109
7.7	*LIFE IS OVER! if you want it,* Tracy Mackenna and Edwin Janssen. Cooper Gallery, Duncan of Jordanstone College of Art and Design, University of Dundee, 2009. Detail showing *Life, Death and Beauty: The Invisible Talk Back – Fear, No Fear.* Double-screen projection, 210 × 280 cm each, duration 05:00 (© Tracy Mackenna and Edwin Janssen 2009)	110
7.8	*LIFE IS OVER! if you want it,* Tracy Mackenna and Edwin Janssen. Cooper Gallery, Duncan of Jordanstone College of Art and Design, University of Dundee, 2009. Detail showing *Life, Death and Beauty: Where Darwin Meets Courbet.* Single screen projection, 210 × 280 cm, duration 10:00 (© Tracy Mackenna and Edwin Janssen 2009)	111
7.9	*LIFE IS OVER! if you want it,* Tracy Mackenna and Edwin Janssen. Cooper Gallery, Duncan of Jordanstone College of Art and Design, University of Dundee, 2009. Detail showing Master of Fine Art	

	students' project *Exquisite Corpse; a Contemporary Unfolding* (© Tracy Mackenna and Edwin Janssen 2009)	113
7.10	*LIFE IS OVER! if you want it*. Cooper Gallery, Duncan of Jordanstone College of Art and Design, University of Dundee. Detail showing discursive event with Lucy Byatt and the artists, and wall drawings (© Tracy Mackenna and Edwin Janssen 2009)	114
7.11	*LIFE IS OVER! if you want it*. Cooper Gallery, Duncan of Jordanstone College of Art and Design, University of Dundee, 2009. Detail showing public studio for presentation, exchange and production, with historical artworks (© Tracy Mackenna and Edwin Janssen 2009)	116
10.1	Skin Lesion (© Irwin Braverman, MD)	151
10.2	*Mrs James Guthrie*, c.1864–1866, by Lord Frederic Leighton, courtesy of Yale Center for British Art, Paul Mellon Collection	152
10.3	Bar graph depicting changes in observational scores between the control and YCBA groups (Dolev, Friedlaender and Braverman 2001)	154

List of Tables

1.1	A comparison of Laurillard's learning experience types and Clarke's learning outcomes	32
1.2	Laurillard's taxonomy of educational media	32
8.1	Data demonstrating the strongly negative preconceptions held by the students prior to their museum visit and the shift to more positive descriptors after their visit	125
10.1	Chart breaking down the performance of students in the control and YCBA groups	154
C.1	Outline diagram of education 'levels' and learning objectives across museums and universities	176

Notes on Editors and Contributors

Editors

Professor Anne Boddington is Dean of the Faculty of Arts at University of Brighton. She is an architect and cultural geographer, and a Fellow of the Royal Society of Arts. From 2005 to 2010 she was Director of the Centre for Excellence in Teaching and Learning through Design (CETLD). Anne is a member of the AHRC Advisory Board and its Peer Review College. She has extensive experience of academic and research leadership and management in higher education, particularly with reference to design, innovation and knowledge exchange in the creative and cultural industries. http://arts.brighton.ac.uk/staff/anne-boddington.

Dr Jos Boys is currently Head of Learning and Student Experience at the London Campus of Northumbria University. She was Senior Research Fellow, Learning Spaces, Centre for Excellence in Teaching and Learning through Design (CETLD) University of Brighton until 2010. Her background is in architecture and she has taught at various institutions, including the Architectural Association and London Metropolitan University. Jos has also been involved in teaching and learning research, leading an innovative BA in Architecture and Urban Studies which completely integrated online and face-to-face learning.

Author of *Towards Creative Learning Spaces: Rethinking the Architecture of Post-Compulsory Education* (Routledge 2010), she co-edited, with Anne Boddington, *Reshaping Learning: A Critical Reader – The Future of Learning Spaces in Post-Compulsory Education* (Ashgate 2011) and is now researching her next book for Routledge, entitled *Building Better Universities: Strategies, Spaces, Technologies*, to be published in 2014.

Catherine Speight is a Research Fellow and an AHRC-funded PhD candidate at the University of Brighton and the V&A. Prior to this appointment Catherine was Research Fellow at the Centre of Excellence in Teaching and Learning through Design (CETLD) based at the V&A. With a background in Cultural Geography and Museum Studies, Catherine is a trained curator and has worked for a number of leading and national museums including Brighton Museum and Art Gallery, the Museum of London and the Imperial War Museum. Catherine was co-editor and author of *Museums and Design Education: Looking to Learn, Learning to See* (Ashgate 2010). Catherine's PhD is a critical examination of the V&A's role in supporting higher education audiences through its network of university–museum partnerships.

Contributors

Having started his career as a history teacher in a comprehensive school, **David Anderson** was attracted to museums by their potential as places for lifelong learning. He has since worked at the Royal Pavilion, Art Gallery and Museums, Brighton, National Maritime Museum in Greenwich and the V&A. In 2012 he took up his current role at Amgueddfa Cymru – National Museum Wales. He is also a Board Member of Creative and Cultural Skills, the Advisory Committee of British Council Wales, and the Museum Association.

David Anderson has published extensively on museums, cultural policy and arts education, including the UK-wide Government report *A Common Wealth: Museums in the Learning Age* (DCMS, 1997, revised 1999).

Anne Balsamo is the Dean of the School of Media Studies at the New School for Public Engagement in New York. Previously she was a full professor at the University of Southern California in the Annenberg School of Communication and the Interactive Media Division of the School of Cinematic Arts. In 2002 she co-founded Onomy Labs Inc., a Silicon Valley technology design and fabrication company that builds cultural technologies. From 1999 to 2002 she was a member of RED (Research on Experimental Documents), a collaborative research-design group at Xerox PARC which created experimental reading devices and new media genres. In her recent book, *Designing Culture: The Technological Imagination at Work* (Duke, 2011), Anne Balsamo offers a manifesto for rethinking the role of culture in the process of technological innovation in the twentieth century.

Susana Bautista received her PhD in Communication from the University of Southern California, and her Master's degree in Art History/Museum Studies. Susana has over 20 years' experience working in the art world as an art critic, curator, Executive Director of the Mexican Cultural Institute, Editorial Director of LatinArt.com, and Arts and Culture Commissioner for the city of Pasadena. Her research focuses on the changing role of museums in the digital age, the distributed museum experience, and the socio-cultural context of how museums are utilizing new technologies.

Before becoming Senior Lecturer in the Centre for Higher Education, Learning and Teaching at the Australian National University in Canberra, **Dr Elizabeth Beckmann** spent more than 15 years working as an educational consultant for museums and other heritage institutions across Australia. With qualifications in natural sciences, heritage management and higher education from the universities of Cambridge and New England, as well as from the ANU, Elizabeth's interests in museum internships as learning opportunities for university students stems from her deep commitment to the capacity of authentic learning to provide students with high-quality learning experiences.

Stephen Brown is Professor of Learning Technologies and Head of the School of Media and Communication at De Montfort University, UK and a Visiting Fellow at the University of London Centre for Distance Education. His career includes course design, research and tutoring for the Open University; Head of Distance Learning, BT Training; Royal Academy of Engineering Visiting Professor in Engineering Design; Director of the International Institute for Electronic Library Research, De Montfort University; Senior Technology Adviser at the JISC Technologies Centre; and President of the Association for Learning Technology. He is currently researching computational methods for matching online images to text-only Victorian photographic exhibition catalogues.

Dr Helen Chatterjee is a Senior Lecturer in Biology and Deputy Director of Museums at UCL. She has a dual position in the School of Life and Medical Sciences and UCL Museums and Public Engagement; this role includes research, teaching and enabling activities. Helen has research interests in mammalian evolution and the role of objects in knowledge enhancement, health and well-being. She teaches mammalian evolution and advocates object-based learning as a core pedagogical tool. She has published a range of papers and books on these topics including *Touch in Museum* by Berg (2008).

Roy Clare currently works in New Zealand, where he is Director of Auckland War Memorial Museum. Until 2011 he was Chief Executive of the Museums, Libraries and Archives Council (MLA); between 2000 and 2007 he was Director of the National Maritime Museum, Queen's House and Royal Observatory, Greenwich. For 10 years from 1989 he was a Trustee of the historic vessel HMS *Bronington*; in 1999 he directed the opening of the Museum of Officers Training within Britannia Royal Naval College, Dartmouth. Formerly an admiral in the Royal Navy, Roy Clare was made CBE in June 2007 'for services to museums'.

Dr Rosalind Duhs is a Senior Teaching Fellow at the Centre for the Advancement of Learning and Teaching (CALT), UCL. She works with the School of Life and Medical Sciences supporting the professional development of university teachers. She also runs courses across the university on a range of pedagogical approaches, and is especially interested in object-based learning using museum collections. Rosalind believes students' motivation is increased when they work collaboratively on object-based tasks. She has promoted active hands-on and virtual object-based learning across the disciplines in higher education both at UCL and in Europe.

Linda Friedlaender has been Curator of Education at the Yale Center for British Art, in New Haven, Connecticut, USA for the past 16 years. She has taught at all levels of education. Ms. Friedlaender co-produced a programme on 'Enhancing Observational Skills' to improve clinical diagnosis skills for Yale University medical students, now a required experiential intervention in their training. The controlled study for this programme was published in the *Journal of the American*

Medical Association in 2001. Ms. Friedlaender has expanded this programme to the Yale School of Nursing and Physicians Assistants, and the University of Pennsylvania's Wharton School of Business, and created a course on scientific inquiry using original works of art for the faculty of the Biological Sciences at Mount Holyoke College.

Sarah Ganz Blythe is Director of Education at the Rhode Island School of Design Museum and was previously director of Interpretation and Research at The Museum of Modern Art, New York. She teaches and writes on exhibition culture and interpretation practices. She received her PhD in art history from the Institute of Fine Arts, New York University and a BA in art history from Wellesley College.

Dr Leonie Hannan is a Teaching Fellow in Object-Based Learning at UCL, where she encourages and supports the use of museum collections in teaching and learning across the university. In this role, Leonie also researches the educational advantages of using objects in learning in a wide range of academic disciplines. Leonie has a professional background in the museum sector and is a social and cultural historian of England in the early modern period. Her wider research interests focus on gender, intellectual life, the early modern household, and material culture.

Tracy Mackenna and **Edwin Janssen** share a collaborative art practice which they regard as a creative and discursive site, integrating research, production, presentation, exchange and education. Areas of focus are issues of life and death, cultural identity, place-making and visual publishing. Exhibition projects have taken place at for example Nederlands Fotomuseum, Rotterdam; Migros Museum für Gegenwartskunst, Zürich; Scottish National Portrait Gallery, Edinburgh; P3 art and environment, Tokyo; Ikon Gallery, Birmingham and on the cities' streets. Recent publications include *Truth, Error, Opinion, Stills* (Edinburgh), *Shotgun Wedding*, *Atopia Projects* and *A Perfect Image of Ourselves* (CCA Glasgow). They are lecturers at Duncan of Jordanstone College of Art and Design, University of Dundee, Scotland.

Leanne Manfredi is Programme Manager for Higher Education and Creative Industries at the Victoria and Albert Museum. Previously she has worked at a range of cultural and higher education institutions in the north-west including the Whitworth Art Gallery, University of Manchester, Manchester Metropolitan University, Urbis, Manchester Art Gallery, The Lowry and the Royal Exchange Theatre. She is currently undertaking postgraduate studies at Goldsmiths.

Rebecca Reynolds is a visiting lecturer in Museum Studies at Reading University. She also works on museum-related education projects, the latest of which is Object-Based Learning for Higher Education funded by the Joint Information

Systems Committee (JISC), a partnership between Reading University, UCL and the Collections Trust. This focuses on developing digitized learning resources based on collections at Reading and UCL for use in higher education and beyond. Previously she worked at the Victoria and Albert Museum for four years researching and developing learning resources for design students, as part of a project funded by The Centre for Excellence in Teaching and Learning through Design (CETLD).

Dr Richard Watermeyer is Lecturer in Higher Education at the University of Surrey. His research and teaching interests are located at the intersection of a sociological examination of education/higher education (HE) and science and technology studies. His research encompasses empirical and conceptual analyses of HE policy; the economic and societal impact of research and the impact of an academic/policy nexus; knowledge transfer/exchange and the relationship between HE, industry and business – methods of knowledge production in a globalized knowledge economy; object-based, experiential and creative pedagogy; public/community learning; and the governance of science and science policy.

Gareth Williams is a curator and writer about contemporary design and Senior Tutor of Design Products at the Royal College of Art with a special interest in the ways in which design is represented in museums. His exhibitions include *Ron Arad Before and After Now* (V&A with Sorrel Hershberg, 2000), *Milan in a Van* (V&A, 2002) and *Telling Tales: Fantasy and Fear in Contemporary Design* (V&A, 2009). His books include *The Furniture Machine: Furniture since 1990* (V&A, 2006) and *21 Twenty One, 21 designers for twenty-first century Britain.* (V&A, 2012).

Dr Carrie Winstanley has taught in schools and higher education for more than 20 years. Currently Principal Lecturer at Roehampton University, London, she also continues to run holiday and weekend workshops with children in museums, galleries and science centres. Carrie is particularly committed to encouraging both undergraduate and postgraduate students to embrace museum and gallery visits as an essential aspect of their learning. With higher degrees in psychology, philosophy and history of education, her interests lie in learning, teaching and challenge in education, with an emphasis on broadening diversity in all phases of education, with reference to social justice.

Preface:
Museums – Reaching Higher

Roy Clare CBE

'Museums safeguard and develop collections, create knowledge and contribute to cultural life.'

'The precise purpose of many "reserve" collections remains unresolved.'

'Specialist knowledge ... comes from a wide range of sources.'

'People who work for museums will need to work differently and develop new skills.'

In a recent discussion paper the Museums Association launched a stimulating and challenging debate. '*Museums 2020*' sets out a radical social agenda and poses fundamental questions about the relevance of museums. This signals a watershed: those who forge ahead will have reacted to the requirement for collaboration, integrated thinking and connected leadership.

Background

Twenty or thirty years ago, museums had things mostly their own way. Curators were famously known for their long experience and personal knowledge. There was a general assumption that the public deferred to the expertise of those presenting the collections and there was relatively little pressure for reform. As a result museums could claim that they were 'for everyone' while acting autonomously and in the interests of relatively narrow elites.

Reality began to intrude a decade or so ago, with a realization that the Victorian ideal was becoming unsustainable. Simply collecting, keeping and doing too little about sharing amounted to a spiral of ever higher costs with diminishing returns to show for the investment, especially where such investment derived from public sources.

Initially, reforms in museums focused on how to cut staff costs. Directors became business managers, curator posts were wrapped together, re-structured or removed altogether. 'Reserve' collections were still growing larger, but the levels of scholarship and intellectual access were beginning to decline. Museums were starting to be perceived as 'attractions'; there was some remarkable growth in reported numbers of visitors.

The advent of lottery funding – and many wonderful opportunities for capital investment – reinforced a sense that museums were places for people to attend. Successive governments reinforced that impression by demanding statistics on 'feet through the door', alongside other equally crude measures to justify public funding. For a time, just admitting the public and counting them seemed to be enough, but people also started to probe the value of the experience and to assess the cultural benefits.

Recent re-appraisal of the environmental standards for long-term care of collections has led to greater realism. Cost-conscious policies are aligning with goals to reduce carbon footprints, to bring about a risk-based approach to the care of collections in reserve stores. At the same time, the absolutism of conservation practice has been giving way to more reasoned and reasonable strategies, which better serve the interests of sustainability and enable more fluent access by researchers and the public at large.

Digital Impact

The rapid increase in the advance of digital technologies has brought previously unimagined democratization. People now have greater expectations of institutions and organizations and – thanks to the Internet and to social media – they have the tools at hand to make themselves heard. Museums have had to quicken the pace at which they were planning to extend the reach of their collections. Museums have had to connect; and with it to nourish and extend the capacity of their leadership.

Most museums now have a web presence of some kind, but with growing experience of working with the public in cyberspace have come pressures for new strategies and approaches. The analogue to digital switchover has started, but comparatively few museums have completed the kind of organizational transformation that is necessary to realize the full scale of the potential for full-blooded participation by the public. Most are embarked on the journey, but progress has been constrained by resources and sometimes by parochial concerns and a fear of change.

Individual museums may not have sufficient resources to develop digital platforms independently and unaided. Partnerships between museums and third parties can lead to the sharing of costs and more ambitious technological development. It is no longer enough to have a website; museums need to invest strategically in their digital systems to support data collection, storage, management and transfer.

In relation to digital content, museums have learned to avoid the trap that confronted early adopters of the web, when resources were allocated to digitizing items in the collections without a full understanding of how that content would be marketed and discovered. Similarly, museums are now less likely than they once were to develop digital products without closely examining the market; teachers' shelves once groaned with unused CDs from well-intentioned museums.

Social Value

On the positive side, there are now sufficient voices prepared to challenge the comfortable notion of museums as merely places to enter, where curators are didactic. It is common for key leaders to remind museums that they exist to provide services to the public; and that the institutions need to be of the age.

Market research was once simply a matter of knowing whether or not people were 'satisfied' with their visit. Now it is becoming important to know what impact has resulted from the visit and what difference a museum makes to human lives.

In the UK at least, there is ample evidence of the impact museum programmes can have on the lives of individuals and communities and a heightened awareness that by adding social value museums can be more relevant to the priorities and policies set by civic leaders and better connected to the communities who in many cases foot the bill.

In 2011 the UK-based Cultural Learning Alliance published a report (*ImagineNation,* see http://www.culturallearningalliance.org.uk/page.aspx?p=100) that focused hard on the evidence of social impact; data sources are quoted and original work is referenced. Longitudinal studies for example *Inspiring Learning for All*[1] have already shown that young people who are exposed to material culture in museums are more likely to become confident, well-educated citizens.

Projects in recent years have also shown benefits from historic collections being used to bring about a greater feeling of well-being, and some have shown advantages for the care of older people, including – for example – in relation to the treatment of those suffering from dementia.[2]

Commentators make the point that people want to engage with collections in order to connect with the past, to learn something about their own identity, to share experiences and to contribute to and participate in the narrative. Many museums are now responding wholeheartedly to these greater expectations. There is recognition of the need to move on from merely existing, to identifying ways to make a difference.

Implications

But the implications are profound, and go right to the heart of the philosophy of collecting. For instance, museums need to embrace the idea of 'developing' their

1 A study by the Museums, Libraries and Archives Council that profoundly influenced the development of better understanding of the instrumental benefits that stem from young people engaging with material culture; the study can be found among others on the website of the Cultural Learning Alliance.

2 For example, Screen Yorkshire's pioneering approach, using films: http://www.screenyorkshire.co.uk/news/news-archive/archive-films-used-in-pioneering-approach-to-tackl and Liverpool Museums' '*House of Memories*' project: http://www.liverpoolmuseums.org.uk/learning/community/house-of-memories/booking.aspx.

collections, not just adding to them. 'Development' is a holistic concept in which objects are risk-managed through a full life-cycle, from acquisition, through storage and care, to display, interpretation, loan, dispersal and disposal.

A risk-based 'development' process should weigh, for example, the environmental consequences of attempting to keep things for unlimited periods of time; the benefits of enabling people to see and handle things; the social and cultural advantages of viewing things in their original context; the knowledge that can be gained from enabling others – including the public – to participate in the stewardship processes.

Enabling people to interact with collections is increasingly becoming a priority and this is also bringing change to almost every facet of museum delivery.

So-called 'permanent' displays are being replaced by stronger story-telling, more vivid interpretation, co-production of some themes, programming involving groups from differing cultural and ethnic backgrounds and a stronger sense of social responsibility. The result is more than simply a dialogue: in the best examples it is leading to citizen-curation and spontaneity in the relationships between museums and their communities.

People are now contributing more substantially, not least online, to the overall sum of knowledge represented by a museum's collections and the themes they spawn.

Opportunities for Higher Education

In this new era for museums, universities and their student populations are a rich source of partnerships, in various respects and in several practical and intellectual ways.

At the most obvious level, universities educate and train successive generations of people who work in museums. Arguably, the relationship between supply and demand is out of kilter, with many more young graduates than the sector can absorb. The strategic connections could be strengthened – perhaps through a more fluent dialogue between higher education (HE) and museums as employers.

Universities are also potential partners in building up and nourishing expertise and know-how in museums. Museums need to anticipate and plan for the extent to which scholarship and 'curatorship' can reinforce each other. Depending on the nature of the collections, research projects can be created and partnerships can be struck with universities and research bodies that may be scientific, social, environmental, digital, educational or behavioural – or a blend.

Collaborative work could focus on the instrumental – say, audience impact and well-being – as well as on the scholarly and professional. Museums in the UK can apply to become 'Independent Research Organizations', which reflects their academic status. But whether designated in that way or not, all museums can forge relationships that are designed to explore their collections in new ways, to discover new information or to place things in context as part of some wider narrative.

Weight is lent to these opportunities through the process of 'developing' collections, in the course of which museums grapple with the reality that their organic expertise is invariably insufficient in relation to the scale of collections and the appetite of the public to know more about them. Research and study are closely aligned and when applied to collections can make all the difference to understanding, but museums on their own are unlikely to afford enough curators.

Museums also need to look for connections to university studies and programmes. For example, museums can cross-examine how their curators are being employed – or mis-employed – and ensure that as a matter of policy curators are spared handling endless, repetitive questions from the public (perhaps through the deft deployment of web-based 'frequently asked questions') and granted periods of time to study their collections and to develop and share their own knowledge about them. These projects can be established jointly.

Of course, investing intellectual resources to know more about their collections in this way, publicly funded museums need to keep the public interest to the fore: curators' research projects need to have outputs for the public, and not merely become exercises in personal and scholarly vanity.

Steps Ahead

In creating and deepening their partnerships, museums and universities enrich collections, extend awareness of them and nourish those who invest their intellectual capacity.

All of these relationships depend for their success on the commitment of both sides to common values and goals.

'Research' is a very broad idea, one that needs to be defined for specific projects and kept on track by continual reference to mutually agreed expressions of the benefits foreseen for the public.

The appointment of external members to an advisory panel can contribute to the sense of direction and help to build confidence that at the level of governance and strategic leadership the museum has access to appropriate advice and scholarly input.

After appropriate screening, research 'fellows' can be appointed to study areas within the museum's themes and consideration can be given to peer-review, to add authenticity and status.

The nature and scope of the collaborations and details of the investment are conveyed as mainstream activities, within the formal plans of the institutions.

All sides can see that in 'reaching higher' there are no feather-beds for culture and the arts; just a need for them to be innovative, relevant and connected.

Acknowledgements

The editors, Anne Boddington, Jos Boys and Catherine Speight, wish to thank the authors for their patience and insightful contributions. We would also like to acknowledge and thank Paul Manners, Director, National Coordinating Centre for Public Engagement (NCCPE), Sally McDonald, Director, UCL Museums and Public Engagement and Hedley Swain, Director Museums and Renaissance at Arts Council England, and especially Roy Clare CBE, now Director of the Auckland War Memorial Museum and previously Chief Executive of the Museums, Libraries and Archives Council (MLA) in the UK, who gave their time and offered candid perspectives on cultural policy in the context of changing political and economic climates across the world.

This is the fifth and final book that documents and takes forward the work from the Centre for Excellence in Teaching and Learning through Design (CETLD) (2005–10). Though now closed, its ongoing work and expanding activities continue to advance the profile and value of design learning and particularly the design and rethinking of learning spaces and their definition in the twenty-first century, as reaching beyond the borders of the academy and including our public, civic and professional institutions in new ways.

We would particularly wish to acknowledge and to thank Professor Bruce Brown and to remember the late David Clews, whose generosity, ideas, shared visions and work within the Faculty of Arts and the Art Design and Media Subject Centre at Brighton helped to shape and steer our aspirations. This book and the work of the CETLD owes much to them both and to the support and encouragement of David Anderson OBE, now Director General of Museum Wales and previously Director of Learning at the V&A.

Lastly we would like to thank our editorial manager, Isobel Creed, for her patience, management, compilation and editorial support of this volume, and Dymphna Evans and everyone at Ashgate for their belief and support for our ideas.

PART I
Policy, Pedagogies and Possibilities

Introduction

Catherine Speight, Anne Boddington and Jos Boys

The educational role of the museum is becoming increasingly central to its mission. There are now far more educational opportunities, new spaces, new interfaces (both digital and physical) and a growing number of education and interpretation departments, educational curators and public engagement programmes. However, despite these developments in the UK at least, higher education (HE) has remained a relatively marginal collaborator compared to primary or secondary education sectors and other forms of adult learning. Consequently, this has meant that partnerships between universities, colleges, museums and galleries have remained relatively unexplored, especially with respect to their potential for generating new and innovative patterns of learning, research and scholarship.

In this book we aim to explore the opportunities to bring together different forms of complementary knowledge and to address the key issues that limit or discourage such partnerships. We want to examine how we might enable more effective connections between these two scholarly sectors, which are long-term, robust and impactful. In this first chapter we identify some of the challenges to museum and university partnerships including conceptual and practical barriers, and then examine whether our current academic frameworks and learning models are fit for purpose.

From the mid 2000s, as the global financial crisis took hold, pressures were already mounting on public educational resources in many countries, yet battles over funding were also identified as enabling new kinds of opportunities for shared scholarship and research. In our current economic circumstances, we believe it is imperative to rethink how this might be undertaken, whilst continuing to support the core missions of both museums and universities as collaborative spaces for dialogue and learning. All the contributors to this volume address aspects of this issue. We will examine what kinds of spaces might evolve as blended models of learning – particularly centred around the power of object-based learning – and the potential benefits these could offer museums and universities. To do this the editors and contributors to *Museums and Higher Education Working Together: Challenges and Opportunities* will:

- reflect on international policy issues, opportunities, institutional identities and challenges;
- explore potential future changes in education at HE level across both sectors;
- examine examples of research undertaken nationally and internationally and to share experiences, so as to better understand the barriers to collaboration and consider methods for enabling enhanced integration;

- offer current examples of contemporary practice in this changing context.

We aim to both bring together work by experts in policy-making and education across the museum and HE sectors, and to offer an up-to-date and critical overview of changing approaches. We aim to conclude with some innovative suggestions about how valuable, relevant and resource-effective forms of partnered scholarship can be established between museums and universities. The ultimate aim therefore is to provide insights and opportunities for future development.

Despite their intertwined histories, the formation of productive partnerships between museums and universities has been uneven and has often occurred in a piecemeal fashion. Many museums have moved far away from their academic origins, when their collections were considered as central to teaching and learning as laboratories or studios. Museums were once seen as public resources for the education of adults but with the growth of formal education institutions this role has diminished such that the curatorial and educational functions of the museum became increasingly separated. It has only been in the late twentieth century that museums have re-focused on their educational role, through the growth of education and interpretation departments, particularly concerned to open up collections to wider audiences, to extend their reach and to demonstrate their cultural and social importance (Speight 2010).

This has led to an emerging field of scholarship (e.g. Hooper-Greenhill 1994, 1999, 2007, Hein 1998, Sandell 2002, Falk, Dierking and Foutz 2007, Cook, Speight and Reynolds 2010, Jandl and Gold, 2012a, 2012b). It has also begun to create a new generation of curators, museum educators and academics who are more confident in transferring their knowledge between formal university educational models and the more self-directed and informal learning spaces of the museum. In the UK, recent imperatives for collaboration, often through government-funded initiatives (some of which are described in this volume) have enabled a number of opportunities for scholars to move between sectors. For museum professionals, educators and students, navigating this institutional permeability can extend their own knowledge, skills and capabilities for independent learning. It also means that together, museums and universities can offer complementary resources that have the potential to enhance the services that students require for their learning and research.

In addition, broadening learning opportunities beyond the lecture and seminar offers a richer, more blended and more experiential approach, centred on engaging with tangible objects which has been shown to have potential for enhancing deep learning (Dewey (1938) 1997, Kolb 1983). In both sectors there is a growing need to examine and understand the particular forms of effective learning that museums and collections (including archives) enable. This includes learning to interrogate artefacts and exhibits, conceived not purely as objects but as 'portals' of knowledge through which to examine the different ways knowledge is constructed. This includes further examination of 'pedagogic stances' and 'unspoken interactions' (Savin-Baden 2000, 2007, 2011, Austerlitz 2008) acquired by students and tutors, which arm them with the tools to navigate complex and integrated forms of knowledge within any given domain.

However, despite the benefits, emerging collaborative practices between museums and universities have remained one-off project-based examples and marginal compared to museums' involvement in schools. While this impact varies from country to country, the policies and strategies enabling effective collaboration have been adversely affected in many places as a result of the global financial crisis. Thus, the potential benefits of enhanced learning through museum and university collaborations have remained unrealized. Throughout the remainder of this introductory chapter, we will examine the background to the current situation, concentrating primarily on England (since other parts of the UK and the rest of the world have taken different trajectories) to briefly explore some of the opportunities and barriers to collaboration.

Background – The English Context

As outlined above (and explored further by Sarah Ganz Blythe, Chapter 5) museums have almost always had some kind of educational mission. In the UK in the recent period, a renewed interest in stimulating relationships between museums and universities stemmed from the New Labour government (1997–2010). The first comprehensive review of museum education in the UK was by David Anderson, whose seminal report *A Common Wealth: Museums and Learning in the United Kingdom* (1997) raised the profile of education in museums, but also highlighted the omission of universities and their potential roles. The New Labour government looked favourably on collaborations between museums and universities and called for stronger links to be made between both sectors (DCMS 2003, DCMS 2005). This call formed part of wider concerns about the role of the public sector, which drew publically funded institutions like museums and universities into political debates surrounding their purpose, value and affiliation to the communities they serve and those they represent (Chatterton 2000, Sandell 2003). The requirement for museums to demonstrate their success in 'meeting local, regional and national objectives' in terms of 'healthier communities', 'safer and stronger communities', 'economic vitality', 'learning' and 'quality of life for local people' of course also generated tensions within the sector as to what success meant for a museum when such objectives failed to acknowledge the museum's 'traditional services' (Gray 2011: 48) such as their duty of care to their collections and safeguarding these for future generations.

A series of government reports demonstrating the value of museums as responsive institutions for learning (DCMS 2000, DCMS and DfES 2004, DCMS 2005; DCMS 2005, DCMS and DfES 2007) signalled a heightened interest in brokering collaboration across the education and cultural sectors; emphasizing the specific value of links between the further and HE sectors and museums (DCMS 2003, DCMS 2005, Dawson and Gilmore 2009) but also acknowledging their role in contributing to the creation and dissemination of knowledge. This was a critical part of the New Labour philosophy that conceived knowledge as a form

of currency that could be shared, distributed and acquired. Although New Labour directly acknowledged the relationship between museums and universities in a number of reports, these were strategically positioned alongside other policies which emphasized the importance of the HE sector in driving forward the nation's economy (Lambert 2003, Cox 2005), and a closer relationship between universities and the creative and cultural industries (DCMS 2003).

Within this context, museums (and libraries and archives) were encouraged to work with universities as a way of bringing together complementary knowledge, sharing insights into working methods and capitalizing on the resources and expertise of participating institutions. Partnership working was also seen as strengthening the cultural offer and creating opportunities for exceptional public and financial benefit (Cutts 2010). In addition, it proved a practical way for an institution to achieve reach and impact beyond its immediate geographical location (Falk and Dierking 2008). However, as New Labour pursued something of an expansionist policy in government with public policy addressing many major societal changes related to work, leisure, families, communities, globalization and technology (Scott 2003), the ways in which museum–university – and other public sector – relationships were pre-dominantly articulated changed considerably. The framing of these policies led to increased public accountability, growing costs and competition for funding within reduced public sector budgets and was characterized by:

> the presumption of instrumental effects in a sphere of activity largely associated with intrinsic value; the introduction of a target culture and accountability by quantitative performance measures; the predominance of economic value in a field often described as one characterised by market failure, and the use of economic indicators as proxies for social impact.
>
> (Selwood 2010: 4)

But in 2010, New Labour were replaced by a Coalition government and there then followed a global financial crisis and economic recession. The UK government moved towards an austerity programme. Through a Comprehensive Spending Review, it announced the closure of the Museums Libraries and Archive Council (MLA) as part of a major reduction in the number of publically funded bodies, subsuming its specialist role within the Arts Council of England (ACE). This occurred alongside a series of strategic long-term fundamental and transformational changes to the HE landscape across the UK. Both public cultural institutions and HE thus face the challenge of a shifting government agenda and the reduction and reframing of what constitutes their futures. For example, increased tuition fees for students studying in England requires that universities consider how they can provide valuable and innovative learning opportunities that will offer distinctive benefit for their students.

While acknowledging the role of HE and HE-related activity as vital investors in the arts and as major players in cultural provision and development (ACE 2006), ACE's longer-term historical role in HE funding for the arts also did little to bridge

with the museums and galleries sector, except in relationship to university-run museums and galleries. The emphasis in its 2006 HE strategy, 'Arts, Enterprise and Excellence: Strategy for Higher Education', was on supporting universities by providing funding for teaching experiences, student placements and performance opportunities. At the same time, it also recommended that universities undertook audits of their current and potential cultural activities as a way of demonstrating their impact and their 'cultural footprint' by helping institutions identify where collaboration most added value and quality:

> Over 2 million people attend public lectures and performance put on by higher education providers, UK academics provide over 30000 working days in support of museums, galleries and related education activity. Our new 'university challenge' initiative also emphasises that higher education providers make a real difference to the cultural life of towns, not least through the facilities which benefit students and communities.
>
> <div align="right">(ACE undated, unpaginated)</div>

Cross-sector partnerships between the museum and HE sectors are thus not dealt with explicitly or strategically in these policies. Current ACE strategies continue this approach, by focusing investment on 'excellent, forward thinking and enterprising museums and libraries best able to drive innovation, care for their collections and share learning' (ACE 2011: 19) but with collaborations still assumed only in their current informal manner:

> What we encourage is knowledge sharing, partnerships and new and innovative ways of working, so I wouldn't say we explicitly encourage museums to work with universities but if you encourage those three things a natural logical progression of partnership will evolve.
>
> <div align="right">(Swain 2012: interview)</div>

Thus, ACE remains in principle committed to supporting 'innovative' partnerships between both sectors in that they are both 'about knowledge, research and accumulation and culturally there is an overlap in their professional expertise and in subject matter' (Swain 2012). Interestingly, their particular focus and interest extends to the university museum sector (currently funded by HEFCE) and what they perceive they can and might share with the public museum sector in terms of engagement with HE:

> University museums should be bringing something to the overall museum sector in addition to being just good museums especially with the fact that they have got access to a deeper pool of research as academics and have a slightly different set of drivers in what they are setting out to achieve and are slightly less driven by visitor numbers and in theory can experiment more.
>
> <div align="right">(Swain 2012: interview)</div>

In the coming years, ACE proposes to work with some of the 'leading university museums in England' including the Ashmolean, Fitzwilliam, Manchester Museum services and UCL's Museum and Public Engagement service to investigate more thoroughly what value university museum services not only offer HE audiences but the wider public:

> It is particularly relevant in the context of the Arts Council and with the Arts. Quite a lot of importance is put on excellence and if you try and translate excellence into museums, some of it will be about engagement, some of it will be about quality of teaching and some of it will be about the quality of services but some of it has got to be about collections, scholarship and research ... I'm really keen to get some of our regional museums really feeling like national museums in having really deep research knowledge and research used for public programmes ...
> (Swain 2012: interview)

Such calls for museums to demonstrate their public value are not new and more frequently come to the fore during times of economic constraints: 'for measuring and articulating the value and impact of the sector is more than an academic exercise, given the policy, financial and business structures in which most cultural organizations operate in England' (Gibson 2008: 320). Commentators have pointed to the importance of developing more sophisticated systems for measuring the impact and value of the museums' sector. The DCMS has recommended looking to HE for guidance on ways of demonstrating quality and measuring excellence: 'there are ... examples from other sectors, for instance the HE sector, which might provide a way forward in measuring excellence not just in research but institutions more generally' (DCMS 2005: 33). This may include, for example, drawing on the field of research impact in universities – 'a process of investigation leading to new insights effectively shared' with a range of stakeholders and audiences' (HEFCE 2009: 6 in Selwood 2010).

UK universities have also become increasingly aware of the importance of both demonstrating and measuring public value since the government specified that it 'should take better account of the impact research makes on the economy and society' (HEFCE 2009: 4 in Selwood 2010). This concept of 'impact' has since been embedded within the assessment of research undertaken across UK universities through the Research Excellence Framework 2014, which will explicitly require data on who benefits, and how.

Museums and Universities Working Together

As outlined above, there was a brief moment in England when museums were encouraged to work with universities as a way of bringing together complementary knowledge and to capitalize on the resources and expertise of participating institutions:

> Collaborations provide a channel for the follow of ideas between the two sectors [museums and higher education institutions], which invigorate and strengthen the departments involved and change the intellectual climate through each institution.
> (Anderson 1997: 57)

The 'flow of ideas', the stimulation of a shared agenda and the establishment of an intellectual climate between the two sectors has encouraged and motivated many of those working in museums and universities to embrace partnership working. There is a general assumption that collaboration between two or more partners is seen as a worthwhile endeavour for reasons of economy and efficiency (Anderson 1997) but all too frequently such calls fail to acknowledge how such partnerships work in practice, and some of the difficulties that may be involved. The recurrent theme underlying government's interest in this area was that collaboration and cooperation between both sectors would deliver opportunities that would lead to the creation of economic, social and cultural capital. For example, through growing economies of scale and through policy effects to stimulate audience demand more effectively (BOP 2011) but also by spreading knowledge about best practice and new approaches between different organizations (MLA 2009) and sharing insights into working methods and the opportunities to develop and share educational and research resources (DCMS 2005).

There have been some UK publications that have examined the impact of collaborations between museums and universities. One report has noted growing activity in this area (Travers 2006), others have focused on regional studies of museum–university partnerships in the North West including 'A Shared Interest: Developing Collaboration, Partnerships and Research Relationships between Higher Education, Museums, Galleries and Visual Arts Organisations in the North West' (Dawson and Gilmore 2009). This report examines how collaboration can strengthen relationships between universities, museums, galleries and visual art organizations in regional areas of England. Case study examples, however, are potentially limited in their ability to draw out transferable models or strategies for future research. For example, they may fail to consider the practicalities of such arrangements from the different operations of power that exist between museums and universities as to their different roles as creators and interpreters of knowledge and its effect on areas of shared enterprise such as learning, scholarship and research.

The most comprehensive study in recent years is by Kate Oakley and Sara Selwood, '*Conversations and Collaborations: The Leadership of Collaborative Projects between Higher Education and the Arts and Cultural Sector*' (2010), which examines the history and landscape of collaborations between universities, the arts and creative and cultural organizations and, in particular, the leadership literature in both the HE and cultural sectors. Published at the end of New Labour's tenure in government, the authors examine the political circumstances and policy-led initiatives that influenced the burgeoning of collaborations between universities and the arts and creative sectors in the UK through that period. These included policy initiatives that have encouraged universities'

involvement in economic development (DTI 1998), support of research through funding initiatives including the Higher Education Innovation Fund (HEIF) – a stream of public funding dedicated to strengthening the links between the knowledge base in HEIs, business and society, the Research Councils' support of research in organizations outside universities to include museums and finally, the perceived wider significance of creativity to the nation's economy including the Arts Council's strategy for supporting HE mentioned above. Oakley and Selwood's work relates to the importance of four key themes: knowledge transfer and exchange, facilitating innovation, measuring collaboration and models of leadership – all of which, they suggest, are threatened by the more recent squeeze on public finances. While, as the authors acknowledge, their report is not an exhaustive or comprehensive study of the many collaborations between HE and the cultural sector, nor does it present a systematic review of all the relevant literature, it does provide an interesting and relevant account of the factors surrounding the interest in museum and university collaborations and the historical and political context in which they are situated.

Oakley and Selwood are also concerned about the costs associated with such collaborations, which, as they note 'do not grow up naturally in market economies' (2010: 6) and suggest the need for seed funding, strategy and leadership to enable museum–university partnerships to evolve effectively. Reasons for partnership vary but in most cases external funding is a key incentive, which of course begs the question as to whether partnerships between museums and universities are sustainable without it? The piecemeal and ad-hoc nature of partnership is highlighted throughout the report. Partnerships were mainly framed around the concept of knowledge transfer, a term used to describe the passing of information between the research base and user community including collaborative research, development and training. This is significant particularly in the UK, where the various public (research) funding organizations, grouped under the name Research Councils UK (RCUK), have begun to focus on a knowledge exchange and 'pathways to impact' agenda in publicly funded research (RCUK undated).

This ongoing difficulty in accumulating comprehensive or comparable data about museum-university relationships, (DCMS 2006, Cook, Speight and Reynolds 2010) makes it harder to evaluate the different types of experiences that working together generates. This is further complicated by the difficulties of imposing external forms of assessment to measure the success of individual museums and universities let alone collaborations between the two when: 'what universities and cultural organizations might take as indicative of collaborations' success may be unclear' (Oakley and Selwood 2010: 56). However, the limited work that has been undertaken in this area does point to benefits that museum and university collaborations provide including professional development, research forums and conferences and research funding (Dawson and Gilmore 2009), models of collaborative or distributed leadership, which allows both partners to pursue avenues of interest and opens up opportunities for new and younger leaders to gain experience (Oakley and Selwood 2010).

Of course, one of the most important drivers for collaboration has been access to funding opportunities:

> Opportunities for partnership funding are of increasing importance and promote valuable cross-institutional and interdisciplinary perspectives and expertise. While much of this has focused on stimulating collaborative research schemes or knowledge transfer projects, it is notable that once links are established between universities and museums they often evolve into relationships that lead to interesting developments in teaching and learning.
> (Arnold-Forster and Speight 2010: 6)

The problem for both universities and museums in a climate of severely restricted resources is that 'following the money' is no longer a viable route. We therefore need to examine forms of collaboration that act not just as capacity builders but also as 'multipliers' in that they can produce resource-effective results through new kinds of sharing structures.

Barriers to Museum–University Relationships

There has been considerable work undertaken examining the barriers to museums and HE institutions working better together – some of it valuably covered by contributors to this collection. Here we want to propose that the key barriers to educational integration are at a deeper level; that is they are built into the way museums and universities have been framed historically, and into how the assumed (or preferred) relationships between the two sectors have been generally articulated. Thus, we need to reflect on how specific institutional 'silos' have grown in particular ways; why 'collaboration' itself has become an unquestionable 'good' (increasingly the predominant means to develop integrated activities); how museums and universities understand and demonstrate their core missions and activities differently; and how they have implemented particular educational objectives and practices (Boys 2010). Each of these challenges will be explored in more detail next.

Framing Disciplines

As we have noted, contemporary museums and universities are products of a particular sets of historical and geographical circumstances but are also dynamic institutions that are exposed to other wider economic, cultural and social processes including 'the post-industrial, post-capitalist, high-modern or post-modern' (Fyfe 2006: 40). In the UK this has led, for example, to a move away from manufacturing towards the service industries, with its associated 'de-industrialisation, transformations of regional economies, the development of comparatively large middle classes, the growth of a consumer society and the breaching of established and modernist boundaries between high and low culture' (ibid).

At the same time, museums and universities have been led and funded in many different ways, including via national, regional and local governments, quangos, private bodies, public–private partnerships and individual sponsors. As Gray has shown (2011) in his explorations into the relationships between structure and agency in the museums and galleries sector, there are considerable complexities in unpacking how national policy is translated into specific institutional and individual goals; and how this is affected by special interest and other groups. As Weil shows (and we return to this in the conclusion) this is underpinned by a lack of clarity as to how we define and then evaluate what constitutes 'success' for a museum (Weil 2000, 2002).

In the UK, museums and universities have been funded and coordinated by different government departments; museums through the Department for Culture Media and Sport and universities currently by the Department for Business, Innovation and Skills (BIS). This division of responsibility appears to have ensured that their ambitions and missions remain distinct and not always complementary in their underpinning strategies. It has also meant that funding streams have not been aligned or connected, and that where these are deliberately linked, the focus becomes about bridging an assumed divide, through active brokerage and with collaboration as its mission. This has led to institutional silos being reinforced rather than challenged since assumed separation is built into both their policy commitments and funding initiatives. Inadvertently, museums and universities have responded opportunistically to funding calls in defining the priorities of their relationships rather than truly considering the strategic value of their shared mission in reassessing the structure of their activities.

There are some examples where universities and museums have been able to commit to building more strategic and long-term relationships despite these artificial but deeply embedded framings of difference. For instance University College London's integration of object-based learning (OBL) into both their learning and teaching policies and staff development programmes, as described by Hannan, Duhs and Chatterjee (Chapter 11), grew out of using the university's museums for learning across the institution, and thus became part of the university's core mission. The development of this book also came from an attempt to create a new dialogic space across sectors, which could open up the potential, not just for individual collaborations but for new ways of thinking about and 'doing' learning. Our initial impetus came from one of the 74 UK government-funded Centres for Excellence in Teaching and Learning (CETL) programmes (2005–10) and was an attempt to examine the spaces for creative learning and scholarship that lie beyond the institutional policies and divisions created by the DCMS and BIS; and to consider how these issues might be overcome. The Centre for Excellence in Teaching and Learning through Design (CETLD) was a partnership between the University of Brighton, the Royal College of Art (RCA), the Royal Institute of British Architects (RIBA) and the V&A Museum in London. Over its five years' duration and through a series of research projects and teaching experiments, the CETLD examined how museums and HE could

better understand one another and offered educational support through design education for its many and varied communities of learners (the legacy website can be found at http://arts.brighton.ac.uk/research/cetld).

If this separation of disciplines has often been externally imposed, it is internally perpetuated with different subjects keeping to their own conferences, research agendas and everyday practices and assumptions. Museum and university educators also need to reflect explicitly on their unspoken differences and to form new cross-disciplinary and hybrid communities of practice. We will return to this in the conclusion.

The Rhetoric and Realities of Collaboration

It could be argued that most museum–university initiatives have been based on the assumption that collaboration between two or more partners is an automatic 'good' and a worthwhile endeavour

Yet, it is also well known that the bringing together of two or more different kinds of organizations represents, in practical terms, many challenges for those involved, and that many such collaborations have failed to achieve their intended goals due to institutional differences that have thwarted otherwise good intentions. The rhetoric surrounding museum and university partnerships may suggest a union of two equal players based on a common understanding and mutual respect of each other's expertise, but this does not include any explicit engagement with the specific knowledge and skills required to conduct successful collaborations. There is often a lack of protocols for dealing properly with unspoken interactions, differences in 'jargon' and ways of working. In parallel, as noted above, research has shown there is considerable collaborative working that is often hidden from view and is developed informally by individuals or groups in spite of funding initiatives. This usually occurs 'under the radar' and is driven by individuals' interest and commitment to a set of specific outcomes. The day-to-day complexities of inter-institutional learning were encountered by the CETLD research team who were based in a satellite office at the V&A Museum but employed by the University of Brighton. The areas in which they experienced difficulties were around different methodologies, terminologies and scholarly practices.

We therefore need to focus more closely on the realities of collaboration, and on what collaboration is *for*, most particularly in what is unique and specific about the kind of learning that both institutions share. In this book, as elsewhere (Jandl and Gold 2012a) many of the contributors explore OBL as a central element of collaboration. What museums and universities share and what *underpins* the value of them working together is a commitment to experiential learning, centrally engaged through objects and the rich range of possible interpretations that may connect them.

We suggest that while these connections around models of learning may be obvious when brought to the fore, they often become invisible precisely because of the differing educational paradigms of each sector. Furthermore, in the UK

at least, the focus has become centrally about collaboration, rather than about *learning*. Experiential and OBL object-based learning are valuable models for both sectors if the boundaries between sectors can become more porous. Experiential learning is not exclusively owned by any sector. The museum provides a rich (if often rarified) environment for OBL for a variety of different learners. But its education and interpretation departments could also develop their educational models beyond basic pedagogic practices by engaging with the best of experiential learning, explored and improved through the knowledge and skills of university staff and students and thereby extended to other audiences in the museum. We will return to this in more detail in the conclusion.

Differences in Core Business

Historically, museums have a core long-term mission and often a regional or national imperative that concerns the collection and conservation of artefacts for future generations. Universities have a different core mission that involves the building of knowledge, and the education and development of successive generations of scholars. Conversely, in universities there is a need to meet the requirements of teaching, learning and research and to convey knowledge in an increasingly diverse sector where a relatively specialist interest in collections and object-based teaching and learning may superficially appear to have no relevance. Museums similarly need to ensure that the variety of activities associated with the preservation and conservation of their collections is not compromised by 'public' access. For systematic and strategic partnerships to occur these differences need to be interrogated, unpacked and clearly articulated in order to overcome either the assumed and artificial divisions across sectors. A previous book collection developed from the CETLD experience (Cook, Reynolds and Speight 2010) began to ask these questions, and the contributors here also return to these, and related themes.

One such example of the problematic implications of such differences in core missions emerged in an early resource development project led by CETLD staff at the V&A. The aim of the project was to create digital trails of museum objects that HE students could access on handheld portable digital devices (PDAs) or mobile phones. The project highlighted the different priorities and expectations of both partners. The V&A was primarily concerned with the creation of the product and focused on the practicalities of using and implementing the materials developed, exploitation of a wide range of museum resources and high-production values that complemented the museum's brand. Such commercial interests are a growing imperative across the museum sector, particularly in the national museums where their brands – whether for exhibitions, websites, publications or other forms of learning resource – are a vital aspect of their growth and development. The University of Brighton, on the other hand, was primarily concerned with the research aspects of the project and the process of developing effective, intellectually stimulating and high-quality teaching

materials for the trails, rather than on the end product. Such work included different emphases on pedagogic issues concerned with design students' learning in the museum, learning outcomes (and outputs) and a need to problematize the process by questioning assumptions. In practice, both sets of aims and priorities were valuable and not mutually exclusive. However, this project set an important precedent for later CETLD projects in that it clarified the need for project aims to be explicitly articulated, and highlighted the importance of managing and testing the expectations of both parties at the outset of the initiative. A better understanding of differences in core missions (rather than just the assumption that collaboration equals, or will lead to consensus), underpinned by a longer-term strategic partnership, enabled both institutions to be clearer about the benefits to be gained from museum-university relationships.

Differing Paradigms of Education

As already noted many authors have explored university and museum education, often using the shorthand of formal versus informal learning to describe the key differences between them; that is, between structured, long-term education leading to accredited scholarly achievement and self-selecting, small scale learning based on amorphous goals around inspiration and enjoyment. As Boys demonstrates (2010) the tendency to a simplistic opposition between these modes can obscure the complexity and continuum between the two. In addition, as Batista and Balsamo suggest in this volume, the opening up of new kinds of spaces through digital media, and the increasingly hybrid inter-relationships it enables, is shifting conventional boundaries between what is learned, how, where, and between 'experts' and 'students'.

Currently, HE learning remains more structured than that conducted in museums (through the conventional frameworks of three- or four-year undergraduate degree and a one- or two-year post-graduate experience), with museum learning usually assumed to be for the 'general public'; that is, more open-ended and more broadly 'free-choice' with the audience less specifically guided. We therefore need to examine in greater detail what unites both, and what separates the university from the museum in their educational roles. This may help us understand what different kinds of learning are for, and where these may be best located. In addition, new forms of collaborative learning are already being developed across public and private sectors that 'sit between' these two basic models, enabling a much wider variety of modes of learning, combination of components, and forms of accreditation. For example, The Guardian newspaper collaborates with the University of East Anglia to enable learners to develop knowledge and skills in creative writing through a choice of short courses that are accredited by the university. This kind of collaborative learning is particularly important as new physical and digital environments enable content, context and sequencing of digital objects to be adjusted in real time; where museums can share content and where the relationship between the physical museum and its digital presence

previously articulated as two entirely different entities, can now be developed and shaped in new ways that interact with one another, and some of which have not yet been conceived or realized.

It is true that universities still mainly offer a sequence, in that methods and learning as well as the content have been organized as a formal 'diet'. However in contemporary university environment, modular systems have been increasingly utilized for their efficiency and effectiveness and these may – depending on the institution – allow more or less freedom of choice and more curation not only by the institution but by academics and students as they build their own repertoire of skills and knowledge. This shift has been the basis for many debates over the years and has now become far more nuanced and sophisticated. The boundaries of educational 'curatorial' freedom have been and continue to be negotiated through the various levels of education; with some module diets prescribed by the institution as core to a named award and others offering the student a range of choices. Here, again, the key issues remain what is learned, how, where and when; and what constitutes the knowledge, skills and relative roles of 'experts' and 'learners'? Who creates content (and how), who selects and orders it (and how), and who interprets it – and most importantly transforms it – are all questions about the processes of learning that the simplistic division between formal/informal education avoids. These are crucial matters for both museums and universities as they grapple with current economic restraints and government policies. Both share a commitment to education not only for the few, or to support the economy, but share a desire to critically and creatively locate the 'place' of expertise within learning in a context where we all need to find better ways of demonstrating our value and relevance. As both kinds of learning environments go through dramatic transformations, perhaps now is a good time to make space for dialogue, and to develop new and fruitful ways through which partnerships might be better managed for mutual benefit. Several contributors to this book examine the different paradigms of museum and university education, particularly in terms of how to describe and then measure successful learning. For example, Stephen Brown (Chapter 1) engages directly with assumed divisions between formal and informal learning, and argues that a better understanding of learning outcomes can resolve the false dichotomy outlined above. Elizabeth Beckmann meanwhile explores instead the concept of core competencies.

Opportunities for Museum-University Relationship

We will end by briefly considering some of the positive opportunities offered by the contemporary moment: first, the possibilities for new hybrid models and practices; second the opening up of new kinds of dialogue, and third, the potential created by new digital media and networks.

Opportunity 1: New Models and Practices

As the environments in both museums and universities undergo transformations as a consequence of national and global factors, it is perhaps too soon to identify new generic or universal models or practices. However by returning to some core issues that focus on learning and how we navigate these changing worlds, we may be able to find new means to traditional ends. Different ways of developing comparative and relational knowledge could offer enhanced access to content and new ways of shaping scholarship and experience; creating spaces in which to host critical debate will also stimulate dialogue across the two sectors. These issues are raised by Williams in Chapter 6 and MacKenna and Janssen in Chapter 7. These authors challenge curatorial authorities and question how these spaces may be differently appropriated. In Chapter 5 Ganz Blythe provides a concise and eloquent summary of the historical shifts in the history of attitudes to museum learning. Her conclusions present a more nuanced proposition that enables authoritative, critical and creative learning activities to coexist within a museum environment. This chapter also offers an alternative to arguing over right or wrong ways of doing learning by suggesting that there are many right ways that can work in various contexts for different learners.

Winstanley's unravelling of the hidden fears that new students have on a first visit to a museum (Chapter 8), and her practical suggestions for developing teaching and learning methods so as to better support them; Beckmann's discussion of internships; and Brown's case study analysis of designing learning resources, are all illustrations of adapted or new practices that come from not making assumptions about either learners or institutional structures. There is an opportunity here, then, to build on these experiences towards a more critical, creative and *strategic* development of innovative educational models that can span museums and universities by learning from their creative differences to diverse the educational offer.

Opportunity 2: Opening Up Dialogue

The joint building of new educational models and practices requires critical self-awareness in the educators own assumptions, and the growth of spaces for constructive debate about the differences and similarities between museum and university teaching and learning practices.

As already noted, this book and the conference from which it arose have been informed by the wider research activities of the CETLD (2005–2010). The international conference hosted by the V&A and the Faculty of Arts at the University of Brighton in July 2010 was entitled *Learning at the Interface: Museums and Higher Education Working Together*. It included keynote presentations from Ed Vaizey (representing DCMS *and* BIS) and the Roy Clare, CEO of the Museums Libraries and Archives Council followed by a plenary session and an afternoon of paper sessions. It specifically focused on the impact of national projects and

policies, the issues that had emerged over the past decade, likely future changes to both sectors and how cross-sector collaboration and partnership could be mutually beneficial. It was specifically aimed at bringing people together across the two sectors. This book expands significantly on that event in an attempt to make a broader contribution in shaping this emerging field and investigating how progress can be made in the apparent absence of strategic funding.

Opportunity 3: The Impact of the Digital

While the spaces and role of the digital environment in museums and universities could be the subject of entirely different volume, Batista and Balsamo (Chapter 3) in this book helpfully outline some starting points; and their diagram of a network learning spaces that are interconnected is an important reference point for placing potential new models of hybrid practice in a broader context. Here, from the learner's point of view, education takes places across multiple sites and through multiple means. Like any relatively new opportunity the digital environment in the museum has ignited much debate, often with a new zeal as to what may be possible in the future. But this is about much more than simply the addition of a new means of communication; it has the potential to deeply affect where knowledge is seen to reside, who has authority for it, how it affects both teachers and learners; and what constitutes the value of physical and digital versions of objects and collections. As one of the participants in the HASTAC (Humanities, Arts, Science and Technology Alliance and Collaboratory) online forum (2012) put it:

> Museums are the original hacker and maker spaces, design yards, and exhibition places. Museums offer educators a model for change in response to new learning technologies, using physical and virtual spaces to create areas of caves for private reflection, campfires for gathering in small groups to learn from our storytellers, and watering holes for exchange of ideas and artefacts that inform and advance civilizations.
>
> As we look at the future of museums, I see so much potential for museums to metaphorically serve as models for learning spaces in all ways. I ask educators routinely, 'how do we make learning in our schools as exciting, interesting, and rich as the best museums make learning experiences in their spaces?' So, as the topic of the 'Future of Museums' is explored, as a public school educator I see the bigger question as being why and how we see museums as integral to the 'Future of Learning for All People'. This dialogue offers an opportunity to make key linkages with the greater edu-ecosystem so that museums become not just a class field trip or patron's visit to a river's edge, but an integral current in the flow of learning rivers everywhere.
>
> (Post by Pam Moran HASTAC 2012)

Returning to the challenges faced at the interface of the museum and university sectors, we might ask what role does the digital play in enabling educational institutions to manage the shift away from an emphasis on content – to the development of scholarly environments that can advance learning facilitated by a digital presence? How can these new spaces enable scholars to bring different kinds of knowledge and ways of knowing together? How does the emergence of digital devices facilitate or create barriers to collaboration? How do we begin to tackle these challenges such that we do not create 'dams or obstructions' to Moran's rivers of learning? Similarly, how then do we ensure that the physical experience of museums is an augmented one, one which reveals more or different kinds of information and includes different ways of knowing that are not just virtual but invite material and physical presence too. While it is not in the remit of this book to answer these questions, they are a vital part of the development of better hybrid models, and of future dialogues across the museum and HE sectors.

Outline Book Structure

Museums and Higher Education Working Together: Challenges and Opportunities is divided into four parts. Following this introductory part, 'Policies, Pedagogies and Possibilities', Part 2 is entitled 'Strategic Alliances, Knowledge Exchange and Opportunities' and comprises a variety of chapters, exploring aspects of the changing policy landscape and the relative roles of universities and museums. The chapters focus in different ways on the opportunities and challenges of partnerships, and the activity and value (or otherwise) of these relationships with regard to public and community engagement, learning and knowledge exchange. Part 3, 'Curating, Collecting and Creative Practices', brings together contributors – many of them artists and designers – who explore the often complex and interdependent relationships that emerge through innovative curatorial interventions, collecting and creative practices. Part 4 is entitled 'Expectations, Assumptions and Obstructions'. The contributors here explore detailed reflections on the experiences of partnerships between museums and universities and the specific forms of support, knowledge and information that students in HE require, as well as guidance in navigating different institutional cultures. This includes both UK and international perspectives. The aim is to identify the challenges, conflicting expectations and the need for mediation between sectors, tutors and students.

In the 'Conclusion: Opportunities for the Future' the editors summarize key issues raised by the contributors, and identify some suggestions about how to respond to some of the emerging opportunities, resulting from changes in the political, cultural and HE landscapes after a time of global economic recession. Finally, two key figures in the field comment on the ideas, examples and debates generated by this book collection. First Roy Clare, currently Director of the Auckland War Memorial Museum and former CEO of the Museums Libraries and Archives Council (MLA) in the UK, offers his perspective on the current situation

internationally. Second, David Anderson, Director General, National Museum Wales, considers developments since his seminal text, *A Common Wealth: Museums and Learning in the United Kingdom* (1997), as well as future possibilities.

Despite the still modest evidence base for this emerging field of museum–university learning and collaboration, this book seeks to present an account of a critical and important cultural moment in the field; and to reveal new and vital opportunities for future research and development. It aims to be a key element of generating debates and strengthening the inter-relationships between museums and universities at a time in the UK and some other places in the world, in which the public sector and publically funded activities are under threat. It argues that out of these difficult times emerges the potential for a constructive and creative rethinking around what learning can be, where and how it can take place; and what new opportunities for hybrid and cross-institutional sharing can benefit not just learners but also scholarship, society and culture more generally.

References

Anderson, D. 1997. *A Commonwealth. Museums and Learning in the United Kingdom.* London: Department of National Heritage.

Arnold-Forster, K. and Speight, C. 2010. Museums and higher education: A context for collaboration, in *Museums and Design Education: Looking to Learn, Learning to See*, ed. B. Cook, R. Reynolds and C. Speight. Farnham: Ashgate.

Arts Council England (ACE). Undated. HEIs, the arts and the community: Cultural Footprint Review, unpublished.

Arts Council England (ACE). 2006. *Arts, Enterprise and Excellence: Strategy for Higher Education.* London: Arts Council England.

Arts Council England (ACE). 2010. *Achieving Great Art for Everyone.* London: Arts Council England.

Arts Council England (ACE). 2011. *Culture, Knowledge and Understanding: Great Museums and Libraries for Everyone – A Companion Document to Achieving Great Art for Everyone.* London: Arts Council England.

Austerlitz, N. 2008. *Unspoken Interactions: Exploring the Unspoken Dimension of Learning and Teaching in Creative Subjects.* London: Centre for Learning and Teaching in Art and Design (CLTAD).

BOP. 2011. *Evaluation of the MLA's National Workforce Skills Development Programme.* London: MLA.

Boys, J. 2010. Creative differences: Deconstructing the conceptual learning spaces of higher education and museums, in *Museums and Design Education: Looking to Learn, Learning to See*, ed. B. Cook, R. Reynolds and C. Speight. Farnham: Ashgate.

Chatterton, P. 2000. The cultural role of universities in the community: Revisiting the university-community debate. *Environment and Planning* A, 32, 165–81.

Chatterton, P. and Goddard, J. 2000. The response of higher education institutions to regional needs. *European Journal of Education*, 35(4), 475–96.

Cox, S.G. 2005. *Cox Review of Creativity in Business: Building on the UK's Strengths*. London: HM Treasury.

Cook, B., Reynolds, R. and Speight, C. (eds). 2010. *Looking to Learn, Learning to See: Museums and Design Education*. Farnham: Ashgate.

Cutts, P. 2010. Working in partnership is a necessity not a luxury. *Museums Journal*, 110(1), 19.

Dawson, J. and Gilmore, A. 2009. *Shared Interest: Developing Collaborations, Partnerships and Research Relationships between Higher Education, Museums, Galleries and Visual Arts Organisations in the North West*. Renaissance North West. eScholar ID:66640.

DCMS. 2000. *The Learning Power of Museums – A Vision for Museum Education*. London: HMSO.

DCMS. 2003. A Research Strategy for DCMS, 2003–2005/06, unpublished.

DCMS. 2005. *Understanding the Future: Museums and Twenty-First Century Life*. London: HMSO.

DCMS and DfES. 2004. *Inspiration, Identity, Learning: The Value of Museums*. London: HMSO.

DCMS. 2005. *Understanding the Future: Museums and 21st Century Life. The Value of Museums*. London: HMSO.

DCMS and DfES. 2007. *Inspiration, Identity, Learning: The Value of Museums*, Second Study. London: HMSO.

Dewey, J. 1938/1997. *Education and Experience*. New York: Touchstone.

DTI. 1998. *Our Competitive Future: Building the Knowledge Driven Economy*. London: Department for Trade and Industry.

Falk, J. and Dierking, L. 2000. *Learning from Museums: Visitor Experiences and the Making of Meaning*. Walnut Creek, CA: Altamira Press.

Falk, J. and Dierking, L. 2008. Re-envisioning success in the cultural sector. *Cultural Trends*, 17(4), 233–46.

Fyfe, G. 2006. Sociology and the social aspects of museum studies, in *Companion to Museum Studies*, ed. S. Macdonald. Malden, USA; Oxford, UK; Victoria, Canada: Blackwell, 33–49.

Gibson, L. 2008. In defence of instrumentality. *Cultural Trends*, 17(4), 247–57.

Gray, C. 2011. Museums, galleries, politics and management. *Public Policy and Administration*, 26(45), 45–61.

HEFCE. 2009. *Research Excellence Framework. Second Consultation on the Assessment and Funding of Research*. [Online]. Available at: http://www.hefce.ac.uk/pubs/hefce/2009/09_38/09_38.pdf [accessed: 31 January 2013].

Hein, G. 1998. *Learning in the Museum*. London: Routledge.

Hooper-Greenhill, E. 1994. *Museums and their Visitors*. London: Routledge.

Hooper-Greenhill, E. 1999. *The Educational Role of the Museum*. London: Routledge.

Hooper-Greenhill, E. 2000. *Museums and the Interpretation of Visual Culture*. London: Routledge.

Hooper-Greenhill, E. 2007. *Museums and Education: Purpose, Pedagogy, Performance*. London: Routledge.
Humanities, Arts, Science and Technology Advanced Collaboratory (HASTAC). 2012. 'The Future of Museums', comment posted 16 May 2012 by Pam Moran. [Online]. Available at: http://hastac.org/forums/future-museums [accessed: 6 May 2013.]
Jandl, S.S. and Gold, M.S (eds). 2012a. *A Handbook for Academic Museums: Exhibitions and Education*. Edinburgh: Museums, etc.
Jandl, S.S. and Gold, M.S. (eds). 2012b. *Academic Museums: Beyond Exhibitions and Education*. Edinburgh and Boston: Museums, etc.
Kolb, D. 1984. *Experiential Learning: Experience as the Source of Learning and Development*. Englewood Cliffs, NJ: Prentice-Hall.
Lambert, R. 2003. *Lambert Review of Business–University Collaboration*. London: HM Treasury.
MLA. 2009. *Leading Museums: A Vision and Strategic Action Plan for England's Museums*. London: Museums, Libraries, Archives Council.
Oakley, K. and Selwood, S. 2010. Conversations and collaborations: The leadership of collaborative projects between higher education and the arts and cultural sector. *Research and Development Series Leadership Foundation for Higher Education*.
Research Councils UK (RCUK). (n.d.) *Mission and Statement of Expectation on Economic and Social Impact*. [Online]. Available at: http://www.rcuk.ac.uk/documents/innovation/missionsei.pdf [accessed: 6 May 2013].
Sandell, R. 2002. *Museums, Society, Inequality*. London: Routledge.
Sandell, R. 2003. Social inclusion, the museum and the dynamics of sectoral change. *Museum and Society*, 1(1), 45–62.
Savin-Baden, M. 2000. *Problem-Based Learning in Higher Education: Untold Stories*. SRHE and Open University Press.
Savin-Baden, M. 2007. *Learning Spaces: Creating Opportunities for Knowledge Creation in Academic Life*. Maidenhead: McGraw-Hill.
Savin-Baden, M. 2011. Curricula as spaces of interruption? *Innovations in Education and Teaching International*, 48(2), 127–36.
Scott, C. 2003. Museums and impact: How do we measure the impact of museums? *Curator*, 46(3), 293–310.
Selwood, S. 2010. *Making a Difference: The Cultural Impact of Museums: An Essay*. National Museums Directors' Conference (NMDC). [Online]. Available at: http://www.nationalmuseums.org.uk/media/documents/publications/cultural_impact_final.pdf [accessed: 4 June 2013].
Speight, C. 2010. Museums and higher education: A new specialist service?, in *Museums and Design Education: Looking to Learn, Learning to See*, ed. B. Cook, R. Reynolds and C. Speight. Farnham: Ashgate.
Swain, H. 2012. Interview discussion about museum and university relationships with C. Speight. Arts Council England (ACE).

Travers, T. 2006. *Museums and Galleries in Britain: Economic, Social and Creative Impacts*. Museums, Libraries and Archives Council (MLA) and the National Museums Directors' Conference.

Weil, S. 2000. 'Beyond management: Making museums matter'. Keynote address at the 1st International Conference on Museum Management and Leadership – Achieving Excellence: Museum Leadership in the 21st Century INTERCOM/CMA conference held in Ottawa, Canada, 6–9 September. [Online]. Available at: http://www.intercom.museum/conferences/2000/weil.pdf [accessed: 6 May 2013].

Weil, S. E. 2002. *Making Museums Matter*. Washington, DC: Smithsonian Institution Press.

Weil, S. 2004. Creampuffs & hardball: Are you really worth what you cost? *Museum News*, 73(5), 42–3.

PART II
Strategic Alliances, Knowledge Exchange and Opportunities

This part includes four contrasting chapters that address educational challenges and present possibilities for new and enhanced forms of learning that extend across universities and museums. What also draws these authors and ideas together is a shared recognition and understanding of learning as a continuum that can occur anywhere and through many different media irrespective of the originating sector. Each presents different ways of addressing the transfer of learning structures and frameworks, alongside exploring issues of identity, authoritative knowledge, public voice and public engagement. Our shared challenge here, then, is to identify what more general and strategic opportunities for enhancing learning can be generated through such forms of exchange and engagement.

In Chapter 1 Stephen Brown offers a critique of the assumed and often accepted division between museums and HE as providing informal and formal learning environments respectively. Drawing from educational theory, particularly constructivism, he identifies the potential opportunities that using learning outcomes offer, not just as statements of learning activities, but also as mechanisms for enabling rigour and clarity in the orchestration of different kinds of learning experiences. From his background in HE Brown provides a helpful critique of the Museum Libraries and Archives Council's (MLA) Generic Learning Outcomes (GLO), and suggests a taxonomy of five different types of learning that supports a continuum from more passive and linear to productive and inter-active, which can be of value, in different combinations, to both sectors.

In Chapter 2 Elizabeth Beckmann brings together university and museum learning through students' experiences of internships and through placements. She highlights the very different perceptions and constructions of knowledge across the two sectors, and the variability of provision and experiences this can produce. Exploring these through a model of professional competencies, she raises a series of challenges and concerns about where responsibilities lie and who teaches what to whom. Following Patrick et al. (2009), she argues that sustainable work-integrated learning experiences in HE require sector-wide initiatives, and, as with Brown, argues that this includes effective learning design and assessment – in her case, also drawing on Wenger's (2006) Communities of Practice model.

In Chapter 3 Susana Smith Bautista and Anne Balsamo explicitly focus on the idea of a continuum of learning across a range of institutional, public and informal environments. These start from the physical but also go beyond the virtual to what they refer to as the mobile. In presenting learning across a distributed network of institutional sites that include both a physical and virtual presence they also present the challenges and opportunities for new kinds of 'mobile museum'. These ideas therefore conceptually extend further the nature of learning and of learner identity, as framed by the first two authors. They also involve rethinking the mediating role for museums in changing and volatile times, as well as the shifting nature of authority and institutional roles. And they propose that: 'The museum's challenge, and indeed its authority in the digital age, comes not only from a sense of accumulated expertise, but also from its ability to seamlessly navigate contradictory spaces and practices within this distributed learning network.' (p.66).

In the fourth and final chapter of this section, Richard Watermeyer explores the democratization of knowledge, writing from the perspective of a UK initiative entitled Beacons for Public Engagement (2008–12) that aimed to connect academic work more directly with the public. He shifts the debate to the demands made on educational, scientific and cultural institutions for better public engagement and the reactions and changes in institutional behaviour that this has initiated. As with Bautista and Balsamo, he is interested in the potential and fluidity of these shifts as a means to challenge the set structures that have previously defined the university. These patterns are, he suggests, actually a barrier to ensuring the development of authoritative knowledge through research and teaching. New forms of public engagement can therefore lead to distinct and different repertoires of expertise that could in time achieve a more effective and nuanced framework for public communication, without a loss of authority or integrity.

References

Patrick, C., Peach, D., Pocknee, C., Webb, F., Fletcher, M, and Pretto, G. 2009. *The Work Integrated Learning Report: A National Scoping Stud.* (ALTC Final Report). Brisbane: Queensland University of Technology. [Online]. Available at: http://www.olt.gov.au/system/files/grants_project_wil_finalreport_jan09.pdf [accessed: 4 February 2013].

Wenger, E. 2006. *Communities of Practic: A Brief Introduction.* [Online]. Available at: http://www.ewenger.com/theory/index.htm [accessed: 31 January 2013].

Chapter 1

Learning Activities, Learning Outcomes and Learning Theory

Stephen Brown

Introduction

UK HE teachers are used to designing learning activities based on expected learning outcomes, that is, precise statements of what it is intended that students will be able to do as a result of completing a specific component of study. This contrasts with learning in museums where it has been argued that because museum audiences are so diverse, what the visitor wants from a learning experience and how they will interact with a learning activity is essentially unknowable in advance, rendering the idea of prescribed learning outcomes meaningless. This chapter examines the implications of this view for developing cost-effective learning experiences in museums. In particular it questions what can be learned from the concept of 'Generic Learning Outcomes' (GLOs), developed by the UK museum sector as an attempt to adapt HE 'formal' models to 'informal' learning. It discusses the strengths and weaknesses of GLOs, concluding that while useful for measuring visitor reactions, GLOs are ill-suited to formatively guiding the design and development of learning activities to ensure maximum return on investment of scarce funds. However, the concept itself is potentially useful and the chapter suggests an alternative way of conceptualizing generic learning outcomes based on a taxonomy of learning experiences already widely known in HE, thus providing a link between formal and informal learning theories. This chapter illustrates how this taxonomy can be used to inform the design and formative testing of prototype museum learning activities. It argues that this approach could be used to improve the educational effectiveness of museum learning activities and maximize effective use of scarce resources at a time when museums are under increasing scrutiny and increasing pressure to deliver more for less.

Demonstrating Educational Effectiveness

Visitors to museums represent a broad spectrum of the population, ranging from young children to family groups and from independent scholars and organized student groups to those seeking recreation. These differences inevitably result in different expectations and requirements and museums have therefore to cater

to a wide range of needs. However, most visitors go to museums to learn and museums are regarded as educational organizations by many museum practitioners (Macdonald 1993, Falk et al. 1998, Ellenbogen 2001, Moussouri 2002). But this has not always been the case. The prime responsibility of museums until relatively recently used to be to their collections rather than their visitors (Institute of Museum and Library Services 2000: 7). Consequently the sector has not developed and established methods and models of its own to support learning activity design. Traditionally the sector has looked to education for guidance but because learning in museums tends to be much more wide-ranging, more self-selected and self-directed (what Falk and Dierking (2002) term 'free-choice'), it is argued that it is difficult to apply formal educational models, theories and methods to learning in museums (Hooper-Greenhill 1991, 1992, Hein 1998, Clarke 2001, Moussouri 2002).

This is potentially problematic for museum management, museum educators and the cultural heritage sector as a whole because of increasing requirements to demonstrate educational effectiveness. In the USA and the UK, for example, in recent decades public funding has been contingent on being able to present such evidence (Institute of Museum and Library Services 2000: 3, Selwood 2001). This in turn is because publicly funded cultural heritage institutions have increasingly been seen by governments as instruments for policies on equality, access, social inclusion and cohesion (Smith and Blunkett 2000, Lawley 2003, Sandell 2003).

In the UK, cultural heritage institutions were quick to align themselves with these policies. For instance, *A Netful of Jewels, New Museums in the Learning Age*, the report from the 1999 National Museum Directors' conference observed that 'we believe that museums and galleries should lie at the core of the new learning networks' (National Museums Directors Conference 1999: 3). In 2001, the UK Museums Libraries and Archives Council (MLA) noted that 'museums are being reinvented as physical and virtual spaces in which people engage and learn, interacting with objects and discovering their stories. Interweaving the real and the virtual creates a powerful brand, enabling museums to occupy centre stage in cultural cyberspace' (MLA 2001: 61). Museums have invested substantial resources in the web as an educational medium, yet little research exists to guide sound development of such resources because of the difficulty of transferring formal educational models to the informal learning environment (Schaller et al. 2005). If museum audiences are so diverse, and their interaction with learning activities so difficult to pin down (Moussouri 2002), how can new kinds of web-based learning resources be effectively designed, employed or evaluated?

Using Learning Outcomes

Learning outcomes or learning 'objectives' as they were originally called, describe the intended goals of a learning activity. A well-formulated learning outcome should be measurable and to achieve that it needs to be both specific

and objective (Bloom et al. 1956, Mager 1984). If the intended outcomes of a design are clearly articulated, then the performance of the design can be predicted in advance by testing how well it supports those outcomes. Prototyping is a well-established technique in many different fields for testing concepts before expensive decisions are made (Rettig 1994, Buxton 2007, Brown 2009). Prototype learning activities can be tested against specified learning outcomes with the help of volunteers or sample learners to assess how well they work. Although formal prototype lesson testing is not commonplace in face-to-face teaching, in contexts such as distance and online teaching where it is important for courses to be right first time, fit for purpose and robust, it is a well-established practice (see for example Brown et al. 1981).

However, while learning outcomes are widely accepted in university education as a rational basis for effective learning design, it is at first more difficult to see how they might apply in museum education. The difference between formal-university and informal-museum learning has been characterized as 'in the first approach someone decides what you will learn, in the second, you are in control and make choices about your learning' (Clarke 2001: 6) and 'each individual learns in their own way, using their own preferred learning styles, and according to what they want to know, each individual experiences their own outcomes from learning' (RCMG 2004: 8). It has thus been argued that a logical consequence of these differences is that attempts to specify learning outcomes in museums are both impractical (because unpredictable) and undesirable, because they restrictively prescribe learner behaviours (Hooper-Greenhill 2004).

In an attempt to deal with this apparently intractable problem, Resource: The Council for Museums, Archives and Libraries (latterly the MLA before its closure in 2011)[1] developed a set of measures for assessing the impact of cultural heritage institutions on their visitors that sidesteps the issue of specified learning outcomes (Hooper-Greenhill, 2002). Known as the Inspiring Learning for All Framework of Generic Learning Outcomes (GLOs), this framework[2] defined five broad areas of impact on museum visitors:

- knowledge and understanding
- skills
- attitudes and values
- enjoyment, inspiration and creativity
- action, behaviour and progression

Using these five areas it is possible to devise measures to ascertain, for example, whether the visitors acquired new knowledge, whether they know how to do something new, whether they feel differently about something, if they enjoyed the experience and whether they intend to do something differently in future.

GLOs have enjoyed some success in UK cultural heritage institutions. Around half of the museums in the UK were using a Generic Learning

1 In 2011 the responsibilities of the MLA were transferred to the Arts Council England.
2 http://www.inspiringlearningforall.gov.uk/toolstemplates/genericlearning/.

Outcomes (GLOs) based evaluation framework within two years of its launch (MLA 2006). Questions framed around these five areas provide metrics that go significantly beyond basic visitor numbers and simple 'happy sheet' style questionnaires. But there is a problem. As implemented, GLOs have not been used to measure actual learning because of the obvious impracticability of administering performance tests to museum visitors. Instead they have been used to examine what visitors perceive about their own learning or the learning of those they were with. Typical responses to questions intended to test knowledge and understanding are 'I could make sense of most of the things we saw and did at the museum' (RCMG 2004: 15) and '70% of teachers judged that pupils had learnt a lot about a specified topic' (Stanley et al. 2004). So while they do measure outcomes, these are more to do with uncovering whether the experience was enjoyable, inspiring, or interesting and how it affected visitors' disposition to museums and learning from museums. This indeed is the purpose for which they were developed, but from a learning design perspective this approach is flawed. Rather, we need to be able to reliably assess the likely *performance* of activities before significant resources have been invested in their development, that is, we need to judge what has been learnt, against what was intended. This takes us back to the position where we need to be able to specify the intended learning outcomes in advance in order to use this specification as a benchmark for testing the design as it develops. But as we have seen, the notion of defining specific learning outcomes for open-ended informal learning contexts is an apparent contradiction.

An Alternative Taxonomy

I believe there is a way out of this apparent conundrum and it lies in better understanding the nature and purpose of learning outcomes. If we critically review the earlier quote: 'In the first approach someone decides what you will learn, in the second, you are in control and make choices about your learning.' (Clarke 2001: 6), a misunderstanding becomes apparent. Learning outcomes do not actually define what a person will learn. Rather they describe what learning the activity should definitely be able to support. How people choose to use an activity and what they get from it is, of course, up to them. So learning outcomes do not need to prescribe or proscribe what a learner will get from an activity, all they do is offer a minimum specification of what a person could learn from it. What the authors of GLOs appear to have done is confuse the teacher's intentions (the intended learning outcomes), with results (actual learning outcomes). This may be because in formal education these tend to coincide.

It is also true that learning outcomes are frequently phrased in terms of acquiring specific knowledge and skills. All too frequently they define learning outcomes using phrases such as 'know that ...', ' understand ...', 'be able

to ...'. Such prescriptive outcomes have been described as 'convergent' by Clarke (2001) who differentiates them from 'divergent' outcomes such as 'investigate ...', 'examine ...', 'gain experience of ...', 'discuss ...', 'form an opinion ...'. An emphasis on prescribed knowledge and skills within 'convergent' outcomes is characteristic of 'behaviourist' theories of learning popularized by psychologists John Watson (1878–1958) and B.F. Skinner (1904–1990). Behaviourists advocate the use of clearly defined objectives, requiring observable actions in response to questions and providing immediate positive or negative feedback to the action in order to reinforce positive responses. It is closely associated with stimulus-response conditioning and programmed learning. Clarke's divergent outcomes on the other hand reflect more recent 'constructivist' theories. Constructivists believe that learners build knowledge and skills by processing stimuli from the environment into cognitive structures that can be used as a basis for behavioural change (for example, Bruner 1990). This is in conflict with behaviourist beliefs that the environment directs adaptive behaviour. Bruner (1990) and Piaget (Piaget 1963, 2001) are the main constructivist theorists while Vygotsky (1978) is regarded as one of the more influential social constructivists, advocating that learning is constructed through interaction with others (although Bruner in later life moved towards Vygotsky's viewpoint). Looking back at the idea that 'In the first approach someone decides what you will learn, in the second, you are in control and make choices about your learning', it seems likely that by associating behaviourist learning outcomes with formal learning and constructivist outcomes with informal learning, advocates of the GLO approach have created a false dichotomy between these two sectors and modes. Clarke, for example, argues that divergent outcomes are more suitable 'for open-ended, flexible and multilayered outcomes' (such as found in museums) and for the online medium (Clarke 2001). We can unravel the artificiality of this distinction with the aid of a well-established model from formal learning, Diana Lauraillard's taxonomy of learning experiences. Laurillard (2002: 82–90) identified five different kinds of learning experience:

- *Attending or apprehending* a lesson as a largely passive recipient of information.
- *Investigating or exploring* some bounded resource in a more active way where decisions about what to attend to, in what sequence and for how long are managed by the learner.
- *Discussing and debating* ideas with others.
- *Experimenting* with and *practising* skills.
- *Articulating and expressing* ideas through the synthesis of some new product.

Clarke's examples of convergent and divergent learning outcomes bear a marked resemblance to Laurillard's five different kinds of learning experience, as Table 1.1 shows.

Table 1.1 A comparison of Laurillard's learning experience types and Clarke's learning outcomes

Laurillard	Clarke
Attending or apprehending	'know that...', ' understand...', 'be able to ...'
Investigating or exploring	'investigate..', 'examine...',
Discussing and debating	'discuss..',
Experimenting, practicing	'gain experience of...',
Articulating and expressing	'form an opinion...'

These, then, can be seen much more as a continuum, rather than an oppositional division. Laurillard's proposition offers a rigorously thought-out taxonomy, which makes it a useful framework for analysing and constructing new learning activities (Brown and Cruickshank 2003). Moreover, Laurillard maps these learning experience types onto more familiar kinds of learning methods and technologies, as shown in Table 1.2, thus providing us with a conceptual framework with which to discuss learning designs and choice of appropriate media to support them.

Table 1.2 Laurillard's taxonomy of educational media (Laurillard 2002: 90)

Learning experience	Methods/technologies	Media forms
Attending, apprehending	Print, TV, video, DVD	Narrative
Investigating, exploring	Library, CD, DVD, Web resources	Interactive
Discussing, debating	Seminar, online conference	Communicative
Experimenting, practicing	Laboratory, field trip, simulation	Adaptive
Articulating, expressing	Essay, product, animation, model	Productive

Narrative media are highly structured, non-interactive and essentially linear. They are useful for the transmission of information but are not appropriate on their own, for supporting the iterative dialogue that is central to knowledge construction. Videos, animations, exhibition information panels and storylines are examples of narrative media employed by museums.

Interactive media offer resources for learners to explore in a nonlinear way. Users can decide for themselves what to look at and in which order. It is important to understand, however, that the user cannot change the content of interactive

media. Catalogues, databases, search engines and physical layouts of galleries, bays and shelves offer opportunities for self-directed exploration, but their contents remain unchanged by the viewer.

Communicative media support discussion and feedback for example, email, discussion groups, video conferencing, wikis, etc. Constructivists assert that feedback and discussion are fundamental to knowledge construction, through which theories and ideas are conceived, shared and transformed into knowledge and understanding.

Adaptive media are similar to interactive media but with the crucial addition of 'direct intrinsic feedback' on learners' actions. That is to say, actions result in consequences that are inherent to the task or system under consideration. Simulations, games and hands-on exhibits that can be used to experiment with various phenomena are common examples of adaptive media used by museums.

Productive media are tools that allow expression and demonstration of understanding, for example through story-telling, reminiscences, picture making and photography.

So, using Laurillard's framework, we may ask 'what kinds of learning experiences do we wish to support with a particular learning activity?' Depending on the answer, we can select one or more media forms from Laurillard's taxonomy to provide the vehicle for the design of a learning activity that encourages and supports that kind of outcome.

Learning Activities and Outcomes in Practice

To show how this might work, I will briefly describe an online learning activity designed for Leicestershire school students, intended to convey the subjective, partial nature of historical sources. Laurillard's taxonomy was used to guide the way the learning design was segmented into different activities. The activity is set in the context of labour unrest among frame weavers in nineteenth century Leicester and Leicestershire. After a short introduction to set the scene, students are invited to investigate historical resources such as newspaper reports, handbills and autobiographies through the eyes of real life characters from the period. Each student is allocated a character belonging to one of three groups: workers, establishment and agitators and invited to answer individually a set of questions associated with that character (see Figure 1.1).

In their character group they then generate and debate proposals for resolutions based on their investigations before engaging in a wider debate with the other character groups. The 'Interactive' activity followed by the 'Communicative' debate reveals sharply differing views about the 'facts' of the situation and conflicts between the different characters as played by the students. The 'Productive' activity of generating solutions leads back into further 'Communicative' debate which may, or may not result in agreement between the different parties. Since the outcome is not predetermined (there is no correct answer), the learning activity

Archives for Learning

INTRO ① ② ③ ④ ⑤ ⑥ Jump to: Character Info More details Notepad Next and Back

Political Activists
Section 1 - Collecting Evidence

Your character
Name:
Thomas Cooper
Born:
Leicester 30 March 1805
Marriage:
Unknown
Home:
Leicester

Notepad Glossary Help

Back to the top

More about: Thomas Cooper

Your father died when you were 3 years old and you moved to Gainsborough in Lincolnshire. You were good at school and learned to read when you were 3 years old.
You have worked in several diferent jobs - as a shoemaker, a preacher, a teacher and a journalist.
You moved to Leicester in 1840 to work as a reporter for the Leicestershire Mercury but you lost your job when you became interested in the Chartist movement. You now work as editor on a Chartist newspaper.
You think that it is wrong that masters charge full frame rent when there is no work.

Notepad

Q: What things are better than during the Luddite years?

Q: What things are worse?

Your character was involved in:
Extract from Thomas Cooper's autobiography

Glossary of Terms:

Chartists Frame rent

Figure 1.1 Role brief for one of the characters in the simulation (© Emsource)

as a whole may be regarded as an 'Adaptive' experiment in Laurillard's terms. In this example the content is unimportant, even though its local nature may be what engages the students' attention. The activity provides a scaffold for the learner to build their own specific, unique, individual learning experience, without directing what they should know or believe or even remember about the historical events at the end of it. Also, although developed as a classroom activity supported by online resources, the exercise would work just as well in a physical museum setting,

directing learners to different rooms and resources for investigative activities and re-assembling for narrative and communicative sessions.

Conclusions

Learning outcomes are a form of performance target widely and effectively used in education to assess the effectiveness of learning activities. This chapter has considered the arguments made against using learning outcomes as a basis for the design and assessment of informal learning activities in museums and assessed the usefulness of the alternative Inspiring Learning for All Framework. It is concluded that the GLOs do not in fact measure learning and that the distinction between formal and informal learning on which they are based is specious. Nevertheless the concept of GLOs is useful within informal learning situations. An alternative framework has been proposed, based on the taxonomy of different learning experience types described by Laurillard in her seminal work on HE teaching and learning strategies (Jacobs 2005). These five types of experience are mainly focused on skills development rather than content acquisition and thus are not tied to specific knowledge domains, neither are they likely to prescribe or proscribe what the learner should learn from activities based on them. This point has been illustrated with an example of a classroom learning activity in which students role play various real historical characters to discover the subjective, partial nature of historical sources and enhance their analytical, creative and communication skills. The precise content and hence factual knowledge that students learn from this activity is subservient to these intended learning outcomes and could easily be replaced by quite different material. In conclusion therefore this chapter agrees with the view 'museums should work towards a convergence of formal and informal lifelong learning' (Clarke 2001) and recommends the use of Laurillard's framework as an appropriate model for this.

References

Bloom, B.S., Engelhart, M.D., Furst, E.J., Hill, W.H. and Krathwohl, D.R. 1956. *Taxonomy of Educational Objectives – Handbook I: Cognitive Domain.* New York: Longman.

Brown, S. 2009. Paper prototypes and beyond. *Journal of Visible Language*, 43.2 (3), 198–225.

Brown, S. and Cruickshank, I. 2003. Pedagogical re-engineering: Using Laurillard's taxonomy of educational media to guide curriculum design, in *Communities of Practice. Research Proceedings of ALT-C 2003. 10th International Conference of the Association for Learning Technology*, The University of Sheffield and Sheffield Hallam University, Sheffield, UK,

edited by J. Cook and D. McConnell. Association for Learning Technology, 56–69.
Brown, S. Kirkup, G., Lewsey, M., Nathenson, M. and Spratley, I. 1981. Learning from evaluation at the Open University 1: A new model for course development. *British Journal of Educational Technology*, 12(2), 39.
Bruner, J., 1990. *Acts of Meaning*. Cambridge, MA: Harvard University Press.
Buxton, W. 2007. *Sketching User Experiences*. San Francisco: Morgan Kaufman.
Clarke, P. 2001. *Museum Learning on Line*. London: Resource, The Council for Museums, Archives and Libraries.
Ellenbogen, K. 2001. Visitors' Understandings of Transport: An Evaluation Report, unpublished internal evaluation report carried out by Kings College London on behalf of the London Transport Museum. London: Kings College London.
Falk, J. and L. Dierking. 2002. *Lessons without Limit: How Free-Choice Learning is Transforming Education*. Walnut Creek: AltaMira Press.
Falk, J., Moussouri, T. and Coulson, D. 1998. The effect of visitors' agendas on museum learning. *Curator*, 41(2), 106–20.
Hein, G.E. 1998. *Learning in the Museum*. London: Routledge.
Hooper-Greenhill, E. 1991. *Museum and Gallery Education*. Leicester: Leicester University Press.
Hooper-Greenhill, E. 1992. *Museums and the Shaping of Knowledge*. New York: Routledge.
Hooper-Greenhill, E. 2002. *Developing a Scheme for Finding Evidence of the Outcomes and Impact of Learning in Museums, Archives and Libraries: The Conceptual Framework*. [Online] Learning Impact Research Project. Leicester: Research Centre for Museums and Galleries, Department of Museum Studies, University of Leicester. Available at: http://hdl.handle.net/2381/66 [accessed: 31 January 2013].
Hooper-Greenhill, E. 2004. Measuring learning outcomes in museums, archives and libraries: The Learning Impact Research Project (LIRP). *International Journal of Heritage Studies*, 10(2), 151–74.
Institute of Museum and Library Services. 2000. *Perspectives on Outcome Based Evaluation for Libraries and Museums*. Washington, DC: Institute of Museum and Library Services. [Online]. Available at: athttp://www.imls.gov/assets/1/workflow_staging/AssetManager/214.PDF [accessed: 31 January 2013].
Jacobs, G. 2005. Hypermedia and discovery based learning: What value? *Australasian Journal of Educational Technology*, 21(3), 355–66. [Online]. Available at: http://www.ascilite.org.au/ajet/ajet21/jacobs.html [accessed: 31 January 2013].
Laurillard, D. 2002. *Rethinking University Teaching: A Conversational Framework for the Effective Use of Learning Technologies* (2nd edn). London and New York: Routledge Falmer.
Lawley, I. 2003. Local authority museums and the modernizing government agenda in England. *Museum and Society*, 1(2), 75–86.

Macdonald, S. 1993. *Museum Visiting*. Series: Representations: Places and Identities. Working papers/Department of Sociology and Social Anthropology, Keele University. Keele, Staffordshire: Keele University.

Mager, R.F. 1984. *Preparing Instructional Objectives* (2nd edn). Belmont, CA: Pitman.

MLA. 2001. *Renaissance in the Regions*. London: UK Museums Libraries and Archives Council. [Online]. Available at: http://www.museumsassociation.org/download?id=12190 [accessed: 7 February 2013].

MLA, 2006. *Museum Learning Survey 2006*. London: Museums Libraries and Archives Council. [Online]. Available at: www.mla.gov.uk/resources/assets/M/museum_learning_survey_2006_10480.pdf [accessed 31 January 2013].

Moussouri T., 2002. *A Context for the Development of Learning Outcomes in Museums, Libraries and Archives*. London: Resource, The Council for Museums, Archives and Libraries/Leicester: Learning Impact Research Team, Research Centre for Museums and Galleries, University of Leicester. Leicester: University of Leicester. [Online]. Available at: http://www2.le.ac.uk/departments/museumstudies/rcmg/projects/lirp-1-2/LIRP%20analysis%20paper%202.pdf [accessed: 7 February 2013].

National Museums Directors' Conference, 1999. *A Netful of Jewels: New Museums in the Learning* Age. A report from the National Museums Directors' Conference, London: Victoria and Albert Museum. [Online]. Available at: http://www.nationalmuseums.org.uk/resources/nmdc-reports-and-publications/ [accessed: 31 January 2013].

Piaget, J. 1963, 2001. *The Psychology of Intelligence*. New York: Routledge.

RCMG. 2004. *Inspiration, Identity, Learning: The Value of Museums*. RCMG Research Report 2004. [Online]. Available at: http://www.le.ac.uk/ms/research/Reports/Inspiration,%20Identity,%20Learning_The%20value%20of%20museums.pdf [accessed: 31 January 2013].

Rettig, M. 1994. Protoyping for tiny fingers. *Communications of the ACM*, 37(4), 21–7.

Sandell, R. 2003. Social inclusion, the museum and the dynamics of sectoral change. *Museum and Society*, 1(1), 45–62.

Schaller, D.T., Allison-Bunnell, S. and Borun, M. 2005. Learning styles and online interactives, in *Museums and the Web 2005: Proceedings*, edited by J. Trant and D. Bearman. Toronto: Archives and Museum Informatics. [Online]. Available at: http://www.archimuse.com/mw2005/papers/schaller/schaller.html [accessed: 31 January 2013].

Selwood, S. (ed.). 2001. *The UK Cultural Sector: Profile and Policy Issues*. London: Cultural Trends and Policy Studies Institute.

Smith, C. and Blunkett, D. 2000. *The Learning Power of Museums – A Vision for Museum Education*. London: Department of Culture, Media and Sport/Department for Education and Employment. [Online]. Available at: http://www.culture.gov.uk/reference_library/publications/4712.aspx/ [accessed: 31 January 2013].

Stanley, J., Huddleston, P., Grewcock, C., Muir, F., Galloway, S. Newman, A. and Clive, S. 2004. *Final Report on the Impact of Phase 2 of the Museums and Galleries Education Programme*. London: DfES. [Online]. Available at: http://www.dfes.gov.uk/rsgateway/DB/RRP/u014406/index.shtml [accessed: 31 January 2013].

Vygotsky, L. 1978. Interaction between Learning and Development, in *Mind in Society* (trans. M. Cole). Cambridge, MA: Harvard University Press, 79–91.

Chapter 2
Internships in Museum Studies: Learning at the Interface

Elizabeth A. Beckmann

Introduction

Perhaps the most obvious illustration of the potent nexus between the HE and museum sectors is the student internship. The typical university-supported museum internship, also known as a professional or work placement, or practicum, generally remains, internationally, as defined some 20 years ago:

> a pre-arranged, structured learning experience ... relevant to an intern's academic or professional goals and to the professional needs of the museum; a continuous period of museum work done under the supervision of a qualified individual, the goal of which is professional development.
>
> (Wallace-Crabbe 1993)

Glaser and Zenetou (1996: 163) described internships as 'essential to a complete and comprehensive [museums studies] program', a view echoed by others (e.g. Camenson 2006, Peoples, Beckmann and Message 2010, Hoy 2011). Almost regardless of whether a student is an undergraduate or postgraduate, and whether they come from courses specifically identified as 'museum studies' or from other areas of study, an internship is generally seen as the 'moment of truth', when classroom theory can finally be tested against professional practice, and the real-life experience so desperately needed for one's resumé finally gained. Chen (2004: 126) found that most US museum professionals felt that a quality internship was vital if graduates of museum studies programmes, especially at bachelor level, were to have a realistic understanding of museum work. This view is communicated strongly in career advice:

> internships are key components to any entry-level museum resumé ... [they tell] your prospective employer that ... you have taken the first step in learning how to put your classroom knowledge to practical use.
>
> (Thomas 2008)

Internships often mark a watershed in students' understanding not only of the immense value of experiential learning, but also of the reality of lifelong learning

in a profession that – though so often dealing with objects of the past – must none the less be absolutely up to date in: its engagement with new communication and curatorial technologies; its responsiveness to societal pressures, including the views and needs of local, regional and national communities; and its infinite capacity to 'do more with less'. Not for nothing have museum-based internships been described as 'a unique learning experience [that] cannot be delivered by any other means' (Abasa 1995: 17).

While the nature of each internship is of necessity highly individualistic – focused on one institution, one student, one workplace supervisor and often just one project – this chapter explores more general considerations, specifically:

1. why university-instigated internships have become crucial components of the pre- and in-service career development of most museum staff; and
2. the role of internships in establishing – or, perhaps more truthfully, breaching – the boundaries between museums and universities, and thus creating opportunities for collaboration, especially through communities of practice.

The chapter will show why university student internships in museums are about much more than individual experiences of what the HE sector now calls 'work-integrated learning' (Patrick et al. 2009). Rather, these internships act as an educationally integrative force between the professional world of museums and the university world of museum studies (and cognate disciplines). Internships reflect and reinforce the movement of museum professionals into academia and vice versa, and offer distinct and wide-ranging opportunities for museums and universities to forge meaningful and effective partnerships that reflect and influence today's – and, more importantly, tomorrow's – society.

From Apprentice to Student: The Winding Path from Museum to University

Traditionally, and certainly in the late nineteenth and early-to-mid twentieth century, career paths in museums were the outcome of specialist discipline-based university courses – for example, in the curatorial disciplines of history, art history, classics, anthropology, zoology or botany – followed by in-house, on-the-job apprenticeship:

> the expert shows the apprentice how to do a task, watches as the apprentice practices portions of the task, and then turns over more and more responsibility until the apprentice is proficient enough to accomplish the task independently.
> (Collins, Brown and Holum 1991)

Curators and other museum staff were thus first and foremost discipline specialists who had, over time and of necessity, acquired skills of collections management, interpretation, exhibition conception and design, and institutional thinking with regards to finances and management. However, as the latter aspects gained

ascendancy, museums could no longer remain insulated from the societies in which they were situated, and from which most derived their continued existence. This was brought to the attention of the sector especially in the 1990s, when the International Council on Museums (ICOM) acknowledged that museums had changed from being 'inwardly focused ... to externally driven' and needed to engage with emerging views about 'the nature of learning, the creation of knowledge, and ... methods of instructional delivery' (ICOM 2000). Audience-focused approaches to collecting and exhibition policies started to dominate, museum leaders reflected thinking described as the 'new museology', and museums began to see themselves as much as mirrors of their modern sociocultural contexts as keepers of those same sociocultural pasts.

With the recognition that museum staff needed a broader set of skills than just disciplinary specialist training came the first notion of 'museum studies'. One of the earliest training schools was established in 1925 by John Cotton Dana for the staff of the Newark Museum (United States of America), with the focus being on students 'learn[ing] their craft hands-on' (Chen 2004: 40). By the latter half of the twentieth century, however, apprenticeship models of training seemed too slow, expensive and cumbersome to cope with the sector's expansion. In 1968 the International Council on Museums (ICOM) founded the International Committee for the Training of Personnel (ICTOP) specifically:

> to encourage and promote training programmes at university level in all regions of the world [and] training programmes for all museum workers as part of a life long education ... to develop professional standards, which will prepare museum workers for the future institutional challenges.
> (International Committee for the Training of Personnel 2012)

In the more than four decades since then, university courses in museums and heritage studies have proliferated: today there are at least 160 distinct postgraduate courses and many undergraduate courses in the USA alone, and dozens more well established in Australia, the UK, Canada, South Africa and many European countries. New courses are starting up each year (not least in China, paralleling the growth there in the number of new museums: Sturgeon 2008), as can be seen from the websites of the American Association of Museums, Canadian Museums Association, Museums Association, Museums Australia, Gradschools.com, and others. While it seems the museum profession has given universities the *imprimatur* to take on a central role in both pre-service staff training and the professional development of existing staff, there is a continuing tension between the relative emphasis on the values of the respective learning environments. This tension is perhaps attributable to their divergent focus: 'the currency of universities is ... words [while] that of museums is ... objects' (Chen 2004: 40).

Moreover, despite (or perhaps even because of) the ongoing proliferation of both museums and museums studies courses, this tension does not seem to be

resolving. A major study examining the future of human resources in Canadian libraries, archives and museums reported that:

> greater curriculum emphasis should be placed on management, leadership, and business skills and ... more opportunities ... provided to engage in hands-on practical experience e.g., through practicum and internship programs.
>
> (Ingles et al. 2005: 6)

Similarly, Trant (2009) noted the sector's emphasis on:

> the importance of non-disciplinary skills – the ability to adapt and change, to grow in a job, to face challenges with enthusiasm, to continue to learn, to master new technology, to work with a team, and to problem solve creatively in a time of diversity and scarcity.
>
> (Trant 2009: 382)

In the UK, the (now defunct) Museums Libraries Archives Council (MLAC) reported the common perception of a mismatch between the needs of museum and library employers and the skills and knowledge provided to would-be professionals through HE (MLAC 2008). Trant argues that this mismatch has come about because:

> current methods of training librarians, archivists and museum professionals emphasize the historic differences between these types of institutions, rather than their emerging similarities. Conventional curricula do not support a profession committed to the creation of integrated, inter-institutional, interdisciplinary information resources accessible to a wide public in physical and digital forms.
>
> (Trant 2009: 376)

Trant further suggests that professional training courses must do more to 'foster the cross-sector collegiality and collaboration needed to address shared challenges' (2009: 376).

Two questions thus arise: why does such a gap exist, and how can both universities and museums do their part to bridge this gap more effectively?

Experts on Everything

One reason why museum employers may feel that universities are not producing appropriately skilled museum staff could be the sheer breadth of this multidisciplinary profession. Even a cursory glance at the selection criteria for career opportunities in museums shows the required skill sets are becoming ever more sophisticated. When ICTOP formally adopted the ICOM Curricula

Guidelines for Museum Professional Training in 2000, with a revision just eight years later, it was seen as marking a:

> shift from a content model focused on museological theory and technical skills to a process model that emphasised broad systems for understanding the museum and individuals' roles and responsibilities in its operations.
> (International Council on Museums/International Committee for the Training of Personnel 2009)

Within the ICOM Guidelines, competencies – 'general descriptions of knowledge, skills and abilities' – are identified within five groupings: (i) museology, (ii) management, (iii) public programming, (iv) information and collections management and care, and (v) general, with dozens of specific skills and knowledge areas identified under each, and the Guidelines intended both:

> to serve as a framework for developing sound, comprehensive training syllabi, and to provide a tool for managing institutional development and/or shaping individual career paths.
> (International Council on Museums/International Committee for the Training of Personnel 2009)

Certainly, it is no easy task for those designing museums studies curricula in HE institutions to ensure that students emerge completely skilled in the more complex and multifaceted 'real-world' competencies identified in the Guidelines, especially when these include:

- ... best practice, cross-cultural skills, processes of change, change management, reflexive practice, techniques for fostering thinking and action in work, understanding how innovations emerge within complex organizations;
- [awareness of] ... political, economic, social and cultural contexts of museums in local, national and international arenas including globalisation, environmentalism, sustainable development, and cultural diversity.

(International Council on Museums/International Committee for the Training of Personnel 2009)

Moreover, while it is accepted that those working in museums require an increasingly sophisticated and broad-ranging set of capabilities to address novel and challenging workplace situations, museums themselves have generally abrogated their own responsibilities to train their own staff. Pushed to their economic limits, many small to medium-sized museums feel unable to justify allocating funds to on-the-job training or within-institution mentorship: fewer than half the museums in the United Kingdom reported having specific training budgets (Holden 2003, Holmes 2006), even before the situation deteriorated with the impacts of the global financial crisis, and the consequent tightening of belts

already on their tightest setting. This not only affects incoming staff, who must arrive already highly qualified and skilled, but also impacts on existing staff, who are expected to manage their own professional development (Abasa 1995, Holmes 2006). Indeed it is well recognized that 'one of the most important things museum professionals can do for their careers is continue their education' (San Diego Natural History Museum 2009).

Internships: Opening the Interface

It would seem, therefore, that the key to successful university-based museum studies and curatorship programmes is the extent to which they explain, supplement and apply museological and other relevant theory in the context of the range of complex and multifaceted 'real-world' competencies of museum staff. Effective approaches to the creation and management of internship opportunities are thus crucial to the credibility of university programmes. However, the internships described by Edson (1995) in the *International Directory of Museum Training* varied significantly in scope, duration and focus: almost 20 years further on, the practice of what does – and does not – constitute an internship in the professional sector remains not only highly variable (Peoples et al. 2010, Hoy 2011), but confusingly so. For example, Holmes (2006) states that 'in the UK, the term volunteer is used to cover anyone working unpaid in a museum' and thus includes interns. Yet in its recently developed set of internship guidelines, the Arts Council England (2011) felt compelled to note clearly what an internship is *not*:

> an internship is not volunteering ... voluntary work ... *student placement (unpaid work undertaken by someone in education as a required part of their course*, with reasonable expenses paid) ... an apprenticeship ... a traineeship ... or work experience ...
>
> (Arts Council England 2011: 6, italics are my emphasis)

Thus, while the Arts Council England's definition of 'student placement' exactly describes the kind of activity that is the focus of this chapter, and which most museums and other collecting institutions identify and support as internships, the Arts Council England specifically excludes such activities from its own definition of internships. It appears that the waters are very muddied indeed.

Money, Money, Money

Assuming that university student placements are, in fact, the most common kind of internships found in the museum sector worldwide, it may help to explore aspects of their diversity in detail. First, there are the historic connotations of museum internships. In Australia, the United Kingdom and the United States at

least, many of the larger cultural heritage institutions still run their own highly structured three-to-twelve-month internship programmes on an apprenticeship model, with a rare few – such as The Getty Foundation, the Museum of Modern Art in New York and the Australian National Maritime Museum – even providing a stipend. Although potential interns apply independently, and very competitively, to institutions such as these, preference is usually given to enrolled tertiary students who can use the internship for course credit. More recently, a few universities, such as Deakin University in Australia, are starting to negotiate ongoing paid internships themselves (Deakin University 2011). In these relatively scarce cases, the internship generally constitutes more of an ongoing research fellowship arrangement between the university and host institution.

In general, however, internships for university credit are unpaid, with the university acting as broker in matching potential interns with museums willing to take them on. Professional networks play a very important role in identifying host institutions and potential workplace supervisors, with many universities developing close ties to particular museums and vice versa, and a well-known museums studies programme or well-connected internship coordinator generally worth their weight in gold to would-be interns.

Secondly, there are the political, economic, social and cultural contexts of university education to consider. In most countries, university education is now a user-pays commodity, with students acutely conscious of the costs of their studies. Not only do students seek value-for-money, but they may actually need to do salaried work to pay for their studies. Internships are generally scheduled courses with fees attached, yet involve significant amounts of 'free' labour at the designated workplace. Student interns may question the financial paradox whereby they are required to pay course fees, and perhaps give up paid work or take recreational leave, for the privilege of working unpaid for (generally public sector) museums. This risks poor quality internships being seen as student-subsidized labour programmes while

> 'universities may be seen as cashing in on museums as free outsourced teaching resources, and failing to resource interns academically [because] intern placement and support is often seen as a role for non-academics'.
> (Peoples et al. 2010: 139)

Thirdly, the opportunities for inequity abound. Logistical and budgetary constraints on different host institutions may affect their commitment of resources to support internships, but these constraints may not always be apparent to the educational institutions, which face their own pressures to develop accountable relationships with industry. In Australia at least:

> large institutions may be unable to meet the growing number of requests for placements while smaller institutions may have difficulty attracting any interns

at all: this does not meet the sector's needs as a whole, and negatively influences students' understanding of the breadth of the sector.

(Peoples et al. 2010: 138)

Best Practice?

Although the museum sector looks favourably on university partner internships, there is virtually no empirical research on what constitutes best practice, or how best to balance the educational goals of HE with the day-to-day realities of host museums. Duration, specific learning outcomes and management support are hugely variable across the sector (Hoy 2011): an internship in one university may be 5 days, in another 20 days, and in another 40 days, yet all may be considered the same in terms of the relative amount of university credit gained. What museums can provide by way of workplace supervision and guidance may be severely limited, so that rather than exposure to a broad set of museum professional competencies, student assessment tasks become single-focus internship projects geared towards museum/employer needs rather than student learning. Even worse are cases where interns are used to supply basic administrative or information technology needs, such as photocopying or updating software (Holmes 2006).

More worrying from the perspective of increasing focus on quality assurance in HE, workplace supervisors may be asked to partly or fully assess students' work, yet have limited, or no, tertiary teaching experience or reference to university standards. This may impact on quality assurance:

> There is an assumption that at every host institution the intern will receive a learning experience equivalent to his or her other coursework. Despite goodwill and a trust in professional competence, this leads to potentially inadequate quality assurance ... Feedback to students and official assessment may be influenced more by a host institution's gratitude at having its needs met than by objective standards of a student's learning ... an intern who has helped catch up on backlogs may be greatly appreciated regardless of the nature or outcomes of the student's learning.
>
> (Peoples et al. 2010: 139)

Patrick et al. (2009) argue that sustainable work-integrated learning experiences in HE require sector-wide initiatives, such as effective curriculum design, as well as engagement by all stakeholders – students, universities, professions, employers and, where appropriate, government. Yet, despite efforts by individual academics, universities and museums to provide effective quality assurance, and the existence of powerful national and international peak bodies that could help shape more unified approaches, a sector-wide approach is not yet evident. In Australia, for example, Peoples et al (2010) report that professional associations and individual researchers/academics (for example Young and McIntyre 1991, Wallace-Crabbe

1993, Abasa 1995, Simpson 2003, Hinchcliffe 2004, Hoy 2011) have repeatedly argued for strategic change in internship management to encourage:

> more awareness of appropriate internship management models, effective quantification of costs and benefits, and especially more consistency in curriculum development and assessment.
>
> (Peoples et al. 2010: 137)

Individual universities can certainly maximize the learning potential of internships in several ways. First, they can provide detailed guidelines not only to the students but also to the workplace supervisors: providing museum partners with greater insight into the student-centred and adult learning frameworks within which they are expected to support and assess students is one step towards developing cross-institutional and cross-sector relationships that create a more substantive style of engagement. Next, internships should be subject to the same educational design as other courses the students are doing: in particular, a focus on constructive alignment (Biggs 1999) is valuable, with learning outcomes aligned to the learning activities, resources, and assessment. This design focus is important, as internships have high variability in (i) the educational setting (the museum), (ii) the 'learning activities' (ideally achieving the competencies identified in the ICOM Curricula Guidelines International Council on Museums, 2000), (iii) the 'teacher' (the nominated workplace supervisor), (iv) the teaching methods (how the intern is encouraged to interact with the museum, its staff and the supervisor) and (v) the assessment tasks (one or more workplace-based projects).

Admittedly, achieving such alignment is not easy, especially as many variables are not necessarily known in detail until the internship is underway, but the aim should be to create a quality learning experience rather than simply an experience of a workplace. For example, encouraging reflective practice as a learning activity helps interns to acknowledge themselves as productive contributors to their internship workplace. Finally, universities should take advantage of diverse communication technologies to ensure that interns are fully supported both as workers and as learners throughout their placement, regardless of their internship location.

Communities of Practice

A useful way of thinking about the internship alliances among students, universities and host institutions may be as 'communities of practice' (Wenger 1998). Members of such a community engage in a process of collective learning through joint activities, discussion and collaboration in a shared domain. On entering the milieu of a museum workplace, interns are expected to – and do – become productive contributors to that workplace, involved in knowledge mapping, problem-solving, debate and provision of information. Macleod (2001) argues that applying

Wenger's theory in the context of museum studies helps overcome the distinctions between theory and practice, and between practitioner and non-practitioner:

> communities of practice enable practitioners to take collective responsibility for managing the knowledge they need, recognizing that, given the proper structure, they are in the best position to do this.
> (Wenger 2005: 4)

Internships are an obvious point of focused collaborations for museums and universities through communities of practice.

An Interface with Three Partners

While this book is focused on the nature of collaboration between museums and universities, an internship actually involves three stakeholders: the university, the host museum, and the student. Unless all three are satisfied, the outcomes will be disappointing. Each stakeholder may have different expectations of the internship and different desired outcomes: only when these are well matched can an internship be considered a successful collaboration.

The Benefits to Students

There is no doubt that, at their best, internships can provide an unparalleled and insightful experience of experiential learning:

> I found the experience of my first internship quite life changing ... [working] alongside other museum professionals in an institution and being exposed to the day to day goings on of a museum was such a rich and eye opening experience ... I became absolutely certain that working in a museum was my calling and I developed a deep passion for museum work which gave me great confidence that I was following the right path by doing a tertiary Museum Studies course. When I started my next three coursework subjects ... I had ... a deeper understanding of how the theory ... could be related to real-world museum work and practice.
> (Bowen 2009)

Internships can especially help minimize the confusion, even disappointment, which can hit students emerging for the first time into the professional museum world:

> the work was just what I expected, but the politics, management, and inter-museum problems were bizarre. I didn't have as much training ... in dealing with this ... real-world stuff.
> (Pyle-Vowles 1998: 66)

For others already working in the profession, the reflective focus of internships allows time to review career choice and aspirations:

> I guess what [this] has done for me is to help me articulate again for myself why my profession is important, alongside all of the other collecting professions. Why each of the professions do things the way they do matters, because it is right for the 'things' we are trying to protect and understand. All of which is why I enrolled in this course – to come to such an understanding.
> (ANU intern journal entry: S. Peoples, personal communication, 2010)

The Benefits to the Museums

Interns are upcoming professionals who can bring up-to-date theory and a diversity of thinking into a museum's staff, providing the fresh perspectives that are vital to the industry (Davies 2007), and contributing to capacity-building in host institutions at the same time they are developing their own skills: '... I have even been able to teach [the head of department] and [the senior designer] a few new uses for [specialist software tools]!' (ANU intern journal entry, April 2010, S. Peoples personal communication).

Another clear benefit of hosting interns for museums is the opportunity to meet and observe potential employees (Holmes 2006, Davies 2007). Hosting interns can be an effective approach to recruitment and trial employment, as interns have often already begun to internalize institutional cultures. Where an intern is already employed in the sector – enhancing her qualifications with her employer's support – internship placements may in fact act as extended job interviews or 'head-hunting' opportunities. Interns also undoubtedly provide a cheap source of labour for host institutions to catch up on backlogs or start projects that cannot otherwise be resourced. However, concern over potentially exploitative behaviour by museums has become more evident in the current climates of economic stagnation, and worse. In the UK, Holmes (2006) considers that the museum sector has been relying excessively on interns and volunteers to do core business, rather than developing fair and reasonable career paths. She reports concerns that internships are being substituted by volunteer positions with far less oversight, with volunteers reporting that although 'there were benefits associated with their volunteering experiences ... none of these were sufficient compensation for a paid museum post' (Holmes 2006: 252). The risk of exploitation is not insignificant, with even mainstream and nationally significant institutions taking what could be considered unfair advantage of people's interest in working in the sector. *Interns Anonymous* reported a prestigious UK institution advertising for a six-month, four-days-a-week, eight-hours-a-day intern as follows:

> Unfortunately no financial assistance is available for interns. However, with jobs in the cultural sector at a premium, and many graduate students unable to secure job interviews without demonstrable work experience, the experience offered

through this internship is invaluable, and past interns have gone on to secure a variety of posts in the cultural sector.

(Interns Anonymous 2012)

The Benefits to Universities

Universities recognize that internships provide their students with highly specialized on-the-job training. The environment of the host institution provides a framework in which students can make the abstract concrete and engage more fully with the context of their studies. Students develop an understanding of museums as workplaces: their norms, expectations, subtleties of vocabulary, hierarchies and management. Moreover, internships are specifically designed to integrate theory and practice, which is highly desirable from the perspective of university researchers: 'the theory has to go out into the field ... if that begins to happen, the professionals ... will begin to understand why museum studies programs are important' (Chen 2004: 179). If the internship occurs within the core of a degree course (rather than as a capstone), students generally return with real-life projects as authentic case studies and future research topics.

Conclusion

Museums Australia, the peak body for professionals down under, has previously concluded that, although internship processes in cultural institutions are largely *ad hoc* and tertiary institutions differ significantly in their requirements, 'cultural and learning institutions are accommodating of each other's diversity and neither sector is placing unrealistic or irresponsible demands on the other' (Hinchcliffe 2004). A similar accommodation seems to hold elsewhere in the world as well. Has this very diversity and capacity to be accommodating, together with increasing competition for both students and placements, militated against a focus on cross-institutional quality assurance or benchmarking strategies? What can we expect in the future from university-museum interactions mediated through the form of internships? One way forward might be for the key players to commission empirical research that capitalizes on the significant knowledge, experience and goodwill throughout the sector, nationally and internationally, to bring about some much-needed strategic change in the way internships are understood, designed and implemented. Optimizing the structural and educational design elements of museum/heritage internships is crucial to ensuring ongoing successful learning and workplace outcomes without the potential for exploitation. The aim is certainly not for uniformity: diversity in internship practices provides choice and opportunity, representing a strength rather than a weakness. Rather, the aim could be for a holistic focus on student internships as the point of intersection for both educational and managerial contexts. As a community of practice sharing the interface, museums and universities could aim not only to achieve better

learning experiences for future interns but also a greater shared understanding, and strengthening, of the relationship between education provider and museum/ heritage employer, and of the two-way flow of theory and practice, ideal and compromise, and evidence.

References

Abasa, S. 1995. *Art Museum Internship Recognition.* Canberra: Museums Australia and Arts Training ACT.

Arts Council England. 2011. *Internships in the Arts.* [Online]. Available at: http://www.artscouncil.org.uk/publication_archive/internships-arts [accessed: 31 January 2013].

Biggs, J. 1999. *Teaching for Quality Learning at University.* Buckingham: Society for Research into Higher Education and Open University Press.

Bowen, A. 2009. Reply posted to Chastening blog about Museum Studies graduates. [Online 9 August]. Available at: http://museum3.org/group/ museumstudiesstudents/forum/topics/chastening-blog-aboutmuseum?comm entId=2017588%3AComment%3A29173andgroupId=2017588%3AGroup% 3A23539 [accessed: 31 January 2013].

Camenson, B. 2006. *Opportunities in Museum Careers.* New York: McGraw-Hill.

Chen, Y.C. 2004. Educating art museums professionals: The current state of museum studies programs in the United States. PhD thesis, Florida State University. [Online]. Available at: http://etd.lib.fsu.edu/theses/available/etd-07132004-121102/ [accessed: 31January 2013].

Davies, M. 2007. *The Tomorrow People: Entry to the Museum Workforce.* Report to the Museums Association and the University of East Anglia. [Online]. Available at http://www.museumsassociation.org/download?id= 13718 [accessed: 31 January 2013].

Deakin University. 2011. *Cultural Heritage and Museum Studies Internship News July 2011.* [Online]. Available at: http://www.deakin.edu.au/arts-ed/chcap/ch-ms/internships.php [accessed: 31 January 2013].

Edson, G. 1995. *International Directory of Museum Training: Programs and Practices of the Museum Profession.* New York: Routledge.

Glaser, J. and Zenetou, A. 1996. *Museums: A Place to Work.* Washington DC: Smithsonian Institute.

Hinchcliffe, M. 2004. Internships in Australian museums and galleries. Museums Australia, unpublished.

Holden, J. 2003. *Towards a Strategy for Workforce Development: A Research and Discussion Report Prepared for Resource.* London: Demos and Resource.

Holmes, K. 2006. Experiential learning or exploitation? Volunteering for work experience in the UK museums sector. *Museum Management and Curatorship,* 21(3), 240–253.

Hoy, M. 2011. Building pathways to working with collections: Can internships and student work experience help? *Australian Academic and Research Libraries*, 42(1), 29–42.

Ingles, E., De Long, K., Humphrey, C. and Sivak, A. 2005. *The Future of Human Resources in Canadian Libraries*. [Online]. Available at: http://www.ls.ualberta.ca/8rs/reports.html [accessed: 31 January 2013].

International Committee for the Training of Personnel. 2012. *About ICTOP*. [Online]. Available at: http://ictop.org/about [accessed: 31 January 2013].

International Council on Museums. 2000. *ICOM Curricula Guidelines for Museum Professional Development*. Smithsonian Center for Education and Museum Studies. [Online]. Available at http://museumstudies.si.edu/ICOM-ICTOP/about.htm [accessed: 31 January 2013].

International Council on Museums/International Committee for the Training of Personnel. 2009. *Curricula Guidelines for Professional Development, Revised Edition*. [Online]. Available at: http://museumstudies.si.edu/ICOM-ICTOP/index.htm [accessed: 31 January 2013].

Interns Anonymous. 2011. *V&A Exhibitions Internship – April 2011*. [Online]. Available at: http://internsanonymous.co.uk/2011/01/23/how-can-a-museum-with-a-public-subsidy-of-40m-and-self-generated-income-of-30m-get-away-with-not-paying-their-interns-at-least-a-nmw/ [accessed: 31 January 2013].

MacLeod, S. 2001. Making museum studies: Training, education, research and practice. *Museum Management and Curatorship*, 19(1), 51–61.

Museums Libraries Archives Council. 2008. *Learning for Change: Workforce Development Strategy*. London: Museums Libraries Archives Council. [Online]. Available at: http://www.mla.gov.uk/what/raising_standards/~/media/Files/pdf/2008/Learning_for_change_workforce_development_strategy [accessed: 31 January 2013].

Patrick, C. Peach, D., Pocknee, C., Webb, F., Fletcher, M. and Pretto, G. 2009. *The WIL [Work Integrated Learning] Report: A National Scoping Study*. [ALTC Final Report]. Brisbane: Queensland University of Technology. [Online]. Available at: http://www.olt.gov.au/system/files/grants_project_wil_finalreport_jan09.pdf [accessed: 31 January 2013].

Peoples, S., Beckmann, E.A. and Message, K. 2010. *Internships: Students and collections*. Paper presented at *Interesting Times: New Roles for Collections, Museums Australia Conference*, 28 September – 2 October, Melbourne. [Online]. Available at: www.ma2010.com.au/docs/MA2010_Conference_Papers.pdf [accessed: 24 January 2013].

Pyle-Vowles, D. 1998. Into the real world. *Museum News*, 77(4), 66.

San Diego Natural History Museum. 2009. Questions to ask yourself when you are considering a museum career. [Online]. Available at: http://www.sdscrolls.org/museums/career/museum-career-main.html [accessed: 24 January 2013].

Simpson, M. 2003. MA internships issue paper. Museums Australia Museum Studies Special Interest Group, unpublished.

Sturgeon, K. 2008. *A Guide to Museums Studies Programs in the US and Canada*. American Association of Museums' Committee on Museum Professional Training. [Online]. Available at: perceval.bio.nau.edu/downloads/acumg/museumstudiesprograms.pdf [accessed: 31 January 2013].

Thomas, J. 2008. *Museum Careers: Fit, Readiness and Development*. VAM White Paper 2011-1. Virginia Association of Museums. [Online]. Available at: http://www.vamuseums.org/associations/13162/files/Building%20Your%20Museum%20Resume.pdf [accessed: 24 January 2013].

Trant, J. 2009. Emerging convergence? Thoughts on museums, archives, libraries and professional training. *Museum Management and Curatorship*, 24(4), 369–386.

Wallace-Crabbe, M. 1993. *Guidelines for Internships*. Art Museums Association of Australia. Fitzroy: Victoria.

Wenger, E. 1998. *Communities of Practice: Learning, Meaning, and Identity*. Cambridge: Cambridge University Press.

Wenger, E. 2005. *Communities of practice: A Brief Introduction*. [Online]. Available at: http://www.ewenger.com/theory/index.htm [accessed: 24 January 2013].

Young, L. and McIntyre, D. (eds). 1991. *After Street Ryan: Training for the Museums Industry*. Canberra: Museums Association of Australia (ACT).

Chapter 3

Understanding the Distributed Museum: Mapping the Spaces of Museology in Contemporary Culture

Susana Smith Bautista and Anne Balsamo

Introduction

Where is the museum for the digital generation? We use the term 'the distributed museum' to describe the form that the museum takes as it is part of the creation and movement among new spaces that comprise contemporary networked learning environments. No longer located in a particular physical space, the museum extends its presence through virtual spaces on the web as well as in the transient spaces created through the diverse practices and technologies of mobility. The distributed museum exists 'over' the conceptual divides between physical and virtual, fixed and mobile. We also consider a third axis of museum offerings that are situated on the continuum of 'making practices' and engagements with DIY (do-it-yourself) culture. This chapter reports on research that examined the ways in which public museums and libraries in the United States offer informal-learning opportunities to the born-digital generation, often as part of a creative network ecology that includes formal learning programmes and institutions. Here we map a range of practices that include closed-ended, guided, making activities (interactives), as well as more open-ended, exploratory ones (tinkering). Rather than presenting a list of 'best practices', we examine several examples that address the key binaries used to define contemporary digital culture: i.e., the virtual versus the physical, fixed versus mobile, open versus closed systems of creative offerings. What we discover is that these practices actually span the continuum between the two axes of any binary. We begin by elaborating an analytical framework to describe and map the distributed nature of museology in a digital age, and we conclude with a set of key insights about the social and cultural implications of the use of digital media in contemporary museums and cultural institutions.

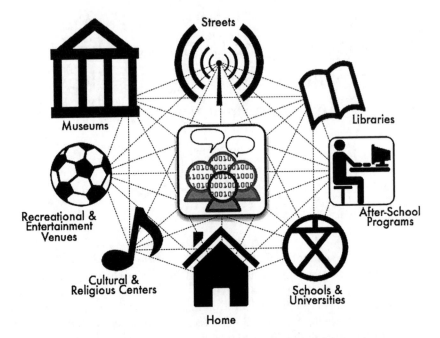

Figure 3.1 Where is the museum for the digital generation? (© Balsamo and Bautista 2011)

From Place to Space

In their formative stage, the identities and functions of museums were strongly connected to their physical place. Museums of the eighteenth and nineteenth centuries were large, imposing buildings of classical architecture that manifested their legacy from royal collections housed in grand palaces. They were centrally located within European metropolises (London, Madrid, Berlin, Paris and Vienna) where all citizens knew them well. These early museums were respectable places that (eventually) invited all parts of society to intermingle in a common public space with the overt goal of 'civilizing' the masses and the covert goal of affirming the elite status of the educated and powerful, alongside other respectable public places such as theatres, libraries, parks and reading-rooms. Museums were connected to physical place on yet another level through their role in representing and glorifying their respective nations. Sociologist Tony Bennett (1995: 98) writes that the public museum represented a coalescence of 'the display of power to the populace and its display within the ruling class'. The lessons on offer were more about remembering than about learning history.

However, as the industrial era brought the working classes to the cities to work in factories, museums became the ideal vehicle for 'teaching' socially acceptable manners, values, dress and comportment.

The museum today remains a dynamic cultural institution. All signs suggest that it is undergoing yet another transformation from an early place-based cultural institution to a more dispersed (post)modern space. As sociologist Michel de Certeau argues, the concept of place has been used by the dominant orders to organize and control society, as through urban planning and architecture. Space, on the other hand, is constructed by people through the practice of living and walking. Place implies stability, 'an instantaneous configuration of positions', while space considers 'vectors of direction, velocities, and time variables'. Thus space is composed of 'intersections of mobile elements' (de Certeau, 1984: 117). As de Certeau asserts, 'space is a practiced place' (1984: 117).

New practices of mobility have contributed to the dispersal of place in the modern museum. We know that mobile culture actually began during the Industrial Revolution when workers migrated to burgeoning urban areas in search of work in the factories. Yet more recently the velocity of cultural change of what Raymond Williams (1983) called 'mobile privatization' is increasing as new technologies such as portable computers, PDAs and mobile phones become more ubiquitous. Noting this transformation, Lynn Spigel (2004) reframes Williams' phrase as 'privatized mobility' – a concept that attests to the cultural significance of portability (now coupled with mobility) that brings private activities into public spaces. The dynamic of privatized mobility serves as one of the contexts for considering the transformation of the place of the museum into distributed spaces of museology.

Museums utilized early versions of mobile technology in the 1950s with handheld devices based on a closed-circuit shortwave radio broadcasting system. The real innovation in new museology, however, came when mobile communications were applied to new populist practices that took the museum experience out of the physical place. Today the 'mobile museum' consists of satellite museum spaces around the city or the globe, museum programmes conducted off-site by museum staff in schools, libraries and community spaces, and special vehicles designed to provide a multimedia learning experience based on museum collections that travel to schools and other organizations throughout the city. In the past decade, the 'mobile museum' has morphed into what we call the 'distributed museum' – a postmodern formation through which the modern museum seamlessly adapts its traditional functions to the new cultural environment of the digital age, and in turn, offers new approaches to learning, often in partnership with formal educational institutions.

The distributed, dispersed, and decentred space of the digital age has also been called a networked space or a space of flows that 'links places at a distance on the basis of their market value, their social selection, and their infrastructural superiority' (Castells 2001: 241). Within this networked space we situate the modern museum as one of the primary nodes. We argue that the space of the new

museology is similarly dispersed, individualized, practised and nonlinear as is the space of the digital age. No longer tied to a fixed place, the new museology can be described in terms of changes in practices, relations and emergent experiences. The new museology continues to address the main functions of the traditional museum such as curating, scholarship and conservation, as well as more recent functions such as education and community outreach. To describe the museology of distributed museums, we focus on the educational mission of the institution as one of its key socio-cultural functions.

The Distributed Environment of Museums and Learning in a Digital Age

Learning in the digital age is likewise dispersed and nonlinear. It is based on a communal sharing of knowledge and information. Anne Balsamo (2011) describes this emergent cultural formation as a 'distributed learning network' that includes various types of institutions such as formal educational efforts of universities, schools, after-school programmes, as well as 'mixed reality sites' such as museums, libraries and community organizations. These new spaces of learning have been described as interest-driven (Ito et al. 2008), affinity spaces (Gee 2004), and voluntary associations (Jenkins et al. 2007). John Seely Brown (2009) coined the term *Learning 2.0* to describe the new experience of 'learning on demand'. He points out that the pedagogical shift from teacher-directed learning to peer-based learning changes what is required of learners in a profound way. Learning, he argues, now depends on the learner's ability to navigate different social networks and knowledge communities. The infrastructure of education is no longer the single school system, but rather a distributed, mixed-node, learning environment.

While museums have long served as informal spaces for learning (from social norms to national history to cultural capital), the modern museum has explicitly embraced its pedagogical intentions by establishing educational programmes with clear connections to formal school systems. These programmes not only bring students to visit the museum during the day with their teachers, but also provide for teacher training at the museum and through their websites with lesson plans that explicitly reference formal curricular topics and learning objectives. The aim for these museum programmes is to support school-based educational efforts by providing an alternative space for learning that is less structured and hierarchical than formal school-based programmes.

At the same time that museums began expanding their educational outreach efforts, other cultural spaces too began to perform some of the traditional roles and functions of museums through, for example, the formation of online creative communities of artists. In fact, a report by the Committee on Information Technology and Creativity of the US National Research Council (Mitchell, Inouye and Blumenthal 2003) asserts that several new online efforts, such as Rhizome and Digital Art Source, might be usefully understood as new forms of art galleries. Other online spaces such as the image databases provided by ARTstor, Flickr

or even Google Art Project, have moved beyond simple collections of digitized images to serve as spaces for the creation of communities of interest where users interact with one another to learn (peer-to-peer) about art and other cultural topics.

These online creative spaces are some of the newest practices that museums are experimenting with and using as the basis for dynamic activities and programmes. According to *The 2011 Horizon Report: Museum Edition*, we should see a dramatic increase in the use of mobile applications and tablet computing by museums within the next year. Further out, in two to three years we will watch the unfolding of programmes and experiences that utilize augmented reality and begin to see more electronic publishing. Towards the end of this decade, museum activities will also include smart objects and focus on digital preservation. What we have discovered in our creative inventory is that experimentation on all of these emergent media technologies is already occurring at different museums throughout the globe. Part of our broader project is to map these experiments as they emerge so that their development and adoption can be visualized, tracked and utilized.

The Distributed Museum

To help analyse the way in which museums have engaged and creatively innovated with the use of new digital technologies, we identify three dimensions that describe key aspects of these new activities.
- physical and virtual
- fixed and mobile
- closed and open

Here, our analytic objective is to create a cognitive map of the contemporary cultural formation of the distributed museum. The first set of terms, 'physical' and 'virtual', describes two ends of a continuum of 'locations' where the term 'physical' identifies a material location and the term 'virtual' identifies a digital location. The second set of terms refers to the boundaries of the experience. The term 'fixed' suggests that the experience is bounded by a particular location; the term 'mobile' means that the experience can be accessed as a person moves among locations. The third set of terms is used to describe the creative expanse of the activity. The term 'closed' is used when the activity is scripted or explicitly organized for a participant. The term 'open' describes activities that can be modified, changed or expanded by a participant. The distribution of the contemporary museum is not limited to digital technology, even in the digital age. There is a tendency to think of analogue practices as traditional in nature when compared to their digital counterparts; however, it is important to recognize that many museums continue to maintain some very popular and successful analogue practices in conjunction with the newer, digital ones.

While the following section focuses on examples of new digital practices, we want to note that we are aware there are interesting analogue antecedents for many of these efforts. The following section offers brief examples of digital practices of

the distributed museum across the three dimensions defined above. We offer this not as an exhaustive list of 'best' digital practices occurring in museums today, but rather as a selection of the innovative efforts going on in museums across the globe. Here we discuss these practices in terms of the ends of each continuum (physical versus virtual, fixed versus mobile, closed versus open). A fuller analysis of specific programmes and activities would likely demonstrate how the efforts actually span the spectrum defined by each pair of terms.

Physical/Virtual

Physically anchored digital experiences include interactive computer kiosks, tinkering and art-making spaces, digital labels, and now iPads. Some of these are located in prominent areas within the museum. For example, the Davis LAB on the first floor of the Indianapolis Museum of Art (IMA) is an education and technology centre, but the museum calls it a 'new gallery space'. It includes several computer kiosks that connect to ArtBabble, the IMA blog, and IMA Flickr photos pool. The museum uses these computers to connect visitors in the physical museum to the museum's virtual sites. As the museum describes it on their website (www.imamuseum.org/interact), 'Leave comments on the IMA Blog, find your favourite IMA Flickr photos, rate art videos, Facebook us, learn about major exhibitions or discover our latest technology experiments'.

Another notable example of physically anchored digital experiences is the San Francisco Museum of Modern Art's (SFMoMA) Koret Visitor Education Center situated on the second floor adjacent to exhibition areas. It offers several computers with interactive features and web links, a video screening area, as well as analogue services such as a library of books. In other cases, the physical digital experience is located throughout a museum building. For example, the MoMA Guide system at the Museum of Modern Art (MoMA) in New York comprises various digital kiosks on the first and second floors of the museum. The information accessed in these kiosks helps visitors to navigate the galleries and locate specific works on view, access works in the museum's collection with artist biographies and art terms, find information on daily events in the museum, and send e-cards with works from MoMA's collection. The information, as well as the e-cards, can all be accessed on the museum's website as well.

At the other end of the physical-virtual spectrum are examples of virtual digital experiences available only to online visitors. Games have become a popular form of online museum experience. The Getty Museum offers Getty Games that include Match Madness, Switch, Jigsaw Puzzles and Detail Detective, all based upon works in their permanent collection. Moreover, the Getty also has a presence on *Whyville*, an online world for teens and pre-teens. The link from the Getty Games page states:

> Visit the Getty Museum in *Whyville* where you can play games and learn about art from anywhere in the world! The Getty Museum in *Whyville* is a virtual

companion to the Getty Center in Los Angeles. The Getty in *Whyville* is where you can get together with friends to chat art, play art, and get inspired to make your own art!

(www.whyville.net/smmk/top/gates?source=getty)

Teen websites are another virtual digital practice offered by a handful of museums such as MoMA, the Walker Art Center (Minneapolis), the Tate Museum (London), and the Bronx Museum of Art (New York). At the Tate, the websites are called 'Young Tate/The Collective' and 'Tate Kids', the Walker's is called WACTAC (Walker Art Center Teen Art Council), and the BxMA Teen Council at the Bronx Museum creates a regular podcast series called *museCasts*. It is interesting to note that as of 2012, some of these earliest experiments in the creation of virtual museum spaces have already become obsolete. For example, MoMA's former teen website 'Red Studio' is currently archived because it was originally built on the FLASH platform, which was by 2011 incompatible with most smart phones and mobile tablet devices, and has been replaced by the new teen website 'PopArt'. These virtual teen sites are not merely sections within the main museum site, but rather separate online spaces that offer highly social and interactive elements such as games, remix activities, chat, polls, teen artwork (including rating and sharing), podcasts created by teens interviewing artists and museum staff, blogs, and public art competitions. These websites are based on the involvement of teen councils formed by the museum with local teenagers that meet regularly at the museum to plan events for other youth, conduct interviews with artists and museum staff, and organize student art exhibitions, often receiving school credit and a small stipend.

While we might properly refer to these previous virtual spaces as mixed-reality spaces because they are designed to be experienced in conjunction with a visit to the physical museum site, there is an increasing number of online-only experiences. Most of the current offerings of online-only experiences are curated by museum staff, based on selections from the museum's permanent collection; these are typically media-rich experiences that include images, text, audio, or video. These virtual exhibitions are curated solely for website visitors and often incorporate interactive features designed to engage web visitors in discussions about the online exhibition. Moreover, these virtual exhibitions often also prompt web visitors to engage in activities that are now becoming conventions of social media communication, such as 'tagging', 'rating', and 'sharing' materials from the exhibition. For example, the Freer Sackler Galleries (Smithsonian Museum of Asian Art) offer online exhibitions of works from their permanent collection arranged by themes and genre. Exploring a different notion of online exhibition, the San Francisco MoMA created *e.space* in 2000, an online collection of websites and projects themselves considered a new form of art. Online or virtual tours that focus on artists, artworks, themes, or museum architecture, and comprise multimedia content are now offered by several museums including the Tenement Museum in New York and the National Gallery of Art in Washington, DC.

Virtual Museums are perhaps the most extreme example of virtual digital museology practice. At the MUVA (Museo Virtual de Artes El País), works in the collection are digital images of actual contemporary artworks from Uruguay. The museum exists only on the web; there is no physical location for the museum. The Adobe Museum of Digital Media is the world's first virtual art museum dedicated to the medium of digital art. As described by the museum's creative director Keith Anderson:

> One of the things we kept stopping and asking ourselves as we were developing the museum is, how would this work in the real world? How would it be in a real brick and mortar building, because we wanted to take the museum experiences that were familiar to people and then transfer those over to the digital space?
> (Anderson 2013)

While the buildings or collections may not be physical in a virtual museum, what we see is that the organization of digital collections often reproduces the conventions of physical exhibitions for the purposes of providing a meaningful navigation context for online visitors.

Fixed/Mobile

The second dimension covers the spectrum from fixed to mobile practices where the term 'fixed' refers to a practice that is located in a specific and particular physical context and the term 'mobile' refers to practices that unfold as individuals travel among locations in time and space. Fixed digital practices sometimes utilize QR codes or Microsoft Tags using HCCB (high capacity colour barcodes). For example, The Mattress Factory in Pittsburgh and the Brooklyn Museum have placed QR codes next to object labels and on walls throughout the galleries.

The QR codes provide information on the objects including video, text and images that can be obtained quickly from most smart mobile phones equipped with cameras, good connectivity, and a code reading application. While these barcodes are primarily location-based tools, they also can connect the physical experience via the mobile device to the museum's website (and particularly the collection database section) that must be made mobile-ready.

One of the forms of mobile digital practice that has captured the imagination of many museums as well as artists, is the genre of augmented reality games, or ARGs. In these experiences, players travel through the museum and its physical spaces, and are able to access (in real time) digital 'overlays' where digital information is spatially synchronized with a particular physical location within the museum. The games require the use of mobile smart phones and usually produce a great deal of social interaction – both physical and virtual – among players. In 2008, the Smithsonian American Art Museum ran the ARG called *Ghost of a Chance*. The game itself was a distributed experience: it 'took place' on the

Understanding the Distributed Museum 63

Lynn Chadwick
England, 1914–2003

Two Watchers: Second Version, 1967
Bronze, ¼

Given in memory of Pamela Djerassi, Class of 1971, by her parents, 1978.145

Tony Smith
U.S.A., 1912–1980

For J.W., 1969 (cast 1992)
Bronze, Lippincott Foundry, 2/6

Gift of Jane Smith, 2002.363

http://goo.gl/qvh2C

This block of QR (Quick Response) code can be read with the QR reader application on a smartphone to access a short film about the installation of *Georgia Granite Circle* by artist Richard Long. The video can also be found at http://www.youtube.com/CantorArtsCenter

Standard phone data charges may apply; refer to your carrier for direct costs.

Figure 3.2 QR codes or Microsoft tags using HCCB (high capacity colour barcodes) Cantor Arts Center, Stanford University, Palo Alto, California (© Susana Bautista 2012)

museum's website, on YouTube, Facebook and MySpace. Two related events were organized outside the museum – at the Smithsonian Museum of Natural History and the Congressional Cemetery – and the final event occurred at the museum with players engaging in a multimedia, museum-wide scavenger hunt.

Geocaching is another genre of mobile digital game playing; it has been deployed as the basis for the creation of what might be considered 'high-tech' scavenger hunts. Geocaches are physical containers that hold objects hidden in locations all over the world. The experience of geocaching is centred on finding a physical object that is hidden in a fixed physical location. The game is played by moving through time and space to find the cached object. Players who register on the website Geocaching.com can search for caches by zip code. There they find the cache description with its longitude and latitude coordinates that can be programmed into a personal GPS device. The Charlotte Museum of History in North Carolina created a geocaching experience called 'Charlotte's Best Kept Secret' by hiding a cache somewhere on museum grounds. Provided only geo-spatial coordinates, 72 visitors have located the cache since 2009.

Closed/Open

The third dimension considers the creative expanse of the activity rather than the spatial or temporal character of the experience. An 'open' activity allows users to individually or collaboratively produce content. A 'closed' activity contains content that has been archived, selected and organized by museum staff for visitors to access. A typical example of a closed digital practice in museums is the creation of mobile tours. Since they were first adopted by museums in the 1950s, mobile tours have changed dramatically, largely due to advances in technologies that by around 2005, enabled visitors to use personal communication devices to engage with the pre-recorded tour. These tours were designed as companion experiences to viewing permanent collections or travelling exhibitions. Shortly thereafter, many mobile tours started to offer opportunities for visitor participation, contributing their own stories and reflections to the larger discourse. This shift from a 'closed' presentation of didactic information to a more 'open' experience that invites visitor comments suggests a more participatory approach to learning.

Open mobile tours allow users to leave messages or feedback on the works. For example, the Walker Art Center's *Art on Call* programme offers two functions that allow for visitor participation. Through the use of a popular social media practice called 'breadcrumbing', the programme keeps track of the artworks accessed by a visitor and expands the visitor's playlist each time the phone is used to listen to a segment. Visitors can access their playlists at home through the museum's website. A companion application called 'TalkBack' records a visitor's audio notes/comments through the phone. *Art on Call* also allows visitors to transfer calls directly to museum staff and services.

Digital tagging is another type of an open mobile practice. Tags are a form of user-generated content applied to museum objects and photographs that register how works are described by the public. Museums are becoming increasingly interested in tagging because it is believed to help build communities of interest and make collections more accessible to the public. Museum professionals Wyman, et al. assert that:

> Tagging lets us temper our authored voice and create an additional means of access to art in the public's voice. For museums, including these alternative perspectives signals an important shift to a greater awareness of our place in a diverse community, and the assertion of a goal to promote social engagement with our audiences.
>
> (Wyman et al. 2006)

The use of tagging makes the museum experience more personal, which many believe creates a deeper and more long-lasting connection for the visitor as opposed to the more traditional (scholarly) descriptions based on art historical or scientific categorization. Some museums utilize the social tagging applications on Flickr for visitors' personal photos and videos. Other museums have created their own tagging applications on their websites. The Brooklyn Museum's *Gallery Tag!* is a mobile tagging game specifically designed for use in the galleries where visitors select or create a tag to attach to artworks on display. Probably the best known tagging effort is called: *Steve: The Museum Social Tagging Project*. Several museums such as the Indianapolis Museum of Art (IMA) and the Los Angeles County Museum of Art link to the Steve Tagger application that prompts visitors to tag an object they see in a specific museum. While the general process of tagging is open, the use of such tags may be more closed of course, depending on how museum staff decide to incorporate the tags into their systems of categorization, how the museum juxtaposes amateur tags with expert ones, how the tags are publicly displayed, and what are the administrative policies regarding acceptable tags.

From Analysis to Application: Challenges and Opportunities

The analytic categories that we elaborate in the previous section were developed to help us understand the permutations of museum practices that are already in existence. We offer these categories as a resource for museum professionals to think about in designing informal learning experiences for their visitors using new media. Beyond this practical use, this creative inventory also points to ongoing challenges for museum professionals and scholars that are not problems to be solved, but rather aspects of the new digital landscape that need to be understood.

As we noted earlier, learning in a digital age occurs within a distributed network of spaces, experiences and environments. As museums participate

in these distributed learning networks, they contribute a particular expertise to the learning experience. One challenge that emerges within the context of the Learning 2.0 paradigm concerns the nature of expertise: through the use of social media and extended networks, learners in a digital age have become accustomed to learning from each other without regard to background, authority, institutional credential, or domain expertise. One challenge for the contemporary museum concerns the demonstration of expertise and authority of the museum professional. Where the digital generation are accustomed to learning from peers who have little or no formal authority or expertise, museum professionals are used to being the primary experts in cultural conversations about museum materials. What they are now being asked to do is to rethink the nature of visitor engagement as one of collaboration that involves two-way conversations. Museums still bring expertise to bear on the conversations, but have become more engaged in discussions with visitors. The populist museum aims to appear friendly and welcoming to all visitors by creating a space for entertainment, socialization and relaxation, often involving new digital technologies. But to accomplish their more serious and traditional aims of collecting and preserving valuable works of cultural heritage, scholarly interpretation and the formal dissemination of knowledge, museums must assert authority and expertise. The museum's challenge, and indeed its authority in the digital age, comes not only from a sense of accumulated expertise, but also from its ability to seamlessly navigate contradictory spaces and practices within this distributed learning network.

Another challenge for museums as well as the public is to understand the full-range of practices and events of the distributed museum, within any particular local community or across the globe. We understand how important and difficult it can be for museum professionals to keep track of innovative experiments and activities at other institutions. We also appreciate how important it is for museums to be able to communicate to their visitors the full range of activities that they offer across these networked nodes and sites. Our approach in this project was not to single out a selection of best practices, but rather to conduct a creative inventory of activities and experiences that museums currently offer to digitally savvy and technology-enabled visitors. Our inventory, however, was delimited by time and location. To address the limitations of this analysis and to help museums better understand the distributed nature of their practices, we are creating an application that will enable the mapping of ongoing efforts of museums and cultural institutions. We believe that such an application would be useful for individual museums to communicate their distributed presence to visitors, as well as to facilitate collaboration with other institutions.

The implications of this creative inventory for new design experience in museums are not tied to particular technologies. As we noted, many of the so-called 'new' practices enabled by the use of digital technologies had their analogue precedents. Technology changes over time, and the commitment to the use of a particular technology or platform will always come with risks and costs as well

Understanding the Distributed Museum 67

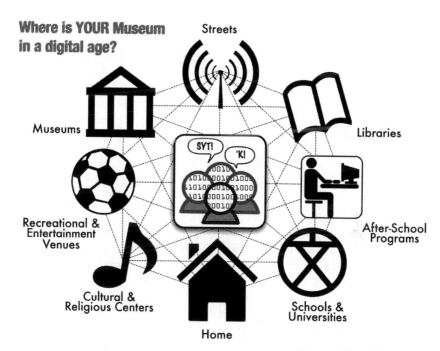

Figure 3.3 A prototype of an interactive map of the concept of the distributed museum is available as a Prezi document: http://prezi.com/6j2kvs8tb_i0/mapping-the-distributed-museum/ (© Balsamo and Bautista 2011)

as benefits and innovations. We identify three key social and cultural implications that have emerged through the use of these technologies by museums across the globe. These implications offer new ways of thinking about the role of the museum in a digital age.

1. An emphasis on open culture. In an age dominated by discussions of digital rights of creative producers and products, where the trend is to limit both access and creative use of works of culture, museums have deployed new digital technologies in the service of making cultural heritage and collections more widely accessible and available. Where earlier websites may have referenced small 'thumbnail' versions of digital images, museum sites today are offering high-resolution versions of their collections. This is a profound gesture that demonstrates the museum's understanding of its role and responsibility to provide public accessibility of cultural materials.

2. An appreciation for the scale of networked communities. There are two implications here. With the wide-scale use of social media, each visitor – whether to the physical place or to the virtual space – brings a network of social relations with them. These networks can be activated on location,

through real-time 'tweets', 'posts', and 'sharing', or well after the visit, through e- mail, Facebook updates, media sharing (Flickr or YouTube), rating sites (i.e., Yelp), or bulletin-board sites (Tumblr, Pinterest, Bolt, FourSquare). Moreover, through the use of social media, museums can understand and communicate faster with the many communities that constitute their network of social relations. The museum's network is not monolithic: it is a network of communities that includes the community of visitors, patrons, teachers, artists, advisers, scholars, local community members and learners of multiple stripes.

3. Place-based experiences. As mobile and online technologies enable the seamless travel among physical and virtual spaces, the location of the museum experience also travels. Place in the digital age no longer implies physicality, locality or even permanence (Bautista 2012). Experiences subjugate place because they can be taken away by the visitor, stored in memory, and recalled through various strategies (analogue and digital) that may no longer relate to the original place-based experience. The museum as a 'place' travels as personal mobile technologies allow visitors to experience the museum wherever and whenever they choose.

In conclusion, we argue that it is these cultural implications, not the technologies per se, which signal a profound shift in the nature of museology and learning in a digital age. The technologies serve as platforms for experimentation. Museums have demonstrated an impressive creative capacity to 'think with the technologies' about the changing nature of the museum experience. We reflect on some of the noteworthy experiments going on in museums across the globe in our analysis, but these are only a select sample based on our familiarity with museums in North America. Considering these cultural implications suggests opportunities for the creation of new learning experiences that will emerge through the increasing collaboration between museums and their visitors, as well as with other institutions that form part of their distributed networks.

References

Adler, R.P. and Seely Brown, J. 2008. Minds on fire: Open education, the long tail, and learning 2.0. *Educause Review*, 43(1), 16–32. [Online]. Available at: www.educause.edu/ero/article/minds-fireopen-education-long-tail-and-learning-20 [accessed: 28 January 2013].

Anderson, K. 2013. *Making the Impossible: Building the Adobe Museum of Digital Art*. Adobe Museum of Digital Art]. [Online]. Available at: http://www.adobemuseum.com/#/video/makingOf [accessed: 28 January 2013].

Balsamo, A. 2011. *Designing Culture: The Technological Imagination at Work*. Durham, NC: Duke University Press.

Bautista, S.S. 2012. The changing nature of museology in the digital age: Case studies of situated technology praxis in U.S. art museums, unpublished doctoral dissertation, University of Southern California, Los Angeles.

Bennett, T. 1995. *The Birth of the Museum: History, Theory, Politics*. New York: Routledge.

Bittanti, M., Boyd, D., Herr-Stephenson, B., Horst, H., Ito, M., Lange, P.G., Pascoe, C.J. and Robinson, L. 2008. *Living and Learning with New Media: Summary of Findings from the Digital Youth Project*. Chicago, IL: The MacArthur Foundation.

Blumenthal, M.S., Mitchell, W.J. and Inouye, A.S. (eds). 2003. *Beyond Productivity: Information Technology, Innovation, and Creativity*. Washington, DC: The National Academies Press.

Brown, John Seely and Adler, Richard P. 2009. Minds on fire: Open education, the long tail, and learning 2.0. Published on Educause Review Online, 18 January 2008. [Online]. Available at: http://www.educause.edu/ero/article/minds-fire-open-education-long-tail-and-learning-20 [accessed; 31 May 2013] © 2008 John Seely Brown and Richard P. Adler. Text illustrations © 2008 Susan E. Haviland. The text of this article is licensed under the Creative Commons Attribution 3.0 Unported license (http://creativecommons.org/licenses/by/3.0/).

Castells, M. 2001. *The Internet Galaxy: Reflections on the Internet, Business, and Society*. New York: Oxford University Press.

de Certeau, M. 1984. *The Practice of Everyday Life* (trans. S. Rendall). Los Angeles: University of California Press.

Clinton, K., Jenkins, H., Puroshotma, R., Robison, A.J. and Weigel, M. 2007. *Confronting the Challenges of Participatory Culture: Media Education for the Twenty-First Century*. Chicago, IL: The MacArthur Foundation.

Mitchell, W., Inouye, A. and Blumenthal, S. 2003. *Beyond Productivity: Information Technology, Innovation Creativity*. Washington: The National Academies Press.

Palfrey, J. and Gasser, U. 2008. *Born Digital: Understanding the First Generation of Digital Natives*. New York: Basic Books.

Spigel, L. 2004. Portable TV: Studies in domestic space travels, in *Technological Visions: The Hopes and Fears That Shape New Technologies*, edited by S. Ball-Rokeach, M. Sturken and D. Thomas. Philadelphia: Temple University Press, 110–44.

Turkle, S. (ed.). 2007. *Evocative Objects: Things We Think With*. Cambridge, MA: The MIT Press.

Turkle, S. 1995. *Life on the Screen: Identity in the Age of the Internet*. New York: Simon and Schuster.

Welcome to Whyville. Getty Museum, Whyville. [Online]. Available at: http://www.whyville.net/smmk/top/gates?source=getty. [accessed: 28 January 2013].

Williams, R. 1983. *Culture and Society: 1780 – 1950*. New York: Columbia University Press.

Wyman, B. et al. 2006. Steve.museum: An ongoing experiment in social tagging, folksonomy, and museums, in *Museums and the Web 2006: Proceedings*, edited by J. Trant and D. Bearman. Toronto: Archives and Museum Informatics. [Online]. Available at: www.archimuse.com/mw2006/papers/wyman/wyman.html [accessed: 28 January 2013].

Chapter 4

Learning at the Interface: The Museum as Public Laboratory

Richard Watermeyer

Introduction

The evolution of British universities from 'ivory towers' to increasingly publicly facing, involved and engaging institutions, is perhaps best understood by reference to the ideological reconfiguration of the science/public nexus, and a paradigm of 'upstream' engagement which has been co-opted into the discourse of a 'public academe' (Watermeyer 2011).

The domain of scientific expertise has in recent times undergone a radical overhaul in the way in which its constituents interface with the public or non-expert groups. The self-presentation of scientists in the public sphere has reconfigured, and some might say, rejuvenated, in response to growing advocacy for non-expert communities as integral stakeholders and licensed collaborators (Watermeyer 2012d) or co-creators of scientific knowledge.

In the course of the last 25 years and certainly since the emergence of a discourse of *public understanding* and more recently *public engagement* with science, the idea of science and the public as two separate, non-interfacing communities has been replaced with an upstream version of the public working collaboratively with scientists in the pursuit of scientific discovery and technological innovation. This model of knowledge co-production is founded on a 'cradle-to-grave' arrangement and the active and equal participation of the public from the inception of the knowledge-building process.

In the UK in the-mid 1980s, a number of high profile policy reports articulated a 'new mood for dialogue' among the mass public previously perceived by the scientific community as uninterested bystanders; unqualified to participate in any meaningful way in matters of scientific production and science governance. This was replaced by a perception of the public as competent handlers and interlocutors of scientific discourse. In the emerging field of Science and Technology Studies (STS), a number of now celebrated scholars called for increased public intervention in matters of scientific enterprise, especially where the science in question posed significant social and ethical concerns; was deemed to be risk-laden and controversial; or was likely to generate public anxiety, alarm and disquiet. Upstream proponents championed the public as integral contributors to scientific discourse providing alternative and

novel insights into the code-breaking of social and ethical complexity of emerging technoscience.

The recruitment of the public in processes of scientific knowledge production and decision-making was based on 'substantive' and 'instrumental' rationales (Fiorino 1990); 'substantive' in that the intercession of lay-publics in matters of technoscience facilitated processes of decision-making in science governance, 'instrumental' in that public involvement served to confirm the transparency and rigour of scientific method. Upstream engagement, as a catalyst for knowledge co-production and synergy between expert and lay coteries, represented therefore, a twofold opportunity for scientists to improve public relations whilst co-opting the public in accelerating and extending the positive impact of their research.

In the UK, a raft of upstream engagement exercises have been staged, in most instances as public consultations or public dialogues. An' 'upstream' model of public engagement is one in which there is a dialogical, two-way and non-hierarchical interaction between expert and non-expert groups and replaces previous notions of the publics as somehow' 'deficit' in their understanding of science and participation with scientific communities. In the last 10 years alone, Sciencewise, the UK's principal agency for public dialogue in science and technology policy making, funded by the UK government Department for Business Innovation and Skills (BIS), has sponsored 17 public dialogues. These dialogues have made explicit the inherent difficulties in organizing and maintaining a fluent, and reciprocal dialogue between expert and non-expert groups, which has value beyond the normative rationale of public dialogue as a 'good thing'. As I have argued elsewhere, a continued investment in dialogue as the pre-eminent mechanism for public engagement with science and technology (PEST) occurs with little acknowledgment of its critical and evaluative learning and has resulted in 'a false dawn of dialogue' (Watermeyer 2012d). The implementation of the upstream vision consequently appears as somewhat erratic, and unfulfilled; leaving some to suspect that public engagement in science and technology remains decidedly inadequate and that an aspiration of scientific democratization has been largely unrealized. The dismantling of what Jasanoff (2005) calls 'scientific technocracy' with 'civic epistemologies' is at best, a work in progress. Nevertheless there is evidence of change in the way the university and museum are configured as sites of scientific knowledge production and a growing accent on the necessity and value of their collaborative interactions with the public.

In the following sections I will establish what progress to date has been made towards improving academics' capacity and proclivity for engaging with the lay-public and then consider how a process of deinstitutionalization of museums lays the path for a more reciprocal interface between scientific experts and the public.

Beacons and Belonging – Universities Moving From 'In' to 'Of' Their Communities

Much of the discourse of engagement, the democratization of expertise and the eradication of the 'ivory-tower' has been mobilized in the UK with the investment by the UK Research Councils (RCUK) in the recently concluded, Beacons for Public Engagement initiative. In 2008 RCUK established a network of six university-based 'Beacons', each given a period of four years with which to inculcate a culture amongst academics of proactively engaging the public. The success of the Beacons, much like that of any short-term culture change initiative, has been limited by how much it impacted academics' attitudes to public engagement and has in part been undermined by the emergence of research impact as a new agenda for HE with arguably more profound professional and pecuniary implications (see Watermeyer 2012b). Nevertheless, the Beacons have succeeded in increasing the prominence of academics' multiple public stakeholders, whilst providing a platform from which to experiment with different engagement methodologies and to build extra-academic links, such as with public facing industries, predominantly located within creative and cultural sectors. Many of the Beacons teams/management groups benefited from the participation and expert steer of museums and science centres as public engagement specialists – the Wales Beacon for instance constituted an alliance of two universities, Cardiff and Glamorgan, with Amgueddfa Cymru (National Museum Wales); Techniquest (science centre) and BBC Cymru/Wales – resulting in more frequent and fluent interactions and chance of sustained and future partnership.

Whilst the Beacon initiative was focused primarily on integrating public engagement as a substantive component of the university portfolio, learning was not simply exclusive to academics but shared with museum practitioners who were afforded fresh insight into HE praxis and helped to identify academic specialists and avenues of potential collaboration. The spoils of the Beacon apprenticeship were, however, mainly claimed by academics whose experience of museological practice and the museum as a catalyst of public knowledge enhanced their awareness of the diversity of public groups, their capacity to navigate the social architecture of public space, and processes in the democratization of knowledge.

Whilst a history of universities in the UK as ambassadors of the public good and agents of social and democratic welfare is far from evident, it is unfair and historically inaccurate to pigeonhole British academics as hermitic and isolationist (Watermeyer 2011). There are not only many prominent academic public engagers in the UK but many who fervently challenge the derision of the university as a closed-shop or site of self-imposed quarantine. They claim public outreach as a de facto part of their professional anatomy, guaranteed through organizational structures, for example engagement as a recruitment and promotional criterion and performance indicator or measure of assessment, such as in the UK's upcoming Research Excellence Framework (REF). There is also it seems, growing recognition in British universities of a critical and academic discourse of public engagement and public engagement for HE as a substantive, stand-alone research concern, with

comparisons and cross-overs to research in community engagement, most prevalent in American and Australian academies (Watermeyer 2012c). Concurrently an emergent UK tradition of museum and visitor studies is uniting the theoretical and applied aspects of museums and bridging academic and practitioner communities.

There is nevertheless, despite good progress, rather less evidence to suggest that academics have made the transition from being 'in' to 'of' their communities (Bond and Patterson 2005). Where the quality of being 'in' a community is ostensibly no more than a chance co-incidence from which little inference of integration and active participation can be made, being 'of' a community infers a history of social participation, membership and alignment with a collective identity and, moreover, cognisance and affinity with local issues.

Academics becoming 'of' their community requires, however, a commitment to interface with public groups in ways which may be unfamiliar and may be especially challenging for those unaccustomed to talking and thinking about their work beyond the context of its production. Nevertheless, becoming 'of' a community demands that academics integrate themselves in ways in which who they are and what they do is made plainly evident.

Academics' success as members of a dialogue economy is underpinned by the dissolution of barriers, which impede the collusion of expert and non-expert groups. In fact in an effort to transform the prejudices held by those for whom universities appear distant and untrusted, academics are challenged to de-clutter yet not 'dumb-down' their self-presentation. They must furthermore be prepared to not only engage the public in the public's preferred way but to disband an expectation that the public will seek out the university and instead move the university to the public. There is clearly much the university can learn from the museum in its attempts to dismantle the ramparts of professional identity and place, so that their travel and impact as knowledge workers throughout a panoply of social/cultural and scientific contexts and interactions is unimpeded by the public supposition or spectre of their being elites.

Deinstitutionalization: The Post-Museum

For academics, one route to reconciling the expert/public nexus is through a process of deinstitutionalization – the disembodiment of knowledge from edifice to experience, articulated in the museum context through Malraux's (1967) depiction of the 'museum without walls'. The deinstitutionalization of the museum experience from physical to what Bauman (2005, 2007) might define as a 'liquid' encounter has accelerated with changes in the governance of its production and the emergence of innovative technologies of dissemination and dialogue.

In the first instance, the emergence within the museum of a new institutionalism or new museology, framed by a turn towards interactivity and the dematerialization of knowledge hierarchies in the design, production and performance of the exhibition, has been motivated by extraneous developments in the social, economic

and political organization of capitalist democracies. In the course of the last 30 years the role and function of the museum in Western societies has undergone radical transformation in response to a myriad of oscillating demands – near universally the consequence of late-capitalism (Hooper-Greenhill 1997, Barker 1999).

Within a milieu of post-modernity, the rampant ascent of consumer culture set in motion a shift from the museum's Enlightenment values of aesthetic progress and authenticity to a new emphasis on commercialization and the production of spectacle, cited by many post-modern critics as precipitating the erosion of the museum as a sanctuary of aesthetic contemplation and its reincarnation as a 'distraction machine' (Virilio 1994) or 'supermarket of culture' (Virilio 1991). Noted by some critics for the ease with which it has threaded almost seamlessly commerce and culture; high and popular culture; education and entertainment, the museum has made irrefutable its credentials as a playground of consumption (Featherstone 1991). The conspicuous incorporation of the museum cafe and/or shop from adjunct to central episode of the museum experience, is for instance a watershed moment signposting the bowdlerization of the museum by the vacillations of market forces and consumer trends and the simulated (Baudrillard 1994, 1998) and schizoid (Jameson 1998) behaviours of visual consumers. Whilst some identify the commercialization and mass popularization of the museum as a negation of its founding principles and another example in the 'dumbing down' of science, its success in 'crowd-pulling' the knowledge-tourist and as a destination of knowledge as the new recreation shows the potential for the public to experience expertise beyond the reach of their usual cultural environment and interests and also changes the way in which knowledge is communicated to museum visitors.

Indictments of this populist approach in museums as synonymous with the demise of its aesthetic value fail to take into account the multiple types of social interactivity which result from the increasingly diverse footfall of visitors and the ways they choose to use the museum space. Furthermore the proliferation of museums' work around community outreach and education demonstrates the commitment of the sector in democratizing and diversifying its aesthetic and is evidence of museums being both *in* and *of* their communities.

Changes in the governance and outlook of museums have also been harnessed by seismic advances in electronic communication. The role of social media as a mechanism brokering new dialogues between experts and the public is indispensable to the future of both museums and universities; where *Web 2.0* provides an incomparable opportunity to communicate with a range of audiences, stakeholders and future collaborators previously unentertained and unimaginable (Watermeyer 2010). Digital interactions allow knowledge specialists to share their ideas and work across different and multiple locales and time-zones in a manner which is instantaneous, continuous and ubiquitous and provide a gateway to a global audience; a means to publicize and popularize events, exhibitions and works of different kinds; a tool for awareness raising; a notice-board; an instrument of (e)learning and means for critical discussion. The digital domain also arguably signposts the fulfilment of the deinstitutionalization of the museum and university, as their physical and social

boundaries are flooded and reshaped by the ubiquity and endlessness of webspace and its innumerable inhabitants; and furthermore, the decentralization of control in the production of knowledge from a few knowledge specialists to a myriad of (nascent) lay-knowledge workers.

Museums as collections of the past and signposts of the future are engines of citizenship and collective identity. They are as a recent UK government consultation paper states, 'at the heart of what we call the 'public realm' ... over which all citizens have ownership' (DCMS 2005: 6). The way with which museums have interacted with audience groups has, however, over the course of recent years changed substantially with a new focus on audience development and a change from a 'product led to audience centered' (Black 2005) approach to audience engagement. The museum sector has consequently, as Kotler (1998: 39) has argued, focused on offering audiences 'multiple experiences: aesthetic and emotional delight, celebration and learning, recreation and sociability'. In parallel, a similar challenge for universities in an age of increased accountability is to reconsider their *modus operandi* and the way with which this is mobilized for the maximum effect, or dare I say, impact.

As a part of the New Institutionalism (Doherty 2004), publics are invited to reassign the use of museum space, doing so almost unwittingly through casual or unmeditated interactions, transforming the museum from repository or storage house of knowledge and learning to catalyst of leisure, social distraction and unexpected encounters. The museum is transformed into a space in which the production of new knowledge is incidental or serendipitous and the byproduct of the museum appropriated for other social and cultural pursuits such as meeting friends, having coffee or writing emails – activities I commit to on a regular basis. Some critics, however, argue that in diversifying the role of the museum or distracting from its founding tenets, its capacity and status as a knowledge institution depreciates. Conversely, the versatility of the museum as a public space that encourages a diverse and unprogrammed range of behaviours and forms of social interactions is what may enrich the experience of new and sometimes complex knowledge.

The museum, or what Hooper-Greenhill (2007) calls the 'post-museum', transcends institutional temporalities and mobilizes a type of social/cultural *bricolage*, where visitors co-opt and reconfigure cultural memes played out in interactions with the museum's exhibition and spaces in order to formulate a narrative which has personal relevance. In this way the museum foments critical agency among visitor populations licensed not only to view but respond and in a way (re)create knowledge through a direct cultural and aesthetic experience. The post-museum then is a space of relational aesthetics (Bourriard 2002).

The transfer of science into the everyday is also a process of dematerializing the locus or habitus of expertise where dominant or hegemonic forms of representation, which delimit and/or impair the potential of its public interface, are substituted for dialogical interplay between scientists and the public, with the latter as licensed and valued contributors of scientific discourse (Watermeyer 2012e). The generation of multiple (informal and on occasion uninvited) dialogues in science has manifold

potential in forging what Wenger (1998) terms a 'community of practice'- where the subject of practice is the generation of scientific knowledge.

Conclusion

As universities and museums continue along a trajectory of engagement and collaboration with a diverse array of public constituencies there is still much in the way of shared and formative learning to occur. The 'ball', however, is firmly in motion.

The Beacons have concluded to be replaced with another RCUK investment, the 'Public Engagement with Research Catalysts programme, dedicated to embedding public engagement within HE working cultures. This investment will no doubt continue much of what the Beacons began in forging conversations, links and partnerships between universities and museums; developing shared mechanisms for knowledge and learning; and extending their respective capacities as spaces for publics' knowledge work. In purely practical terms, the Catalysts like the Beacons before, might mobilize an awareness of activities between museum professionals and university scholars, and elucidate points of shared interest, commonality in methods, orientation and programmes of work and routes to partnership.

Despite these initiatives some among the academic community remain sceptical and unconvinced that public engagement for universities (and to a lesser extent museums) is anything more than a veiled process of public-making, which has more to do with the legitimization of academics or scientific process or what some have called legislating a 'licence to operate' than publics, and specifically latent or disenfranchised publics, being involved in the mechanics, cradle to grave, of knowledge production (Watermeyer 2012d). The persistence of a deficit public suggests that public engagement is more aligned with universities' self-promotion and marketing and the manipulation and containment of publics' expectation and concerns. Much the same may be said of museums as they defend (where publicly funded) their status as a public investment. In response, further investment and participation within a critical discourse of engagement appears essential in overcoming the stalemate of institutions' or disciplines' protectionist and/or silo default that inhibits the materialization of the public in expert domains.

The museum and university will continue to be challenged to move beyond the sanctuary of their institutionalism and embrace the prospect of change, divergence and contingency – hallmarks of the public domain and knowledge economy. In meeting this challenge, both museum and university must be prepared to adapt and continue along a line of diversification and reinvention, where who they are and what they do continues to hold value to those they serve and/or as Thomas Hoving –director of the Metropolitan Museum stated in an address to American Association of Museums (AAM) as far back as 1968, 'we must continually examine who we are, continually ask ourselves how we can make ourselves indispensable and relevant' (Hoving 1968: 16). Concurrently, universities and museums ought to begin to redress an imbalance

of power between the standard-bearers of connoisseurship and those intent on 'going public'. For one, universities/museums might collapse the constructedness of institutional taxonomies such as 'research' or 'teaching', 'curating' or 'conserving', 'local' or 'international' which needlessly incite divisiveness between institutions and their habitués; cause superficial hierarchies; and respectively destabilize a holistic vision and effort as beacons and defenders of the public realm. Furthermore, universities and museums ought to embrace the liquidity of the networked society (Van Dijk 2006) and the dissolution of their temporal/institutional confinement through migration to online territories and transformation into open spaces of knowledge transaction without walls (or intimidating architecture (McClellan 2003) – open and accessible by all.

For universities as museums, fulfilling the potential of their public ambition – becoming in and of their communities – begins with a process of getting to know and being available to be known. An improved relationship between museums and universities will surely provide a firm foundation to further the task of illuminating the diverse publics and help in innovating what Lezaun and Soneryd (2007) term 'technologies of elicitation', critical in producing an effective interface between expert and lay coteries and in the potential for co-investment in the production of knowledge.

References

Barker, E. 1999. *Contemporary Cultures of Display*. London: Open University Press.
Bauman, Z. 2005. *Liquid Life*. Cambridge: Polity Press.
Bauman, Z. 2007. *Consuming Life*. Cambridge: Polity Press.
Black, G. 2005. *The Engaging Museum: Developing Museums for Visitor Involvement*. London: Routledge.
Bond, R. and Patterson, L. 2005. Coming down from the ivory tower? Academic's civic and economic engagement with the community. *Oxford Review of Education*, 31(3), 331–51.
Bourriard, N. 2002. *Relational Aesthetics*. Dijon: les presses du reel.
DCMS: UK Department for Culture Media and Sport. 2005. *Understanding the Future: Museums and Twenty-First Century Life: The Value of Museums*. London: DCMS.
Doherty, C. 2004. The institution is dead! Long live the institution! Contemporary art and new institutionalism. *Engage*, 15, 6–13.
van Dijk, J. 2006. *The Network Society*. London: Sage.
Featherstone, M. 1991. *Postmodernism and Consumer Culture*. London: Sage.
Fiorino, D.J. 1990. *Citizen Participation and Environmental Risk: A Survey of Institutional Mechanisms. Science, Technology and Human Values*, 15(2), 226–43.

Hooper-Greenhill, E. 1997. Museum learners as active post-modernists: Contextualising constructivism. *Journal of Education in Museums*, 18, 1–3.

Hooper-Greenhill, E. 2007. *Museums and Education: Purpose, Pedagogy, Performance – Museum Meanings*. London: Routledge.

Hoving, T. 1968. Branch out. *Museums News*, 47.

Jameson, F. 1991. *Postmodernism or the Cultural Logic of Late Capitalism*. Durham, NC: Duke University Press.

Jameson, F. 1998. *The Cultural Turn: Selected Writings on the Postmodern, 1983–98*. London: Verso.

Jasanoff, S. 2005. *Designs on Nature: Science and Democracy in Europe and the United States*. Princeton, NJ: Princeton University Press.

Kotler, N. and Kotlet, P. 1998. *Museum Strategy and Marketing: Designing Missions, Building Audiences, Generating Revenue and Resources*. San Francisco, CA: Jossey-Bass.

Lezaun, J. and Soneryd, L. 2007. Consulting citizens: Technologies of elicitation and the mobility of publics. *Public Understanding of Science*, 16, 279–97.

Malraux, A. 1967. *Museum without Walls*. London: Secker and Warburg.

McClellan, A. 2003. A brief history of the art museum public, in *Art and Its Publics: Museum Studies at the Millennium*, edited by A. McClellan. Oxford: Blackwell.

Stilgoe, J. and Wilsdon, J. 2009. The new politics of engagement with science in R. Holliman, E. Whitelegg, 2009, in *Investigating Science Communication in the Information Age: Implications for Public Engagement and Popular Media*, edited by E. Scanlon, S. Smidt and J. Thomas. Oxford: Oxford University Press.

Virilio, P. 1991. *The Aesthetics of Disappearance*. Paris: Semiotext.

Virilio, P. 1994. *The Vision Machine*. London: British Film Institute.

Watermeyer, R. 2010. Social network science: Pedagogy, dialogue and deliberation. *Jcom*, 9(1).

Watermeyer, R. 2011. Challenges for university engagement in the UK: Toward a public academe. *Higher Education Quarterly*, 65(4), 386–410.

Watermeyer, R. 2012a. A conceptualisation of the post-museum as pedagogical space. *Jcom*, 11(1).

Watermeyer, R. 2012b. From engagement to impact? Articulating the public value of academic research. *Tertiary Education and Management*, 18(2), 115–30.

Watermeyer, R. 2012c. Issues in the articulation of 'Impact': UK academics' response to 'Impact' as a new measure of research assessment. *Studies in Higher Education*, DOI:10.1080/03075079.2012.709490.

Watermeyer, R. 2012d. The false dawn of dialogue: Impediments to publics' decision-making and the management of choice, in *Matters of Science and Technology in Technologies of Choice and Control: The Life Sciences under Neoliberalism*, edited by L. Busch. London: Routledge (in press).

Watermeyer, R. 2012e. The presentation of science in everyday life: The science show. *Cultural Studies of Science Education* (in press).

PART III
Curating, Collecting and Creative Practices

This part presents three case study chapters, two from the UK and one from the US. Each serves to illustrate the challenges, complexities and contradictions that have emerged as the intersecting roles of museums and universities continue to change over time. Contributions focus on the different and often complex, interdependent relationships that emerge through innovative curatorial interventions, collecting and creative practices. Thus, the emphasis is on the nature and content of display and the role of collections and objects in 'meaning-making' about the world.

All three examples are drawn from art and design. This is both because there has been a long history of museum development as integral to art and design education, and because both fields centrally engage with the construction of public narratives, that is, are involved in meaning-making about society through the design, display, arrangement and interpretation of images, objects and spaces. In the current period, public cultural institutions have been increasingly charged with playing a strategic role in balancing their responsibilities for curatorial custodianship, histories and public narratives with advancing contemporary and emergent ideas and the education of future generations. This has led to many tensions. Museums can be accused of constructing narratives that merely reinforce existing societal power structures, and which fail to incorporate the diversity of public (non-expert) perspectives. Or they can be seen as losing their authoritative scholarly voice to the pressures of consumer preferences and opinions. Artists and designers, as well as curators and museum educators are responding to these issues through curatorial and creative practices. This, in turn, is leading to contestation over what museums are *for*, and to explorations of how the 'conventional' processes of exhibition and display might be disrupted or re-thought.

In this context Sarah Ganz Blythe presents an engaging historical account of the changing relationships between the museum and the disciplines of art and design. She shows how the role of the museum in the education of artists and designers has shifted over time from one of emulation of masterpieces to one of 'appropriation and intervention' (Chapter 5: 136). She argues that the contemporary university museum is best seen as enabling all of these various historical relationships that is, by being open to many different kinds of learning from artworks and objects simultaneously, functioning as what she calls a 'generative site'.

Other contributors, among them practising artists and designers, come more directly from the paradigm of the contemporary moment, centrally interested in modes of disrupting the perceived assumptions and conventions of museum curatorial practices. In his chapter Gareth Williams, a curator and tutor in HE, explores the problems of exhibiting contemporary design work. His two examples are by designers who deliberately generate form as much out of process and method, as out of function or aesthetics. These pieces thus aim to act as a critical commentary on, and challenge to, the very role of objects in society, and to the 'standard' nature of the design process. This also offers a challenge to museums and galleries in how such work should be exhibited and interpreted since, from Williams' point of view, they do not fit easily within any series of historically fixed narratives, suggesting that the positioning of one or other object within different museological contexts has all too often lessened its critical purpose and identity.

In so doing he proffers a disruption of existing social and cultural histories (and the power relationships that these support) through the introduction of designed objects and exhibitions into the museum setting that can posit alternative narratives. He therefore raises a significant question that underpins both museums and universities about how the authority of social and cultural histories are forged and how these can be effectively sustained alongside the provision of a dialogic space within which to make space for other voices, not just through written interpretative texts but also through acts of object-making.

From the perspective of practicing artists and educators Mackenna and Janssen pose a different series of challenges that aims to blur the boundaries between the space and purpose of museum and gallery. They present artists and their work as part of a different – more radical – curatorial authority that can overwrite conventional historical and cultural narratives (including its normative methods of display, interpretation and engagement with audiences) and therefore questions the very function of gallery and museum exhibitions. Their work draws on the performative as a means of public engagement which foregrounds public participatory processes which are then subsequently drawn into the production of their work as both art and curation. While their experiment challenges resists material production and what they refer to as a fetishistic relationship with stuff it does raise fundamental methodological questions as to whether and how such processes may be understood, read and interpreted by other publics or communities of practice and whether and how they might contribute to the longer-term reading, shaping and interpretation of culture and society over time.

Chapter 5
Keeping Good Company: Art Schools and Museums

Sarah Ganz Blythe

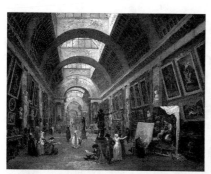
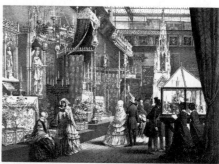

Figure 5.1 Hubert Robert, *View of the Grande Galerie of the Louvre*, 1796, Musée du Louvre; The Medieval Court, from 'Dickinsons Comprehensive Pictures of the Great Exhibition of 1851,' lithograph, pub. Dickinson Brothers, 1854, Victoria and Albert Museum; The Waterman Galleries, c.1915, courtesy of Museum of Art, Rhode Island School of Design; *Raid the Icebox I with Andy Warhol*, 1969, courtesy of Museum of Art, Rhode Island School of Design; Classical Gallery, 1939, courtesy of the Museum of Art, Rhode Island School of Design

'Keep good company: that is, go to the Louvre.' So Thomas Couture advised his pupil Paul Cézanne who, like artists before him, attended the school of the museum and took his lessons from the masters of the past. The relationship between art schools and art museums seems like a natural one – the gallery an artist's instructor, muse, or studio. Yet, the role of museum objects in the education of artists and designers has often been beleaguered by outmoded expectations. Born together of the eighteenth century, one might expect that art schools and museums remain co-conspirators in the cultivation of artists and designers. However, neither institution looks nor acts the way they did 200 years ago. In fact, their independent evolution seems to have quickened as of late with impassioned re-imaginings of interdisciplinary art schools and participatory museums for the twenty-first century. I will first look to the past and the shifting expectation for the role of museum objects in the training of artists and designers, from seventeenth-century models of emulation to late twentieth-century acts of appropriation and intervention. This account of historical strategies will serve to situate present pedagogical practices that replicate the route from imitation to invention, while also seeking to support contemporary conceptions of research, professional practice and public engagement. Finally, a consideration of an object-based interpretive approach, which emphasizes the conditions of making, leads to a notion that by highlighting creative process museums might begin to more actively function as a generative site, inspiring both artists and the public to learn about and make sense of the world imaginatively.

The collection and display of objects for the purpose of educating artists has a long history indeed. In his mid sixteenth-century discussion on training, Giorgio Vasari called for a space in which works of the masters could be displayed for students to emulate. With the actual formation of art academies in the late seventeenth and eighteenth centuries, this encounter between object and artist was systematized. Novice artists copied antique works (often in reproduction prints) as an introduction to ideal form, while more advanced students continued making copies as a way to refine their vision. The masterpiece, literally a work of outstanding skill, was believed to hold the secrets of the masters – Michelangelo, Raphael, Carracci, etc. – and through the process of looking and remaking, such skill could be assimilated. In his first discourse on art delivered to the students of the Royal Academy in 1769, Joshua Reynolds championed the study of 'authentic models' through which 'the idea of excellence which is the result of the accumulated experience of past ages, may be at once acquired; and the tardy and obstructed progress of our predecessors may teach us a shorter and easier way' (Reynolds 1997). Copying directly from the masters would reveal the principles of art to the diligent student, and allow them to skirt their forefather's 'painful investigation' and thereby accelerate the learning curve and the overall progress of art (Reynolds 1997).

This selective imitation of the past for training purposes was further institutionalized with the 1793 opening of the Louvre in Paris, a model that was quickly replicated in other aspiring capitals. Learning from original works of art as opposed to engraved reproductions was a privilege for advanced students and they

did so in public, performing the act of becoming an artist fashioned in homage to the past. In re-performing the gestures, techniques and processes of the past, as far as they could be surmised from a completed work of art, the technical foundation essential to an artist in the classical tradition could be established. Within galleries arranged by nationality, artists attended schools – Italian, Northern, French – each with their own masters and followers. The museum inculcated an artist's relationship to the past in the form of hero worship. 'Tradition set the standards against which the production of art students was measured', as Thierry de Duve assiduously states (1994), and the museum masterpiece was the arbiter of that measure within the art academy (de Duve 1994).

Design education had similarly recognized the importance of learning from historical models of expert craftsmanship. One of its most decisive moments followed the Crystal Palace Exhibition of 1851 and the founding of the Museum of Manufacturers (by 1857 called the South Kensington Museum and in 1899 renamed the Victoria and Albert Museum) to offer access to works of art and, as the original name suggests, to serve as inspiration to British manufacturers. The educational principle of the museum rested on the expectation that to see superior design would lead to the assimilation of good design principles, the production of better design, and ultimately improved industrial production. This built upon the academic model of emulation, but widened the scope beyond classical models to the material culture of the world. The display of objects in a museum for close observation and productive impact on industry became the driving force for the educational missions behind a myriad of museums founded within schools and schools founded within museums in the later nineteenth century in Europe and the United States. The hope, as articulated by William Morris, was that objects from the past could offer makers in the present what could not be achieved in art school instruction – the close study of a historical object to inspire innovation. 'Let us therefore study it wisely', Morris stated in his address to the Traders' Guild of Learners in 1877, 'be taught by it, kindled by it; all the while determining not to imitate or repeat it, to have either no art at all, or art which we have made our own' (Morris 1901). As such, the South Kensington model quickly found its way across most of the United States in institutions founded as museums and art schools including the Museum of Fine Arts and School Boston (1876), Rhode School of Design and Museum (1877), and Art Institute of Chicago – Museum and School (1879) among others conceived as sites for the education of artists and the aesthetic advancement of the general public.[1]

1 RISD offers one such model. Rhode Island emerged out of the Civil War period as a leading industrialized state with a strong desire for better manufacturing through exposure to good design and fine art. In a winning toss-up between erecting a public drinking fountain and investing in art and design education, the RISD Museum was founded in 1877 with the dual mission of public museum and teaching museum for art and design students. Dawn Barrett and Andrew Martinez (eds), *Infinite Radius: Founding Rhode Island School of Design* (Providence: Rhode Island School of Design, 2008).

Almost from the moment of their founding such institutions struggled to reconcile the foundational principles of academic training with the modernist trajectory of the contemporary art world that formed in opposition to historical models. Indeed, at the same time that Morris was passionately articulating the pedagogical virtues of the old in the fashioning of the new, young Claude Monet claimed he did not have time to go to the Louvre. Nonetheless he took advantage of the student artist's access to the museum and with the great masterpieces and all their secrets at his back, he recorded modern life instead. Where progressive and avant-garde practice was concerned, the lessons to be learned from nature and modern life gradually usurped the dependence on dusty varnished museum masters and playing by their rules. Rally cries against the academic models championed by museums gathered pace in the early twentieth century, as vividly articulated by the Italian Futurists who in 1909, recently emerged from art school, called for the diversion of 'the canals to flood the cellars of the museums!' (Marinetti 1909). This reaction against academic training served as the springboard for avant-garde practice and formed a recurrent trope in the career trajectories of modernist artists and designers committed to a new art born of the imaginative inventiveness of the individual as opposed to innovation through re-imagining the past as Morris advocated. In the United States, the 1913 Armory Show catalysed the search for independent artistic languages and profoundly impacted art education by de-emphasizing the necessary access to original works for training purposes (Lehman 1997). This rupture coincided with early breakups within the art school-museum model, but it also spurred re-articulations of the academic museum's *usefulness* to the training of artists and designers for the modern age. In his 1917 lecture, *The Producer, the Art Student, and the Museum,* Rhode Island School of Design president Earle Rowe enumerated the institutions who were developing a more 'intimate relationship' between the art school and museum by 'seeking to increase their usefulness in every way' (Rowe 1917). Using the RISD Museum as a case in point, he outlined a durational and evolving relationship in which the emerging artist would learn 'to haunt the museum' as 'a laboratory to which he eagerly turns for a development of his analytical powers. He should approach the same object from a dozen different ways' (Rowe 1917). Gallery views of the RISD Museum from this period reveal that a laboratory meant displaying student work with masterworks, and 'fine' with 'applied' art. This proximate gallery relationship between maker and made embodied a pedagogical approach devoted to cultivating a relationship between artist and historical object that worked against the blind replication of traditional models and made public and social the creative process. For Rowe, the museum could 'encourage expression, develop taste, present opportunities for comparison and judgment, and invite close study of all examples of fine or applied arts', thereby offering a palpable testament to the benefit of long training through 'hard labor with hand, eye, and brain' (Rowe 1917: 86). As such, the museum offered a site where progressive art could be inculcated within the academy by virtue of the fact that historical art and design would develop the capacity to perceive and imagine, skills deemed essential for the advancement of new art.

The centrality of perception and imagination, otherwise known as creativity, to the production of art became the cornerstone of avant-garde discourse and progressive pedagogies.[2] The Bauhaus, established in 1919, was the most notable art and design school to grow out of, formalize and perpetuate these forces. Fundamentally resistant to received knowledge, Bauhaus thinking further shifted the art school model away from emulation of historical precedents towards a laboratory of experiment cultivated through individual and creative expression and the interrelation between media (Dickerman and Bergdoll 2009). The emergent disconnect between the production of art and its display was compounded by the fact that, for the most part, museums were slow to collect modernist art or foster relationships between their historical collections and practising artists. A reconciliation of this rupture between modern art, art school pedagogies and museums is offered by the philosophical view expressed through Alexander Dorner's exhibition displays. As the young director of the Landesmuseum in Hannover, Dorner formed close relationships with Bauhaus artists which lead to some of the first museum acquisitions of art and design by Lázló Maholy Nagy, Kasimir Malevich and El Lissitsky among others. While such examples of modernism had been conceived by working against historical precedents, Dorner constructed an episodic view of history where atmosphere rooms embodied the 'way of seeing' particular to each epoch.[3] This historical narrative culminated with El Lissitsky's *Abstract Cabinet* and was to be followed with Maholy Nagy's *Room of Our Time* consisting of filmic projects that would position the now as the heroic culmination of past perceptual models. These plans were quickly curtailed by the Nazi regime and in 1937 Dorner assumed the directorship of the RISD Museum, where he embarked on a radical makeover of the galleries. To stage his atmosphere rooms all traces of art instruction, from plaster casts to student work, were dispatched to the studios. Rather than display aesthetically isolated objects, Dorner's saturated environments sought to stimulate wonderment and awe, immersing the visitor in the imagined look and feel of a given period. Music, literature and gallery talks offered through an unprecedented audio programme sought to recreate the complex life-world in which the objects once operated. Rather than models of emulation, objects of art and design were actors in theatrical spaces that sought to provide 'an experience' particular to each evolving historical age.[4] While museums had long perpetuated a dual address where artists performed

2 See Thierry de Duve on the emergence of creativity within progress education and modernist discourse (de Duve, 1994).

3 On Alexander Dorner's career in Hannover see Joan Ockman, 'The road not taken: Alexander Dorner's *Way beyond Art*', in *Autonomy and Ideology: Positioning an Avant-Garde in America*, edited by R.E. Somol (New York: Monacelli Press, 1997), 80–120; and Samuel Cauman, *The Living Museum: Experience of an Art Historian and Museum Director – Alexander Dorner* (New York: New York University Press, 1958).

4 John Dewey's writings on art and experience had just been published in 1938. See *Experience and Education* (New York: Collier Books, 1963). His work was of particular

their learning in galleries witnessed by the public, for Dorner, every member of the public was creative and his affective galleries sought to embrace and encourage creative man through 'the developments of the human spirit in its most independent and liveliest object – in art' (Dorner 1927).

In the late sixties, such hermetic narratives reconciling the present with past became the source of scepticism, if not outrage, against the authority and inequalities embodied in museums. This was compounded by the infusion of critical theory and poststructuralist thought into art schools that drew discourse away from historical objects housed in outmoded institutions that appeared disconnected from studio practice and social issues. Museums associated with art schools were slow to embrace critique and fumbled their way toward cultural and social relevance. If the existing institutional apparatus could not accommodate other voices then allowing a contemporary artist to play curator presented itself as a remedy that would ideally oblige aspiring artists to consider the role of the museum in their practice through institutional critique. From this reasoning, Andy Warhol's *Raid the Icebox I* took form in 1969 and defied convention by allowing the artist to scour the RISD Museum's storage for his display, setting in motion the now ubiquitous practice of artist as curator 'mining the museum'.[5] Warhol's selection and arrangement of entire cabinets of shoes, Victorian umbrellas and Windsor chairs hung from the ceiling, Native American blankets and European paintings reflected his personal tastes while challenging display conventions. The latitude to shuffle the deck of history and embody novel ways of creating meaning remains in play today as an effective way to rupture master narratives and unmask institutional systems. The adoption of such curatorial and interpretive strategies has served to insert the artist's hand into the museum leading to operative ways to activate the gallery as a participatory space. While the resulting approaches vary widely in form and emphasis, the 'educational turn' of curatorial practice, pedagogy as artistic method, and relational aesthetics share an interest in the variety of meanings and experience constructed by the participant rather than then transmission of single authoritative interpretations.[6]

This episodic account suggests a gradual pedagogical pendulum swing from the authority of historical precedents that must be absorbed and mastered for the individual artist to succeed, to the agency of the individual over the past who must critique and defy it to innovate. Within this arc, the expectation for museum objects

interest to Dorner who later invited Dewey to write the introduction to his book *The Way beyond Art* (New York: New York University Press, 1958).

5 See *Raid the Icebox 1*, with Andy Warhol: An Exhibition Selected from Storage Vaults of the Museum of Art, Rhode Island School of Design, 1969; and Fred Wilson, *Mining the Museum: An Installation*, edited by Lisa Graziose Corrin (Baltimore: The Contemporary in cooperation with the New Press, 1994).

6 See for example Hans Ulrich Obrist, *Do It* (New York: e-flux/Revolver, 2005) and Paper Monument (ed.), *Draw It with Your Eyes Closed: The Art of the Art Assignment* (New York, n+1 Foundation, 2012).

in the training of artists and designers follows a causal model: if masterpieces are copied, then ideals will be perpetuated; if expert craftsmanship is understood, then innovation will occur; if the past is approached with imagination, then new forms can be created; if the past is a construction, then it can be deconstructed. Following the gambit from authority of the past over the producer in the present, to the autonomy of the individual to construct irrespective of the past, there appears to only be choices among points along this spectrum. But what if we were to see the education of artists and designers as a complex navigation through and across such models that are allowed to coexist within the museum?

What might this look like? Returning again to the galleries of the RISD Museum, one finds students copying from old-master paintings in a salon style gallery. By slowly decoding works of art through emulation, they are simultaneously in the company of makers past, physically standing in their place, gaining a sense of equal footing with their genealogy while also keeping company with the public, privy to the process of creation. In a display of twentieth-century art and design, discussion and debate connects painting, textiles, furniture and photography as students weave connections between media and technique, participating in critique and honing analytical skills. Elsewhere a student's textile design uses the process of dobby weaving to evoke the colours and pattern in an eighteenth-century Nō theatre costume – evidence of technical facility and an active working relationship running across and through coexisting past models. When new design is displayed in company with its precedent, the public can decode the historical work through a contemporary interpretation and likewise, unpack the contemporary through the past. Beside a ceramic amphora from 500 BCE, a student shares the process of fabrication with a child, pointing to constancy and change in ancient and contemporary fabrication. In good company with visitors of other generations and interests, the student becomes the teacher, simultaneously accruing and sharing their 'creative capital'.[7] Wandering further, the making of things keeps company with the making of situations that might be performative, participatory or pedagogical, puncturing decorum or permitting multiple interpretations to open up through a facilitated encounter between object and viewer in the co-creation of new meanings.

This 'dynamism of the creative process' Carol Becker imagines for the museums of the future becomes tangible when works art are interpreted in terms of the conditions of their making and the galleries in which they are situated

7 Bourdieu argued that the ability to decode a work of art was not shared by all and, as such, is a form of 'cultural capital' accumulated by some to the exclusion of others, an equality that museums perpetuate. See Pierre Bourdieu, *The Field of Cultural Production* (New York: Columbia University Press, 1993). Catherine Speight has recently demonstrated how design students need help interrogating objects and navigating museums much like other constituencies. See Catherine Speight, 'Museums and higher education: A new specialist services?', in *Museums and Design Education*, edited by Beth Cook (London: Ashgate, 2010).

become generative sites (Becker 2009). Artists and their publics experience and participate in the building of connections, between old and new, art and design, drawing and engraving, ideal representations and social media, etc. Sometimes these associations take form easily, other times they traverse a circuitous path to arrive at the unexpected and new. This space, unique to museums connected art schools, does not perpetuate a dual address that separates the artist from the public, but by addressing artists specifically, the public is asked to be likewise curious and creative and emerging artists and designers work in productive company with the public for whom they create.

References

Becker, C. 2009. Museums and the neutralization of culture: A response to Adorno, in C. Becker, *Thinking in Place*, London: Paradigm, 51. Dickerman, L. and Bergdoll, B. 2009. *Bauhaus: Workshops for Modernity*. New York: The Museum of Modern Art.

Dorner, A. 1927. Kunstmuseum und Publikum. Provinzialmuseum. *Hannoverscher Anzeiger*. Hannover, Germany. Quoted by I. Katenhusen. [Online]. Available at: http://www.aicgs.org/site/wp-content/uploads/2011/10/katenhusen.pdf [accessed: 29 January 2013].

de Duve, T. 1994 When form has become attitude – And beyond, in *The Artist and the Academy: Issues in Fine Art Education and the Wider Context*, edited by N. de Ville and S. Foster. Southampton, UK: John Hansard Gallery, 23. Lehman, J.W. 1997. Art museum schools: The rise and decline of a new institution in nineteenth-century America, in *The Cultivation of Artists in Nineteenth-Century America*, edited by G.B. Barnhill, D. Korzenik and C.F. Sloat. Worcester, MA: American Antiquarian Society, 207–18.

Marinetti, Filippo Tommaso. 1992. *The Foundation and Manifesto of Futurism* [1909], translated by R.W. Flint, reprinted in *Art in Theory: 1900–1990*, edited by Charles Harrison and Paul Wood. Oxford: Blackwell Publishers, 148.

Morris, W. 1901. *Hopes and Fears for Art*. New York: Longmans, Green, and Co, 20.

Reynolds, J. 1997. First Discourse, in *Discourses on Art*, edited by R.R. Wark. New Haven and London: Yale University Press, 15.

Rowe, E. 1917. The producer, the art student, and the museum, in *Proceedings of the American Association of Museums Vol. XI*, edited by Paul M. Rea. Cambridge, MA: Harvard University Press, 85.

Chapter 6
Curating Emerging Design Practice

Gareth Williams

New works of design that are performative, time-based, or otherwise ephemeral and unclassifiable are challenges to museum conventions: they are difficult to keep, hard to explain, and new works lack the critical distance of historical artefacts so our judgements of their quality is necessarily more subjective. Yet these circumstances present opportunities to reshape museums physically and intellectually, analogous to the way modernist art of the early and mid twentieth century directly gave rise to the white-box galleries that now house it. This essay looks at what happens when museums exhibit young student designers' works that may not fit into pre-existing typologies of design. It raises several key issues: do museums select and curate design works that reinforce their intact curatorial expectations and what do they do when they are faced with unconventional works? Is incorporation into the museum canon a legitimate learning outcome as part of a design education, or does it artificially skew the development of design practice towards certain types of exhibitable spectacle?

Future-oriented design students constantly reconfigure practice. Established conventions of industrial design, craft work, mass- or one-off production, and even newer fields such as computer-related or interaction design, rapidly seem inadequate terms to map new practices which sometimes subjugate the production of objects to the creation of experiences or events. Some practice disregards conventional modes of commercial production and consumption altogether: these designers are not interested in designing commodities for markets. Instead they are engaged with cultural activity and arguably their works are didactically better suited to museum presentation than for sale and use. Problematically, however, history-oriented museums still privilege objects and fixed collections of static artefacts. They are formulated around established taxonomies, and may have difficulty assimilating practice that does not conform to existing conventions or contexts. Therefore, in gaining access to the museological canon, emerging design practices present curatorial challenges.

I want to make an important distinction here. I am speaking of how museums treat works that have been created outside the museum context, rather than works that may arise from within museums as a result of collaborations with invited designers or HE. In this I am considering museums as collections of objects that are curated and interpreted together to tell narratives about culture, society and history, rather than an alternative view of museums that regards them as educational spaces or 'learning laboratories'. Digital and performative design

works may make a strong case for museums to act more as temporary exhibition venues or 'kunsthalle' and less as perpetual repositories of collections. But if this so, and museums do not acquire 'difficult' work for permanent collections, should we regard this as an abnegation of responsibility on their behalf? Furthermore, if museums collect conventional design objects (because they are easier to keep and to interpret) instead of more experimental and ambitious projects, do they create alternate canons of design that do not adequately or accurately describe the actual innovations being made by experimental designers? In this scenario, museum collections could only tell a biased and self-serving version of history.

What is the role of HE in this? The best design education exists to hone the critical and creative skills of designers, to better fit them for the challenges of shaping the world of the future. As spaces for research and reflection, HE courses are essential places for designers to develop speculative design practices unfettered by commercial pressures and constraints. For this reason, much of the most forward-looking and challenging work arises directly from design education rather than from commercial studios. In a sense, HE provides the *content*, while museums give the *context* where design ideas can be considered, interpreted and evaluated. Displaying their work in museums gives designers a platform to share their ideas with broad non-specialist audiences as well as with like-minded communities. This is a valuable opportunity but the dangers are twofold. One risk is that designers may cease to design critically and speculatively, but keep one eye on whether the work may be picked up by a museum. In the 2000s the glut of stylized limited edition design works that composed the 'design art' boom was very much connected to the sensibilities of the Design Academy in Eindhoven where many of the leading designers of that moment had studied, and earned criticism of the school for training 'star designers'.

The other risk is that museums may only treat new design practices as novelties, as we will see with the examples that follow. Museums generally consider industrial design as an agent of progress and in this sense design has been regarded as part of the story of the modern period. Finished, market-ready goods are usually collected and those in box-fresh condition are privileged. Exclusive or advanced design and products are favoured over collections of everyday goods that are generally confined to stories of social history rather than design. The larger or more in-depth design collections may also collect prototypes, drawings, models and other paraphernalia of the design process, and here the subject focus shifts from the social or economic role of the object to an exploration of the creative process of the designers or manufacturers. In the context of these curatorial prerogatives new practice may seem decidedly odd.

In order to think through these issues in some depth I intend to talk about two recent student projects, one a machine to draw self-portraits and the other a handmade simulacrum of a cheap electric toaster. Neither project fits into the ways in which design is generally represented in museums. Both projects are *about* industrial design and mass production, but neither is a typical result *of* this system. They are commentaries, open to artistic interpretation as well as critical

judgement. In their original educational contexts they existed to demonstrate the students' command of their subject: their subsequent displays in public museums subtly transforms their meaning and purpose.

The Self-Portrait Machine

The Self-Portrait Machine by Jen Hui Liao (born in Taiwan, 1982) was designed and made in 2009 when he was a second-year MA student in the Design Products Department at the Royal College of Art.

Figure 6.1 Jen Hui Liao, *The Self-Portrait Machine*, variable dimensions, mixed media (© Royal College of Art 2009)

The designer was inspired by footage of factory conditions in contemporary China where workers appeared subjugated to the machines they operated, and by portraits drawn by Shanghai street artists that represent the most anonymous and mechanical production of art.

The Shanghai portraitists, their subjects and the Chinese factory workers are compromised by, and integrated into, the mechanized world. Factory production and the nature of self-identity, therefore, informed Jen Hui Liao's *Self-Portrait Machine*, a performative device that creates a symbiotic relationship between sitter and machine where both parties together create the sitter's self-portrait. Through

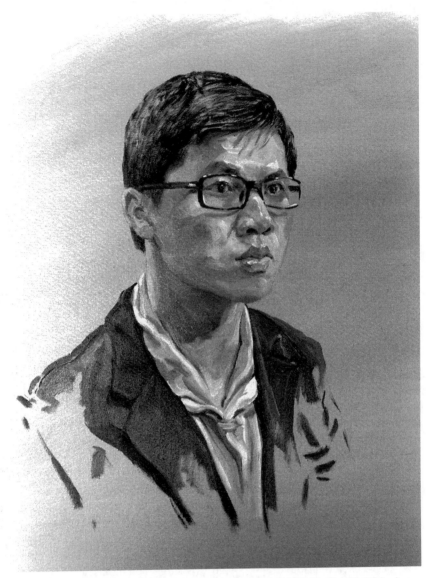

Figure 6.2 Unknown street artist, *Jen Hui Liao*, 2008 (© Jen Hui Liao)

it we can examine the discourses of industrial design and production as well as consider the nature of artistic production and the expression of human identity.

The device looks like a piece of laboratory or medical equipment, or a highly specialized and finely tuned industrial tool (which, indeed, it is). The mood is not altogether benign, but suggests a laboratory experiment, or a medical examination, neither of which are the traditional sites of artistic creation.

Curating Emerging Design Practice 95

The Self-Portrait Machine is time-based and requires a performance: it can only be fully understood by operating it. In order for this to happen the subject, or artist, must consent to be bound to two robotic arms: like workers in factories, human and machine become one. At a cue, the lights flare and a camera fixed across the desk takes a digital image of the sitter. *The Self-Portrait Machine* draws our portrait in public as a spectacle. The sitter is laid bare as the mechanized image equates to his or her mirrored self-image.

With a mix of off-the-peg, customised and self-written software, Jen Hui Liao's machine captures the image of the sitter's face, simplifies it into two tones, and operates the motions of the robotic arms in broad, smooth diagonal sweeps across the paper, lowering the artist's hand to press the pen to paper in the areas that need colouring, and raising it to pass over the blank areas. The sitter is utterly

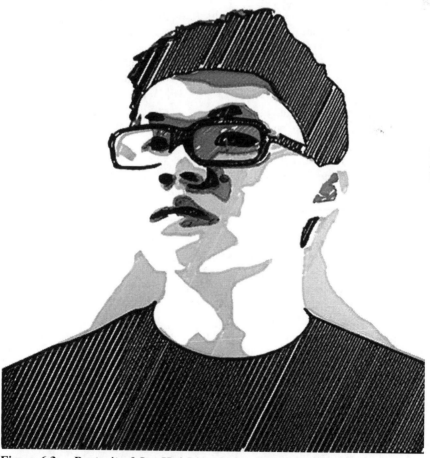

Figure 6.3 Portrait of Jen Hui Liao drawn by *The Self-Portrait Machine*, ink on paper, 2009 (© Jen Hui Liao 2009)

subjugated to the machine that is creating his or her self-image. Yet the machine cannot draw the portrait without the cooperation of the sitter, who has volunteered their image and now holds the pens.

Once the portrait has been drawn, which can take several minutes, the machine signs its signature, Geppetto, the father of Pinocchio and the famous maker of puppets who sought, above all else, their humanity.

The portraits necessarily look machine-made and share with Andy Warhol's silk-screen portraits (and more recent portraits painted by Julian Opie) a bold, garish, Pop Art simplification of the human face. *The Self-Portrait Machine* is a complex work referring to the nature of mechanical production in general and particularly of art, and the creation and presentation of self-identity. Crucially, it is performative in the sense that it only gains meaning as it performs its task of portraiture as a public spectacle. The curatorial challenge is to contextualize and interpret it. For a start, what part of this process constitutes the work and where is its focus? Is *The Self-Portrait Machine* itself the 'object'? Or should we privilege the artworks and regard the machine as just the specialist tool to create them? Are the Shanghai portraits and films of Chinese workers part of the work, or part of its design process? Is this work part of art history, or a commentary on science and technology? Is it a media device, a sculpture, a performance piece, an example of advanced product design, a robot, or an artistic representation of any or all of these? Ultimately we should also see the subject of this project as Jen Hui Liao himself, and the machine and its works constituting a portrait of his own sense of self-identity.

One way to consider how to interpret this work is to think about how its environment affects it. To date *The Self-Portrait Machine* has been presented publically several times relatively briefly. On each occasion it has been to a lesser or greater degree curated and has been subject to the curatorial imperatives of its site. As the designer's graduation project, it was regarded as a virtuoso demonstration of his technical and philosophical mastery of his subject, design, presented to a learned public. The Shanghai portraits and films of Chinese factories accompanied it and gave context. Installed with the machine they showed how Jen Hui Liao had both constructed and answered his research question. In no way was the machine proposed as an industrial prototype. Instead it was an experiential commentary on social and technological issues arising from studying industrial design.

Its next appearance was at the Victoria and Albert Museum where it was presented as a performance for one evening accompanying the museum's exhibition of digital design, Decode in February 2010 (it was not included in the exhibition itself). Liberated from both educational and industrial design contexts, and even the exhibition context of the Decode exhibition proper, the machine was installed in the sculpture gallery surrounded by English eighteenth-century portrait busts, where its industrial aesthetic and mechanical Pop Art portraits contrasted sharply with refined classicism. Importantly it was shown without the Shanghai portraits or Chinese factory films. Now it was arguably a novelty attraction and the lack of design discourse context contributed to the stripping away of meaning. Without

adequate interpretation much performative, time-based, interactive digital art and design work like this can appear gimmicky and ephemeral in museum settings.

The machine featured in HotelRCA, a group show of RCA students and alumni in Milan during the annual furniture fair (April 2010) where, in the broader context of the furniture fair, the machine can be regarded as an experimental cultural design exercise when compared to the largely commercial and industrial content of a trade show. (That said, the Milan event is so much more than a trade fair and has long been an arena for the exploration of advanced design ideas.) Other presentations focused on the designer's process, such as its inclusion as an illustrated lecture in the London Digital Design Week in September 2009.

Jen Hui Liao's ambition is to display his work in a portrait gallery (such as the National Portrait Gallery in London) where the machine itself would be secondary to the portraits it drew. In this context no longer would the work be about the mechanical process, or the symbiotic relationship between artist, machine and subject, but about the process of drawing, and quite specifically the particularities of creating portrait images as signs of individual identity.

The Toaster Project

When museums display industrial design they have a tendency to fetishize their design qualities by decontextualizing the objects.[1] Thomas Thwaites's *Toaster Project*, however, explored the design and production of electrical products from an entirely different perspective. It was all about the context. Thwaites (who graduated from the RCA Design Interactions department in 2009), sought to replicate from scratch a £3.99 Argos toaster, mining the materials and making the components himself. The aim of his project was to remind us of the complexities of everyday ubiquitous products we take for granted, both in terms of their own physical presence and the economic and industrial complexes that produce them, and to emphasize the utterly unbalanced value we place on some resources.

Thwaites meticulously recorded his process in various media, including an online blog and in film. His quest for materials such as iron, mica, copper and plastic led him to disused mines and to numerous experts for advice. He also had recourse to ingenious ways of replicating large-scale industrial processes, quite literally in his own backyard or kitchen, for example by smelting iron ore in a domestic microwave oven. Throughout the process the futility and poignancy

1 For example, the exhibition of products by the great German designer Dieter Rams, held at the Design Museum, London (18 November 2009 – 9 March 2010), displayed his projectors, radios, record players and other electrical devices designed for the manufacturer Braun, in precise arrangements, but omitted references to their users, explanations of their obsolete functions, and even the messy power leads that would have once powered them.

of his determination to make his own version of a low-cost appliance is both apparent and the point of his quest. His films add a performative quality to the project, and also affect its focus, as the project is largely a portrait of the indefatigable Thwaites himself.

In its educational context the Toaster Project both dramatized and recorded the learning of the student designer and his understanding of the theoretical context for his work. His faux-naivety was a mechanism for him to challenge the precepts of mass production, and his quest to make the toaster tested and demonstrated his tenacity and ability to find creative solutions to problems. Of work by his students, Thwaites's head of department, Professor Tony Dunne, commented:

> It amazes me how much debate and discussion they generate beyond academia. I can't think of any other profession where MA work feeds so directly into the formation of disciplinary discourse. Which is great. On the one hand it is testament to the quality of the student work that comes out of the RCA across disciplines, but on the other, it says something about the profession that most debate about new ideas and thinking in design happens at the student level.
> (T. Dunne, email correspondence with the author 2 February 2012)

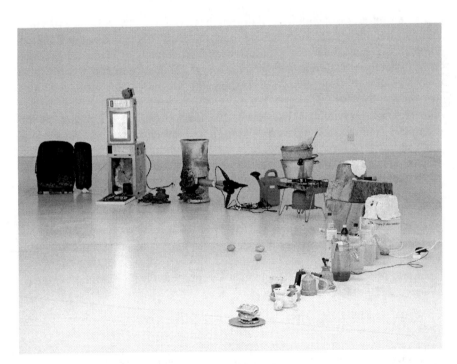

Figure 6.4 Thomas Thwaites, *The Toaster Project*, mixed media, variable dimensions (© Nick Ballon 2009)

Perhaps the privileged space afforded by HE, where pure research can take place beyond the reach of commercial imperatives, underpins why it is the best place for innovative design thinking: arguably the privileged spaces of museums act in similar ways.

In contrast to the mint condition generally desired of industrial products in museum collections, Thwaites's toaster never functioned, and was seriously compromised. After all, he was not setting out to design an improved prototype for industrial production and he described his toaster as 'a very imperfect likeness to the ones that we buy – a kind of half-baked, hand made pastiche of a consumer appliance' (T. Thwaites, RCA Design Interactions department, 2009).

In his degree show Thwaites exhibited the final toaster alongside the equipment he made to create it, and his films, displayed roughly chronologically. It is important to acknowledge the work as a composite of all its parts, and the final version of the toaster is a component, not a summation. This work is a collection, not a single object. Since its first appearance at the RCA, the longest exhibition of the *Toaster Project* to date has been in an exhibition titled 'Ten Climate Stories' at the Science Museum, London (20 January 2011 – 28 September 2012). This took the form of a series of interventions into existing displays of the permanent collection, ostensibly all concerned with the threats posed by climate change. On one level Thwaites's project is about over-production, a root cause of climate change, but climate change per se is not the project's subject. He found his project placed alongside none other than Stephenson's Rocket in the heart of the Making the Modern World Gallery. This gallery celebrates milestones of technological development that together created the system of over-production and consumption that Thwaites is critiquing, and of which his toaster could be read as the awful summation, but this was not apparent in the display. The *Toaster Project* was shown in more or less the same way as in Thwaites's degree show with no additional interpretation. Its nature as a composite of peculiar archival fragments works against its comprehension in the context of a gallery of discrete objects, as it requires considerably more consideration and thought to decipher. Furthermore, and crucially, as a simulation of industrial processes to create what is in effect a model of a toaster, the exhibit subverts and questions the authenticity of the industrial archaeology surrounding it, but again this was not the avowed intention of exhibiting it. On the other hand the Toaster Project is arguably more authentic than the highly conserved and decontextualized, even fetishized icons of technology like the Rocket as its matter and manner are entirely and honestly derived from its mode of production and purpose.

The Ten Climate Stories display was initiated as part of the Science Museum's Contemporary Art Programme that seeks to enrich the dialogue with visitors by introducing art alongside the science and technology exhibits. Hannah Redler, Head of Arts Projects, conceded that 'Although I appreciate Thwaites probably categorizes himself more within the critical design canon, for me his original concept, sustained involvement and the visceral qualities of the finished product

make it sit comfortably in the role as an art work.' She observes that the museum contains many difficult objects 'from human remains to live text-based data whose protocols will die one day', but 'the sort of questions I would ask around collecting an object like this would surround our ability and opportunities to continue to display it in ways which are true to the spirit of the idea and its outcomes' (H. Redler, email correspondence with the author 2012).

Thwaites succeeded in penetrating to the heart of the Science Museum, but only temporarily and only if his project could be interpreted as art, not design.

The *Toaster Project* has also been displayed in various international gallery settings in Lancaster, Dublin, Rotterdam and Tokyo, most often in galleries dedicated to science and technology rather than to art and design. It occupies a middle ground between all these disciplines. It is about science, technology and design but does not stand alone as an example of any of these. It is a commentary upon the realities of industrial production without being industrially produced. I am inclined to think it is most successful as a media event and to think of the core of the project being the films documenting Thwaites's process, rather than the lumpy malfunctioning outcome. It is as if the awful toaster Thwaites managed to make is intentionally a weak simulacrum of the real thing. It necessarily must be so, in order to create the sense of critical distance from the ubiquitous original artefact and all the issues surrounding its production and use. As Baudrillard observed, simulations prove the power of their opposite.

Conclusion

These examples have many similarities and curatorial problems. Both comprise relatively large-scale multimedia installations, two- and three-dimensional documentary archives, and delicate mechanisms. Both are digital and analogue, and have performative and ephemeral aspects. Both projects require considerable contextualization and explanation to make sense. Both projects are *about* industrial design but are not *of* it and are commentaries upon its nature. They were both conceived and executed to demonstrate mastery of design thinking and understanding of the technical processes and parameters of industrial design, not first and foremost as museum exhibits. Both projects have in-built weaknesses that compromise their longevity. For *The Self-Portrait Machine* it is the inevitable obsolescence of its software, coupled with the volatility of the inks and papers used for the portraits that will lead to their inexorable degradation. Meeting no agreed standard for production, Thwaites's toaster (and the associated tools that made it) is already past the state of self-destruction normally applied to museum collection objects, and will only degrade further, as the homemade synthetic compounds within it act upon one another. In the museum setting these are serious issues, and collecting policies may conspire against objects with in-built obsolescence and self-destruction.

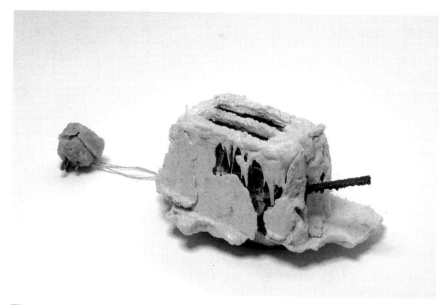

Figure 6.5 Thomas Thwaites, toaster from *The Toaster Project* (© Daniel Alexander 2009)

Perhaps the only reasonable curatorial response is to host these works as temporary insurgents into the academy, but this inevitably makes it more difficult to consider them with the critical distance and depth of objects permanently accepted into the canon of design and collecting. As I have shown, the danger is that they are presented as conceptual art installations or even as novelties, rather than within the context of design discourse where they are most meaningful. This is deeply regretful as both works clearly have lasting resonance and significance.

The various presentations of the *Toaster Project* and *The Self-Portrait Machine*, from degree show exhibitions to national museums, show how the curatorial context changes our understanding of the design work. These are examples of complex speculative consideration of design issues, embodied in nuanced works primarily created as demonstrations of design excellence in an educational context. As such they require sensitive and informed interpretation in order to bring them coherently to broader publics in museum settings. Just as museums are sequestered, privileged spaces, so too these works exist beyond and above the normative; they are fantasies that comment upon it. Museums need more resilient exhibition strategies that embrace the performative, transitory and ephemeral qualities of much experimental work emerging from HE, acknowledging their complexity and contextual requirements. Perhaps there is scope for closer collaboration between the sectors in how experimental work is displayed and interpreted that may be fruitful for all parties.

Chapter 7

Artist-Led Curatorial Practice: Mediating Knowledge, Experience and Opinion

Tracy Mackenna and Edwin Janssen

Museums and Us

As artists and educators our engagement with museums takes many guises: as visitors, exhibitors and as those commissioned to explore collections and institutions. Our involvement with a museum is often the result of a request to make an artefact or a collection more accessible to the public, when it has become inaccessible either through rarity, a fixed approach to presentation, or an inability to adapt to new contexts. We are motivated to re-present historical artefacts, through a series of actions that lead to their re-contextualization, and new proposals for their organization. We take the repositioning of collections, museum practices and even the institution as a starting point, in order to broker connections with expanded and new audiences. Craig Richardson has described our motivation so, 'visibility, even where it may only be the transcription of the spoken to the textual, is a central political aim of their work ...' (Richardson 2007).

Artist-Led Interventions

During 15 years of collaborative working we have devised a series of artist-led interventions and interpretations in partnership with museums and our university (the University of Dundee, Scotland, which incorporates Duncan of Jordanstone College of Art and Design) including *Ed and Ellis in Schiedam*,[1] with the Stedelijk Museum Schiedam, the Netherlands, as part of which we established the political party *Lijst 0* to investigate the museum's relationship with its changing audience and its position within the town council's development strategy.

1 *Ed and Ellis in Schiedam*, Stedelijk Museum Schiedam and the streets of Schiedam, the Netherlands, 1998. The museum's core collection is of Dutch art since 1945, including works from the CoBrA group. Its additional main collection is Cultural History, and it also presents temporary exhibitions of contemporary art. http://www.mackenna-and-janssen.net.

Figure 7.1 *Ed and Ellis in Schiedam.* Stedelijk Museum Schiedam and the streets of Schiedam, the Netherlands. Detail showing the alderman for culture announcing the election results in Lijst 0's headquarters, in the Stedelijk Museum Schiedam (© Tracy Mackenna and Edwin Janssen 1998)

Figure 7.2 Shotgun Wedding, Scottish National Portrait Gallery, Edinburgh. Detail showing one of six video projections, 300 × 400 cm each, duration 20:00 each (© Tracy Mackenna and Edwin Janssen 2007)

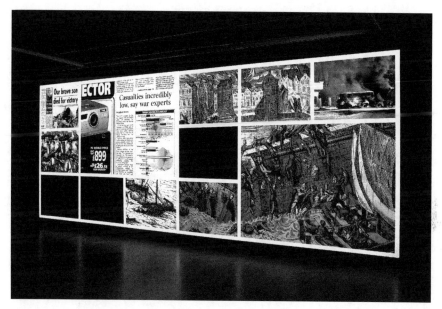

Figure 7.3 *WAR AS EVER!*, Tracy Mackenna and Edwin Janssen. Nederlands Fotomuseum in collaboration with the Atlas Van Stolk, Rotterdam, 2012. Detail showing the slide projection *WAR AS EVER!: Eighty Years and One Day*, made up of a selection of prints from the Van Kittensteyn album and newspaper excerpts reporting the Iraq war, bought on 1 April 2003, the day the artists' daughter was born (© Tracy Mackenna and Edwin Janssen 2012)

In *Shotgun Wedding* at The Scottish National Portrait Gallery (Edinburgh 2007), we reproduced material of varied cultural standing from several European collections through the medium of video to create six films that explored the Union of 1707 between Scotland and England.

The recent multifaceted project *WAR AS EVER!* (Rotterdam 2012) was the result of an invitation from the Atlas Van Stolk, part of Rotterdam's historical museum, to make one unique artefact in its collection, the Van Kittensteyn album, accessible to a broader audience.

Through a process of visual interpretation and photographic re-presentation we explored similarities between historical and current political and religious conflicts leading to the repositioning of the collection in a contemporary perspective and its presentation in a museum distinct in nature to that of the historical museum, the Nederlands Fotomuseum in Rotterdam. The coming together of the two museums was negotiated by the artists. Closer to home, in *On Growth, & Forms of Meaning*, (Dundee 2011) elements of The D'Arcy Thompson Zoology Museum collection in Dundee were re-curated, re-situated and re-presented to occupy a specially

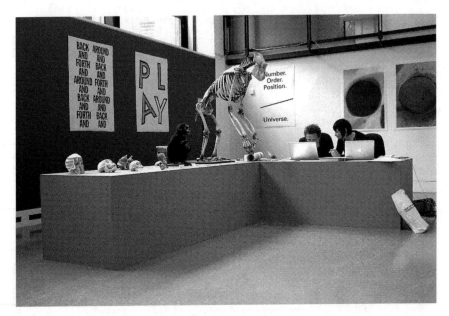

Figure 7.4 On Growth, & Forms of Meaning, Tracy Mackenna and Edwin Janssen. Centrespace, Visual Research Centre, Duncan of Jordanstone College of Art and Design, University of Dundee, Scotland, 2011. In collaboration with The D'Arcy Thompson Zoology Museum, University of Dundee. Public studio for presentation, exchange and production. (© Tracy Mackenna and Edwin Janssen 2011)

designed hybrid environment for the interrogation and analysis of a subject within a multidisciplinary framework.

Progressive Approach to Curation

As artists we value museums as both the cornerstone and sparring partner of our practice, and are acutely aware of the complexities of museum practice. We focus on experimenting in a way which gives an immediate and visible alternative narrative or interpretation of a particular exhibit or collection. We use different approaches to change the interpretation, but changing the way the space is used by using technology for example, and more ephemeral forms of display, where work evolves in public over long periods, offers the viewer and participant many different points of access and re-access.

One central aim is to significantly enrich the visitors' experience by opening up the making process that in a standard museum context is closed off. Ideally, the process becomes shared between artists and visitors, offering insight into the way

we think and work as artists, our ideas about the potential of art in contemporary society, to be able to respond to and be affected by interaction with visitors and participants. Experience has taught us that museums struggle to know how to position what it perceives as the 'educational' component of our work in relation to its own definitions of education, and the museum's positioning of its own educational activities.

This art practice, when regarded as a prototype, offers institutions the possibility of promoting exchange and collaboration between disciplines, institutions and people. For the art college, it can expand the sites and contexts for learning, permitting the artist to become an inter-institutional mediator and cultural agent. This enables students, the artists of the future, to connect with and reflect on the world beyond their own private creative space by improving their understanding of the forces at play when considering museum politics, and the museum as a key site for presenting and creating cultural narratives.

We regard the museum as a versatile and creative site for exploring culture and therefore expect that the relationship between the museum and art education should be challenged on an ongoing basis. We are of a generation that have grown up using the museum as a primary site for the understanding of culture and communication of cultural positioning. Our work in HE across Britain and continental Europe demonstrates to us that increasingly students no longer regard the museum as a natural destination and source of first-hand visual material and knowledge. Within HE art education we encounter disengagement with the museum site's representation of culture, and a strong division in the way universities and museums work, stemming in part from their differing educational aims. The museum is a vital site for learning, yet a visit with students can have little impact on them, its success heavily dependent on mediation. As artists we are an active audience who benefit from what museums have to offer, and on a smaller scale within the arena of our practice, we incorporate those gains to publicly explore histories and the state of our human existence.

Museums appear to be losing authority over the presentation of commonly owned historical and cultural narratives, amidst the proliferation of alternative platforms including virtual sites and online projects, and the rise of social media as an apparently democratic organ for comment and contribution. They appear slow to demonstrate a re-articulation of the importance of humankind's fetishist relationship with 'stuff'. As Daniel Miller has commented, 'We live today in a world of ever more stuff ... possessions often remain profound and usually the closer our relationships are with objects, the closer our relationships are with people' (Miller 2009: 1). Museums are inherently bound by conservation concerns and the requirement to address audiences' demands for re-imagined displays and exhibitions. In societies embracing new and faster modes of communication and consumption, museums are expected by their audiences to reconsider the public's desires for new modes of engagement, which may also reinvigorate the institution.

Hosting the Museum

This chapter explores a specific intervention into museum collections and a university gallery that aimed to question the identity and function of the gallery and museum exhibition today.

In *Life is Over! if you want it* (Dundee 2009) notions of collecting were played out by removing historical artworks from their collections and repositioning them in an exhibition environment designed to stimulate a series of interactions around a specific subject in an educational setting.

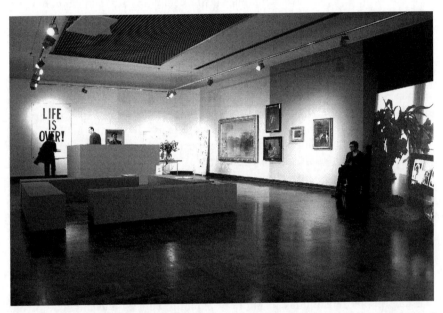

Figure 7.5 *LIFE IS OVER! if you want it.* **Cooper Gallery, Duncan of Jordanstone College of Art and Design, University of Dundee. Detail showing projections, wall drawings, historical artworks, public studio for presentation, exchange and production (© Tracy Mackenna and Edwin Janssen 2009)**

An array of artistic acts and gestures invited the public to co-investigate the subject matter through their own engagement and contributions, blurring the boundaries between artists and audience. The project's key issues were developed collectively in the real time of the project's duration.

The project evolved out of an existing collaborative art practice between the authors. This art practice is in itself an environment that enables us to explore key issues of existence such as life and death, through art making, teaching, research and public discourse. As creators and collectors of stuff and experiences, we invite contribution and actively build partnerships with

the museum sector, motivated to examine the stuff of life, investigating the everyday through art. The projects adapt to their own developing dynamics, curating circumstances in order to open up common subject matters through their contextualization within appropriated forms of museum practice and by sharing within carefully designed environments that encourage change through intervention.

Edwin Janssen's personal need to examine his experience of his father's assisted suicide formed the basis for *Life is Over! if you want it*, which took place in the public gallery of the art college we both work in. It was the first in an ongoing exploration of the role that art can play in mediating issues of life and death, and loss.

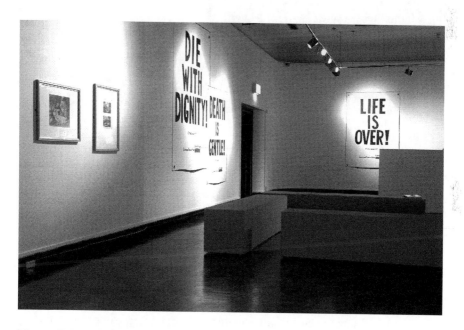

Figure 7.6 *LIFE IS OVER! if you want it.* **Cooper Gallery, Duncan of Jordanstone College of Art and Design, University of Dundee. Detail showing projections, wall drawings, historical artworks, public studio for presentation, exchange and production (© Tracy Mackenna and Edwin Janssen 2009)**

A large-scale double-screen slide projection occupied a central position in the exhibition, sited immediately opposite the entrance to the main gallery space. Each screen was 210 × 280 cm, showing a five-minute looped projection. *Life, Death and Beauty: The Invisible Looks Back – Fear, No Fear* comprised two elements.

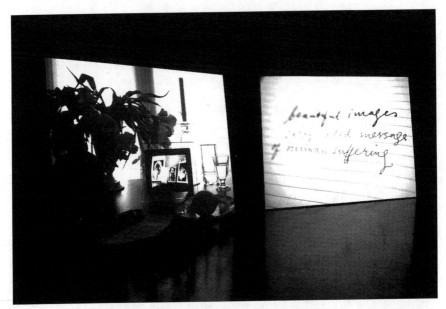

Figure 7.7 *LIFE IS OVER! if you want it*, Tracy Mackenna and Edwin Janssen. Cooper Gallery, Duncan of Jordanstone College of Art and Design, University of Dundee, 2009. Detail showing *Life, Death and Beauty: The Invisible Talk Back – Fear, No Fear*. Double-screen projection, 210 × 280 cm each, duration 05:00 (© Tracy Mackenna and Edwin Janssen 2009)

One was complete at the start of the project: a still-life of a table surface holding a collection of objects and a series of photographs that changed sequentially within a photographic frame. These photographs presented a collection, made by Edwin in the transitional period when his parents' house became uninhabited, slumbering and the composition of each room suspended.

The second screen, the still-life's partner, was blank at the opening, and came into being incrementally, to be completed at the project's end. Tracy Mackenna, present throughout in a public studio, explored the different registers that might be possible in response to the work of art and the subject matter through conversation with visitors. In response, she wrote a series of texts that were projected daily as notebook pages, each revealed the merging of her words with those of her conversationalists. The conversations and scripted events redefined the value of the images in the exhibition environment, creating new and changing perspectives on them.

Irit Rogoff asserts that artists' focus on the importance of conversation in art, whether formal or informal, is 'the most significant shift within the art world over the past decade' (Rogoff 2010b: 43). The presence of the actual historical works on site acted as physical references, real artworks framing and contextualizing a set

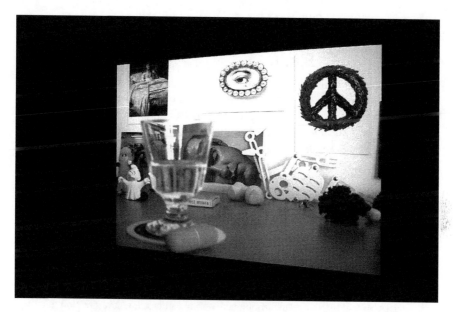

Figure 7.8 *LIFE IS OVER! if you want it*, Tracy Mackenna and Edwin Janssen. Cooper Gallery, Duncan of Jordanstone College of Art and Design, University of Dundee, 2009. Detail showing *Life, Death and Beauty: Where Darwin Meets Courbet*. Single screen projection, 210 × 280 cm, duration 10:00 (© Tracy Mackenna and Edwin Janssen 2009)

of conversations enacted between disciplines and publics. These objects embodied the action and materiality of the making process contributing to the definition of the gallery's atmosphere and thereby affecting discussion of the project's key issues, in contrast to the inert state of an image referred to through reproduction. Directly facing the entrance to the gallery (an ante-gallery to the main gallery), *Life, Death and Beauty: Where Darwin Meets Courbet*, the 210 × 280 cm projected display showed 48 compositions in a 10-minute loop. It consisted of the artists' personal collection of historical and contemporary art in reproduction (postcards, drawings) and objects on the theme of life, death and beauty, assembled in the artists' studio during the research and production phases, revealing the collecting of material stuff as vital to the research process. The slides proposed a particular reading of the material through photographic framing; 'an art history without text' (Warburg).

Personal collections, and the organization of material within a frame of domestic space were proposed by John Berger as a valid alternative to a museum (Berger 1972). Scrutinized through photography and film, this collection presented a different thematic interpretation to that of a museum. Our private imaginary museum revealed the evolutionary process of researching into a subject through practice. Andrea Phillips, when writing on the ethics of practice in relation to a

'rearrangement of institutional pedagogy' talks of practice-based research as an ideal way of working:

> one that describes what artists do anyway and allows them to do it to profitable effect between galleries and education systems. Practice-based research allows for the recognition and further articulation of art as a process of knowledge production and transfer which can and does access a whole range of practices as well as those traditionally defined as artistic, influencing and being influenced by them to broad social and creative effect.
> (Phillips 2010: 91)

For each new person entering the space, a different priming process was devised by the artists, which took the form of a conversation, enabling visitors to know what to expect, in order for them to feel they could participate; a passage eased by the artists with consideration of Paulo Freire's comments on the power of the transformative:

> To surmount the situation of oppression, men must first critically recognize its causes, so that through transforming action they can create a new situation, one which makes possible the pursuit of a fuller humanity. But the struggle to be more fully human has already begun in the authentic struggle to transform the situation.
> (Freire 2001: 31–2)

In the space between conversation, presentation and presented writing, persistent public note-making (Benjamin 1928) became a performative tool enabling both artists to investigate in real time, while consciously excluding social media's ability to spread remotely.

The Artist-Educators

In our work as artists who are educators, we strive for a more active approach, a public 'cultural recycling' through art practice, whereby not only appropriate objects, artefacts or existing images are presented but where the creation of environments in which works can be given new meaning can lead to transformative experiences, through the sharing of knowledge. Miwon Kwon has noted that 'the distinguishing characteristic of today's site-oriented art is the way in which the art work's relationship to the actuality of a location (as site) and the social conditions of the institutional frame (as site) are subordinate to a *discursively* determined site that is delineated as a field of knowledge, intellectual exchange, or cultural debate' (original emphasis, Kwon 2004: 26). Our aim as educators is to give prominent place to the voices of those who are being educated, by enabling learning through action, helping students to develop skills by guiding them through a process that facilitates their own shaping of the investigation of their interests.

Art education provides society's newest professional cultural producers who will contribute to the future museum's holdings. For the institution to provide students with the richest, most enduring experience and to best equip them to enter professional domains, Eilean Hooper-Greenhill's observations are central to our work:

> The concept of 'education' has been deepened and widened, as it has been acknowledged that teaching and learning is not limited to formal institutions but takes place throughout life, in countless informal locations. Formal educational processes are only a small, and not always very effective, part of those learning processes that are necessary throughout life, and which involve both the acquisition of new knowledge and experience, and also the use of existing skills and knowledge. A focus on enabling learning has led to an interest in the ways in which individuals make their experience of formal and informal learning personally meaningful and relevant. The focus on personal interpretation opens up issues of identity and culture.
>
> (Hooper-Greenhill 2006: 2)

Figure 7.9 *LIFE IS OVER! if you want it*, **Tracy Mackenna and Edwin Janssen. Cooper Gallery, Duncan of Jordanstone College of Art and Design, University of Dundee, 2009. Detail showing Master of Fine Art students' project** *Exquisite Corpse; a Contemporary Unfolding* **(© Tracy Mackenna and Edwin Janssen 2009)**

While we see teaching as an essential component of being artists, the projects we design and curate are also platforms for learning, offered to students as a way to actively consider key aspects of contemporary art practice. In this specific example, students were given the entire project as a platform from which to create and critique. Led by a PhD student, the Master of Fine Art group devised a collaborative occupation of the site *Exquisite Corpse; a Contemporary Unfolding*, where over the course of 24 hours we, the artists, were invited at intervals to interact with a range of performative situations in which we responded to instruction, such as one-to-one recitals, and by wrapping an emerging, collectively made 'body' with tape.

Subsequent tutorials referred back to that collective experience, binding the group and its shared issues. Crucially, the students were able to affect their peer groups from the heart of the situation we had created, in ways that we could not, by exploring their individual experiences and issues of loss through collective practice, in a time period that they had decided, framed by a historical art perspective in a public environment. The students' intervention sat within the broader framework of the programme of public events presented across the project's duration and located within the gallery, aligning presentation and education where they are normally separated within the museum.

Colleagues and students were invited to present and test their own related ideas on this platform. These included a multidisciplinary symposium that asked what

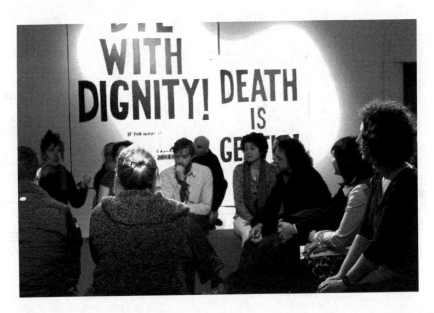

Figure 7.10 *LIFE IS OVER! if you want it*. Cooper Gallery, Duncan of Jordanstone College of Art and Design, University of Dundee. Detail showing discursive event with Lucy Byatt and the artists, and wall drawings (© Tracy Mackenna and Edwin Janssen 2009)

role art can play in mediating issues around life and death and a seminar focusing on the relationship between place, architecture and suicide. Other related events were an artists' talk that interrogated contemporary art practice as a site for production, social engagement and reflection and a discussion on artists' perspectives on mortality, between the artists and Lucy Byatt, Head of National Programmes at The Contemporary Art Society whose activities include the purchasing of significant works of contemporary art to give to public collections in the UK.

Exhibition as Process

The normal conventions of gallery and museum sites are increasingly open to interrogation and intervention by contemporary artists, acting as makers, curators, directors and sleuths. The structure devised for *Life is Over! if you want it* allowed us to develop and tamper with exhibition typologies. The conjunction of differing modes – the presentation of the art object, making, conversation and staged events – *made* reality in the site of the exhibition project, rather than merely representing it. Heeding what John Dewey has articulated as a conscious relationship between what is presented and how, in anticipation of the visitor:

> Because perception of relationship between what is done and what is undergone constitutes the work of intelligence, and because the artist is controlled in the process of his work by his grasp of the connection between what he has already done and what he is to do next, the idea that the artist does not think as intently and penetratingly as a scientific inquirer is absurd.
>
> (Dewey 2005: 47)

– a fluid, playful approach freed up elements of the display to be activated and altered by a range of participants, many of whom made multiple visits, together building a shared story in real time.

Amongst the exhibition project's range of production forms, and in distinction to the framed, borrowed historical works, projection technology served to explore the evolving relationship between imagery, narrative and truth. Distinct from the reading required of a small scale work, as the biggest objects the projections required the visitor to engage their whole body in the reading of the changing images, crossing between the screens to capture detail. Each projection displayed a series of slides that formed infinite circular narratives, exploring the fragmentation of time, metanarrative and image.

Negotiating Curation

Continuing the use of curatorial strategies employed since the inception of our collaborative practice, we acted as commissioners of our own work, with partners

Figure 7.11 *LIFE IS OVER! if you want it*. **Cooper Gallery, Duncan of Jordanstone College of Art and Design, University of Dundee, 2009. Detail showing public studio for presentation, exchange and production, with historical artworks (© Tracy Mackenna and Edwin Janssen 2009)**

whose modes of operation resonated with the multiple roles we inhabit, in a location that would enable us to foster intense and sustained engagement. We would assert that our responsibility is to merge art practice with academic roles, opening ourselves for scrutiny within the framework of a critical subject matter. Within our community we adopted an explicitly critical position, potentially disrupting a delicate balance.

The museum, with all its magic and problems, is a natural partner for artist-academics who consider themselves as facilitators, cultural agents and cultural critics who wish to explore societal issues. Through their practices access can be created for students.[2] We develop an approach to learning that is an active, site-relevant 'creative practice of knowledge' (Rogoff 2010a: 41). The re-presentation of

2 The art college (DJCAD) recognizes the urgent need to change, and has adopted Tracy Mackenna's re-articulation of the rationale of its long-standing Master of Fine Art programme, from September 2012 focusing on new modules *Art, Society & Publics* that clearly position the investigation and development of individual practices within the broader framework and understanding of art's relation to society and a range of publics.

(valuable) historical artworks[3] through juxtaposition with contemporary artworks, outside their natural museological domains, raised significant curatorial issues.

We resisted the museum's expected, standard role – the custodian – that reinforces an artwork's value when historical works and collections are generally presented as dormant (closed and complete) and where there is literally and metaphorically no space remaining for creative addition.

Towards New Models

But a quite different form of value could be posited; one predicated upon the benefits of exchanges that arise out of trust, generated through intensity of engagement, commitment to knowledge in the making, and sharing – a resistant move against the fetish value of the object, towards a dematerialized art object. *Life is Over! if you want it* created an environment where participants and audiences could take ownership and play an active, self-determined part. As artist-curators of the university gallery we brought the museum into our work, utilizing its presentation strategies to bring together the different worlds of contemporary art, the museum and HE art education. The gallery became a site for active learning where members of the public took up new roles in their learning experiences.

As artists who together work within the framework of an educational institution, we have an ability to broker relationships and new models. And for these to be imagined, it is worth reflecting on the Van Abbemuseum Director, Charles Esche's invitation to consider the very appellation 'art' itself:

> Now, the term 'art' might be starting to describe that space in society for experimentation, questioning and discovery that religion, science and philosophy have occupied sporadically in former times. It has become an active space rather than one of passive observation. Therefore the institutions to foster it have to be part-community centre, part-laboratory and part-academy, with less need for the established showroom function.
>
> (Esche 2005: 122)

3 Historical works were loaned from nearby collections: *The Doctor's Visit*, Jan Steen, oil on canvas on panel, *c.*1660, University of Edinburgh Fine Art Collection, and from Perth Museum & Art Gallery, Perth & Kinross Council *Still Life with a Violin*, Franciscus Gysbrechts, oil on panel, *c.*1680; *Still Life with a Lobster*, Jan Davidsz. de Heem, oil on canvas, 1606–1684; *War Baby, 1918*, Robert Henderson Blyth, oil on board, 1945; *The Burial of the MacDonalds of Glencoe*, Colin Hunter, oil on canvas, 1892; *Flower Study*, Abraham Breughel, oil on canvas, 1671; *Death of a Pierrot*, William Strang, drawing, undated; *A Human Sacrifice in a Morai in Otaheite, the Body of Tee, a Chief, as Preserved after Death in Otaheite*, from a series of engravings from Banks' New System of Geography, published by Royal Authority.

The HE art curriculum is not fixed but should be more concerned with a holistic learning journey that enables students to explore concerns in a broader cultural context, to go beyond visual and aesthetic considerations to encompass the emotive, the haptic, the sensory and to welcome disruption as a positive force in the breaking of moulds.

References

Benjamin, W. 1928, 1996. One-way street, in *Selected Writings*, trans. Edmund Jephcott. Cambridge, MA: Harvard University Press, vol. 1, 45.
Berger, J. 1972, *Ways of Seeing*. London: BBC and Penguin Books, 23.
Dewey, J. 2005. Having an experience, in *Art as Experience*. New York: Perigee, 47.
Doherty, C. 2006 New institutionalism and the exhibition as situation, in *Protections: This Is Not an Exhibition*, edited by A. Budak, and P. Pakesch. Graz, Austria: Kunsthaus Graz and steirischer herbst.
Esche, C. 2005. Temporariness, possibility and institutional change, in *In the Place of the Public Sphere?*, edited by Simon Sheikh. Berlin: B_BOOKS, 122–41.
Freire, P. 2001. *Pedagogy of the Oppressed* (30th edn). London and New York: Continuum, 31–2.
Hooper-Greenhill, E. 2006. *Museums and the Interpretation of Visual Culture*. London and New York: Routledge, 2.
Kwon, M. 1997. *One Place after Another: Notes on Site-Specificity*. Cambridge, Massachusetts and London: MIT Press, 92–3.
Life is Over! if you want it, Cooper Gallery, Duncan of Jordanstone College of Art and Design, University of Dundee, 24 January – 14 February 2009. http://www.mackenna-and-janssen.net.
Miller, D. 2009. *The Comfort of Things*. Cambridge and Malden: Polity, 1.
On Growth, & Forms of Meaning, Centrespace, Visual Research Centre, Duncan of Jordanstone College of Art and Design, University of Dundee, 2011. In collaboration with The D'Arcy Thompson Zoology Museum, University of Dundee. http://www.mackenna-and-janssen.net.
Phillips, A. 2010. Education aesthetics, in *Curating and the Educational Turn*, edited by P. O'Neill and M. Wilson. London and Amsterdam: Open Editions/de Appel, 91.
Richardson, C. 2007. Appearance of state, in *Shotgun Wedding*, edited by Tracy Mackenna and Edwin Janssen. Aix-en-Provence and Massachusetts: Atopia Projects.
Rogoff, I. 2010a. Practising research: Singularising knowledge. *maHKUzine, Journal of Artistic Research*, 9, 41.
Rogoff, I. 2010b, Turning, in *Curating and the Educational Turn*, edited by P. O'Neill and M. Wilson. London and Amsterdam: Open Editions/de Appel, 43.
Shotgun Wedding, Scottish National Portrait Gallery, Edinburgh, 2007. http://www.mackenna-and-janssen.net.

WAR AS EVER!, Nederlands Fotomuseum in collaboration with the Atlas Van Stolk, Rotterdam, 2012. http://www.mackenna-and-janssen.net.

Warburg, A. 1980. *Ausgewählte Schriften und Würdigungen*, edited by D. Wuttke. Baden-Baden, Germany: Valentin Koerner, 592.

PART IV
Expectations, Assumptions and Obstructions

In contrast to the chapters in Part III that draw on examples from art and design to challenge and disrupt perceived assumptions as to what museums are for, the contributors to the four chapters in Part IV are drawn from educators, less interested in the museum as a contested space but in enhancing the museum experience and learning process itself. In different ways, each chapter explores and evaluates specific aspects of museums as a learning space.

As part of teacher education, Carrie Winstanley considers how to draw the next generation of educators into using the museum as a space of learning, particularly those who do not feel comfortable or are not familiar with using museums or galleries for learning. Having encountered a surprisingly high number of negative preconceptions of museums amongst her university students, Winstanley thus starts from a key point – how to minimize (learners) anxieties through pedagogic adjustments.

Winstanley argues that the students she works with relate most immediately to museums through their own (often negative) experiences, rather than through any kind of larger intellectual concern about the role of museums in society. Thus, she suggests, it is only from the development of a sense of belonging that students can come to make their own claims on, and therefore use effectively, museum collections for both their independent learning and as places for teaching future generations.

Her findings are perhaps counter-intuitive for many academics in that this has led to more structure rather than less and to carefully planned and sequenced sessions rather than a more 'spontaneous' or deliberately disruptive form of engagement.

As museum educators Leanne Manfredi and Rebecca Reynolds similarly argue that 'students need forms of teaching and learning which are thought out for museum spaces rather than either having a normal lecture or seminar-type session in a museum space, or at the other extreme being invited to browse with no clear objective' (Chapter 9: 198) and both offer specific examples of collaborative projects they have initiated in different contexts including both a public and university museum settings. Their examples identify a wide range of knowledge and skills that museums can also support that include locating their own work within the museum, object based-learning and visual analysis also explored in

more detail in Chapter 11, and how to manage performances and events alongside the practicalities of display, curation and interpretation.

In Chapter 10 Linda Friedlaender adds to this list of possible educational opportunities through the enhancement of observational skills, framed as part of a growing interest and more general development of visual literacy (Burham and Kai-Kee 2011) and by 'promoting the ability to look, describe, interpret, negotiate and make meaning from information presented in the form of images' (Chapter 10: 212). Such skills all are particularly challenging to teach through conventional lectures or seminars, or via student emulation of their tutors or practitioners. Here, as with the other contributors to this part, she is interested in the value of tackling the unfamiliar (for example artworks observed and analysed by medical students) as a potent tool for applied learning that extends beyond pre-conceived assumptions and by emphasizing an attentiveness to detail and to a different kind of reading and a more systematic understanding of visual analysis. As she says, 'the aim is not only seeing, but flexible, fluid seeing' (Chapter 10: 219).

In Chapter 11 Leonie Hannan, Rosalind Duhs and Helen Chatterjee expand on the potential of meeting particular educational aims from museum collections by contextualizing education through a brief history of the changing relationships between such collections within universities. Though clear evangelists for OBL they also explore the assumptions that academics and students have about teaching and learning in order to better understand why museums and OBL in many traditional academic subjects remains surprisingly difficult to implement at HE level.

As Hannan, Duhs and Chatterjee note, active learning engages students in the process of meaning making that engages a wide range of sensory skills, rather than the passive absorption of theoretical knowledge presented in a lecture format. This enables the student to understand and to experience both the resonances and dissonances between their own existing 'common-sense' knowledge of the world, and to build into that new concepts as they are introduced. This facilitates both reflection on and transformation of their own assumptions and perspectives built through an experiential extension. As with Friedlaender, all these authors recognize the potential of objects and experiences to promote enquiry precisely because of their ability to forge a bridge between the familiar and the unfamiliar but equally through the shared experiences and the social dialogues forged through a different medium. 'Facing students with an unknown object and asking them to deduce what they can from its physical form, encourages just the sort of analysing and hypothesizing that are the life force of scholarly enquiry' (Chapter 10: 236). As Winstanley identifies, though unfamiliarity that can produce resistance, the careful planning and sequencing of shared and collective experience can assist and support the collective crossing of learning thresholds and prove to be not only an efficient but also effective and transformative experience.

Chapter 8

'Museums and Galleries? No Thanks, Not For Me.' A Critical Review of Attitudes to Museum and Gallery Visits among University Students on an Education Degree Programme

Carrie Winstanley

Based on my observations and research with 300 of undergraduate education students at Roehampton, University of London, this chapter examines students' attitudes to museum and gallery visits. It is well-documented that the 18–30 audience is particularly difficult to entice into museums and galleries as adult users (Harland and Kinder 1999, Black 2005: 38, Jensen, in Hooper-Greenhill, 2004: 110). Despite knowledge of these difficulties, it is not unreasonable to suppose that students in HE may buck this trend. Having committed to exploring their own learning at an advanced level, it would seem compatible that they would be interested in expanding their knowledge and learning through such trips and visits. It is understandable that tutors might make the easy mistake of assuming that museums and galleries would be valued as places of potentially vibrant and exciting non-formal learning.

However, in the context of my experience, I found that a significant number of students hold negative feelings towards museums and galleries, even those who actively choose courses that are likely to involve such visits. As well as the personal value of using museums and galleries for the students there is the importance of encouraging others to explore these cultural institutions. Those who work with children and young people will be influential agents and perhaps role models to those in their care. If students are to be encouraged to visit museums independently in the future, museum educators need to have a clear understanding of what museums and galleries can offer these audiences. In this chapter, I look at how students can be encouraged to use these valuable learning resources for their own study as well as for enjoyment.

The course, 'Informal Learning: Learning through Leisure' is an elective module of 12 three-hour-long weekly sessions for students in the second year of their undergraduate education degree programme at Roehampton, University of London. As well as museum and gallery education, the module covers educational broadcasting, publications for school and home, multimedia in education and adult education courses, and some further themes that come together to build a

picture of learning and leisure, known also as 'free-choice learning' (Falk and Dierking 2002) and sometimes dubbed 'edutainment' (Combs 1999). When selecting the course, students are aware that compulsory visits are included and that these will fall within the class timetable and will not be at any additional cost to participants.

The module does not aim to 'convert' students into regular museum users but neither does it allow for extensive examination of Museum Studies. Some explicit discussion is encouraged and a few of the essay question choices deal with free-choice learning in a broad sense. However, due to the nature of the degree course and to the desires of students to tackle pragmatic concerns, these aspects are limited. For the sake of students' work, there is an agreed standpoint that free-choice learning is more or less a valuable enterprise that should be encouraged for current users and future generations. Reasons for this viewpoint are generally agreed by the group in early sessions and tend to include the following:

- the use of resources from museums and galleries offer a chance to break out from the usual pedestrian ways of learning for most schoolchildren and for students (this can include online work);
- when on a visit, it is freeing and exciting to be and to work in a different environment;
- one's usual ways of researching are challenged and often enriched and refreshed;
- it helps people feel connected to their cultural and social contexts;
- it provides a break in routine.

Despite having discussed these positive reasons for bothering to pursue work in museum and gallery contexts, a significant minority of the group remained apathetic and approached the visits with a subdued air of indifference, or even with hostility. For example, on average, around 5 students from a class of 25 would appeal to the tutor to be excused from the trips for reasons of lack of interest, whilst making no formal application to be excused, presented negative attitudes on the visit. These were easily discerned through negative comments, body language and through a reluctance to engage readily as well as through the adjective task as discussed later in this chapter.

Surprised by the students' lack of enthusiasm and unhelpful attitudes towards the visits, I began to compile data on the reasons for their views and any changes brought about by confronting how they were feeling. The analysis in this chapter is based on research with 300 undergraduate students (89 per cent female) from mixed backgrounds (56 per cent self-declare a minority ethnic background, although university data suggests a figure of around 66 per cent). A fairly large proportion of the students are parents (37 per cent) and a small number (5 per cent) have a disability that would affect the preparation and/or undertaking of the visit. As well as interviewing students about their experiences of museums and galleries, I have derived data from email exchanges, more formal essays, anecdote and overheard comments, plus evaluations of the course and personal communications.

In order to record students' views, simple data collection was undertaken each year. During an early session of the course, students were asked to write three adjectives describing museums and galleries. These were written anonymously on slips of paper and the folded slips were then collected in an envelope and passed around the group. Students were asked to be completely honest about their views, it was emphasized that this would not have any bearing on their assessments and that the data being compiled was for an academic paper and no other reason (beyond the implicitly expressed interest of the tutor and author of the paper). By the end of the course, students would have participated in a number of compulsory accompanied visits to (at minimum): one national museum, one major gallery and an outdoor interactive science centre. They were then asked to repeat the adjective task. The pre- and post-visit data were compared, and changes have been highlighted (this activity is referred to as the 'Adjective Task'). This table represents the largest changes in views as shown through the adjectives students used to describe museums and galleries and starkly demonstrates how tailored visits serve to improve the way they feel about these institutions.

Table 8.1 Data demonstrating the strongly negative preconceptions held by the students prior to their museum visit and the shift to more positive descriptors after their visit

Adjectives	Pre-visit (n = 300)	Pre-visit (%)	Post-visit (n = 300)	Post-visit (%)	Percentage change
Dull/boring/ uninteresting	207	69	74	25	−44
Unwelcoming/ off-putting/ unfriendly	114	38	15	5	−33
Fun	21	7	209	70	+63
Interesting	96	32	197	66	+34
Big/huge/vast/ overwhelming	87	29	13	11	−20
Interactive	–	–	73	24	+24

The data here demonstrates the strongly negative preconceptions held by the students prior to their visit and the shift to more positive descriptors after their visits.

I now go on to make recommendations based on the findings of this study to help other HE professionals make the most of museum visits with their students. This may also be valuable to educators working in museums and galleries who wish to improve their relationship with HE students. I will begin by outlining students' anxieties about visiting museums.

Surprising Disquiet

Over the last seven years, a number of concerns about students' experiences of visiting museums have been well-documented (Black 2005, Falk and Dierking 2000, Harland and Kinder 2007, Hooper-Greenhill 2004 and Horlock 2000). These ranged from students' basic concerns about finding their way around, through an expectation that the exhibits would not represent their culture, to a general feeling that a trip to a museum would be disempowering in the same way that school visits were perceived as 'over-controlled' and thus irrelevant.

More unexpected was the anxiety around subject knowledge. Students claimed that not having qualifications such as GCSEs in Science and Art would make the visits more difficult, with some feeling that they were imposters and there was a danger that their ignorance of the subject would be discovered causing embarrassment. A minority of students considered museums and galleries as places that test knowledge rather than foster or encourage learning. This group consisted of three women (brought up in Monserrat, Iraq and Nigeria) out of the 300 student cohort that had never visited a museum or gallery in London prior to the module.

Despite all our classroom discussion about constructivist pedagogies, engagement and interaction, in most of the groups a desire to 'be taught formally' persisted. Without even a short lecture-type segment to the trip, students felt that they had not learnt as much as they had hoped. Earlier in the study (over the first couple of years) visits were quite loosely structured with the group splitting up to follow interests and then reconvening for plenary sessions, reflection and review. Less satisfaction was expressed on these occasions than the more popular visits where tutor control was tighter and less choice was given over to the students. This seems to be for two reasons; equity of experience, and the perception that 'being taught' is more valuable than 'independent learning'. It seems that students find having a guide helpful as the experience of visiting a museum can be overwhelming. They are also very focused on their assessment and seem to consider that being accompanied by the tutor who will mark their work is helpful.

> It's useful going around in a group with you [the tutor] because now I really know what I should be looking at for my essay.
>
> (undergraduate, Education)

When I did my museum visit in the First Year [unaccompanied visit to Bethnal Green Museum of Childhood] I was a bit useless as I don't really go to museums. I wandered around and even missed the bit on Froebel that I was looking out for.

(undergraduate, Education)

Oh, I'm glad I'm following you – I would be completely lost by now otherwise.
(These are all from Education students on the same course)

Recommendations and Comments

My recommendations and comments aim to take into account the 'holistic nature of the museum experience' (Black 2005: 75). In expanding this notion, Black notes the following three elements required to engage visitors:

Providing stimulus to visit

Placing visitors in the 'right frame of mind' to engage with collections

Providing motivation and support – quality of interpretation

(Black 2005: 75)

All of these elements can be directly influenced by teaching staff in universities and what students reported as off-putting in the past (in relation to these themes) are exemplified here with direct quotations from undergraduates in Education:

Providing stimulus –

Don't assume we love museums just because you do.

Why do we have to go?'

How does this actually help me with my degree?

Placing visitors in the 'right frame of mind' to engage with collections 'I don't know what I'm supposed to be focusing on.'

(undergraduate: Education)

There's too much going on

(undergraduate: Education)

It's confusing.

(undergraduate: Education)

Providing motivation and support –

When you say that we need to look at the display, what exactly does that mean?
(undergraduate: subject)

What am I looking for?
(undergraduate: subject)

In order to address my students' concerns and in relation to the study and our shared experiences on the trips, my recommendations follow linked to Falk and Dierking's 'Contextual Model of Learning' (2000). The suggestions are based around ongoing reviews of the visits by all tutors involved and adaptations to sessions in museums in collaboration with educators in different institutions.

Contextual Model of Learning: Eight Key Factors that Influence Learning

Personal Context:
1. Motivation and expectations
2. Prior knowledge, interests, and beliefs
3. Choice and control

Socio-Cultural Context:
4. Within-group socio-cultural mediation
5. Facilitated mediation by others

Physical Context:
6. Advance organizers and orientation
7. Design
8. Reinforcing events and experiences outside the museum

(Ibid 2000: 135–48)

Personal Context

Students are encouraged to consider their motivation and expectations openly in class through safe, well-managed conversations, which allows students a platform to express their concerns and fears about the museum visits. Learning is only feasible without anxiety and it is the responsibility of university staff to quash any worries prior to the museum visit. An engaging way to do this is to show students postcards and Internet images of what will be seen on the trip. Asking students to imagine the actual scale, display context and other physical characteristics opens up dialogue around the visit with a focus on the exhibit, not the students. For example, Matisse's *Snail* (Tate Modern) cannot be adequately captured in a postcard. Students unfamiliar with the work gasp in amazement when they see its true dimensions but in the discussion beforehand some will casually express their

concern that they are unable to place the work and would not know for example, which way up it should hang. Revealing these anxieties is easier when the focus is on the exhibit rather than the student and we have learnt much more about students' worries through undertaking such activities than through direct questions addressing their fears.

It is recognized good practice to make use of visitors' prior knowledge, interests and beliefs and so these can be usefully explored before the visit. Some interests only surface on the trip itself, however. Asking students to consider what 'surprised' them about the exhibits can sometimes help expose their interests more effectively than asking them to articulate what they 'liked best' or found 'most fascinating'. Using 'surprise' also allows for people to express negative views since a surprise can be welcome or unwelcome. It frees the idea of 'what is interesting' from the sense that students have to be interested in things that are good, universally valued or obvious.

Interestingly, as free choice on the trips decreased, so the generally expressed enjoyment increased. Students were encouraged to pursue their interests after the taught session and so free choice and control of their time in the museum was incorporated, but not central. With the tutor shaping the session around the learning needs of the students and making direct links to theory and assessment ideas, students found the trips more satisfying:

> Now you mention Hein and compare this gallery [LaunchPad, Science Museum] the other one [Making of the Modern World, Science Museum], I can see what you mean about a web or a maze; yeah, that makes more sense now.

> I didn't think I'd enjoy the gallery so much [Tate Modern], but now I can see that you could probably do some fun things with reception age children and they could do quite a lot of the Early Years Foundation Stage learning too.

Once tutors overcame a certain sense of disappointment (for me this felt like spoon-feeding), it became easier to balance tutor and students' expectations. Throughout the session, for example, tutors offered suggestions for further independent learning as well as making constant reference to previous knowledge and activities.

Using emotional experiences (stories, mysteries, humour, etc.) helps to tap into the sense of visits being a different type of learning with a richness and depth that cannot always be captured in the classroom for example, remembering when a couple of tourists joined the group in front of an exhibit whilst the tutor was explaining details about handing in coursework generated a ripple of amusement from the group. Striking the right balance between seriousness and enjoyment is important; after asking students what they felt was useful on the visit, we started to include a formal section to the visit (as short as we dared) since the groups perceived this as vital for their learning. It seems that some HE students feel they learn best in this way, even if their logical self tells them that a lecture-text style of learning is less effective than this informal approach.

Socio-Cultural Context

Students, like any communities using the museum, have both group and individual identities and learning is affected by these factors. Reinforcing the group identity explicitly is worthwhile as the occasions where this was successful were reported more favourably than more loosely conceived trips. Many students commented positively on shared experiences, observing that the group felt 'bonded' compared to typical teaching groups. On occasion when tutors referred to other teaching groups from previous years or different sessions, students seemed to derive a more intense feeling of belonging, speaking almost competitively (such as 'No one in our group turned up at the wrong Tate gallery this year!'). No rivalry was encouraged but an impression of group identity seemed more palpable, with groups describing and characterizing themselves as 'lively', 'interested', 'thoughtful' and 'helpful'. Tutors might say 'Oh, yes, you're the group that loved the Rothko room so much' and some group members, previously rather reticent, would start to refer to themselves as the 'Rothko Fan Club'. Such light humour and bonding through the visits helped to break down inhibitions in discussion and students became more ready and willing to work with less familiar peers both in and out of the university classroom. Once we discerned this effect, tutors encouraged the groups to develop their identities where possible.

Overall, an informal ethos was encouraged on the visits and despite having to maintain a register of attendees, the sessions had a very different feel from standard university taught sessions. At times, some of the less mature students would be embarrassed by the more informal tone of the sessions and also by the inevitable requirement to share responses to some of the more challenging exhibits. There were many opportunities to allow students to express their ideas directly to one another without being judged, this helped students to feel comfortable about sharing their ideas.

Again, this created a specific context for learning and whilst we try to avoid any discussion that prioritizes one culture above another an active cultivation of a 'teaching and learning group identity' appeared to emerge. Certain 'in-jokes' and references to shared experiences helped the less confident students feel able to express themselves more openly than in other contexts:

> Remember when we all lined up to press the button on the pedestrian crossing at the Transport Museum?
>
> Why was that so fun in a museum when we do it everyday?!

Students' cultural references are integrated as appropriate and whilst the group identity is powerful; each student brings their own specific viewpoint. Multiple opportunities for these diverse groups to relate themselves to the exhibits are provided by encouraging self-expression wherever possible.

As the course has developed over six years, we have seen an increase in the guiding role of the university tutor and the diminishing of the museum staff role during the trips. Typically in a 90-minute visit, an ideal amount of input from museum staff seems to be around 20 to 30 minutes. This allows for the bulk of the session to be directly related to the group's needs without the need for lengthy preparation sessions or joint planning. Where relationships between museum and university staff are very well-developed, this ratio can usefully shift, allowing for more input from the museum or gallery.

Physical Context

All tutors on the course were surprised at how many students struggled with getting to venues on time. Our university is located in south-west London and merely a bus, tube or train ride away from the locations and yet there was substantial confusion. Over the years, increasing amounts of information have been provided now in a standard recognizable format and we have arranged a buddy system for exchanging contact details, ensuring that each person in the group has several routes to pass on urgent messages. In some cases we undertook a group virtual tour of the destination in a taught session, or set students a guided Internet task to help them gather all required information.

Precise entrances were chosen and meeting places were specified to avoid any ambiguity. It can be more complex with a group of HE students as they are sometimes invited or required to use the schools' entrance but in some cases this is not allowed, or is discouraged. Where possible, we avoided these entrances as they resonated with some of the negative views held by students. Earlier in the course, say for the first trip, less intimidating entrances were purposely selected to ease students into the visits. These entrances would often be the side entrance, or less imposing doorway with clear access to shops, cloakrooms, cafes and toilets. Students expressed a preference for these entrances over the more imposing main doors, often with dramatic stairways and high ceilings. Later in the course, as galleries and museums were demystified, we were able to use a variety of entrances with more success. The initial impact of the building and the entrance were often cited by students when we talked about visits and the emotional impact was powerful, amplifying the notion that entrance, navigation and exit can be usefully managed to enhance student experiences.

Explicit discussion about navigation in the museum is valuable and opportunities to both follow directions and design one's own route should be provided in ways that meet the needs of the group. Over the last years of the study, students used the adjective 'overwhelming' less and less as the four visits on the course provided a progressive development from tutor-direction toward increasing personal freedom through a programme of learning how to make the best of a space.

Wherever possible, we have tried to make return visits very attractive for students by introducing them to staff who may be present at a future evening

event, for example, or at a half-term activity. Occasionally, we have been able to encourage students to make independent visits and an offer of half-price entry to a special exhibit or cafe discount have been valuable incentives. Outreach is an obvious way to engage students and follow-up or prepare for visits and on the few occasions where we could arrange this, students responded very well to seeing the same members of museum staff both in and out of the museum context as they felt as if they were developing a positive relationship.

Conclusion

My aim in this chapter was to present findings of my research into the experiences of HE students visiting museums and to make recommendations for museum and university staff on how to improve the experience of group visits for HE students. From my experience, it is important not to assume that HE students will automatically see the value of museum visits and that some of their concerns are rooted from personal experience. Counter-intuitively, tightly structured visits with a lecture-type feel seem more appealing to the demographic of students examined here, due in part to a lack of confidence in using resources beyond the classroom. With careful monitoring and a liberal injection of humanity, humour and imagination, visits can definitely enrich the learning of HE social science students, but tutors should tread carefully if they want to encourage continued use and enjoyment of museums and galleries.

References

Black, G. 2005. *The Engaging Museum: Developing Museums for Visitor Involvement.* Oxford: Routledge.

Combs, A.A. 1999. Why do they come? Listening to visitors at a decorative arts museum. *Curator: The Museum Journal,* 42(3), 186–97.

Falk, J.H. and Dierking, L.D. 1992. *The Museum Experience.* Washington, DC: Whalesback Books.

Falk, J.H. and Dierking, L.D. 2000. *Learning from Museums.* California: AltaMira.

Falk, J.H. and Dierking, L.D. 2002. *Lessons without Limits: How Free Choice Learning is Transforming Education.* California: AltaMira. Harland, J. and Kinder, K. (eds). 1999/2007. *Crossing the Line: Extending young People's Access to Cultural Venues.* London: Calouste Gulbenkian Foundation.

Hein, G. 1998. *Learning in the Museum.* London: Routledge.

Hooper-Greenhill, E. (ed.). 1994/2004. *The Educational Role of the Museum.* London: Routledge.

Horlock, N. (ed.). 2000. *Testing the Water: Young People and Galleries.* Liverpool: Liverpool University Press and Tate Gallery Liverpool.

Knowles, M.S. 1981. Andragogy, in *Museums, Adults and the Humanities: A Guide for Educational Programming*, edited by Z.W. Collins. Washington, DC: American Association of Museums, 49–78.

Chapter 9
Tales from the Coalface

Leanne Manfredi and Rebecca Reynolds

Introduction

The authors of this chapter both work in museum-based education for HE students, one in a national museum, the other in a small university museum. Here we reflect on our experiences of working for a number of years at the interface between museums and universities. During this time we have supported and participated in museum-HE collaboration of many types, from developing and teaching museum-based modules as part of HE curricula, to building up partnerships with individual tutors in order to plan and run events, to researching students' responses to museum-based courses. This chapter examines some of the complexities and challenges that have arisen in our individual work roles and makes some suggestions about how museums can enrich the HE learning landscape. It looks first at museums as unique learning spaces and goes on to consider different models of collaboration between museums and HE.

Leanne Manfredi has worked at the Whitworth Art Gallery in Manchester and the Victoria and Albert Museum (V&A) in London. Rebecca Reynolds has worked at the V&A for the Centre for Excellence in Teaching and Learning through Design (CETLD), and at Reading University's Museum of English Rural Life as teacher of accredited optional museum-based modules for undergraduates.

REBECCA REYNOLDS

The Museum as a Unique Learning Space

Here I would like to examine two aspects of the museum as a unique learning space. The first is its role as an actual space, an alternative to more familiar campus spaces such as lecture halls. The second is the museum as an environment which brings with it particular – and to many HE students, novel – ways of learning and teaching. For this I draw on research undertaken as part of my role as tutor for two modules for first to third year undergraduates at the Museum of English Rural Life, University of Reading (Reynolds 2012). Called 'Analysing Museum Displays' and 'Object Analysis and Museum Interpretation', the modules were originally developed by Rhianedd Smith (2010). They were offered to

students from departments including Archaeology, Ancient History and Graphic Communication. The course for first years aimed to help them with 'museum literacy' – for example, identifying how objects may be understood differently depending on how they are displayed, and introducing students to central issues in display construction such as label design and understanding audiences. Tasks for the second- and third-year students included researching, cataloguing and designing a display for an object from the collections.

Fifty students from the 2010/2011 and 2011/2012 academic years (out of a cohort of 84) completed the questionnaires. About 21 of these also took part in discussions about their experiences of the modules.

The questionnaires showed that the most valuable elements of the course for students were learning about museum theory and practice, applying academic and theoretical knowledge to actual museums, attending sessions with museum staff and gaining hands-on experience with museum collections. Comments from discussion groups which add detail to these questionnaire findings include:

> The process of acquisition ... I didn't have a clue about the whole bureaucratic side of things which everyone has to go through. [I got it from] filling in the acquisition form, you have to evaluate whether there is space for it, whether it fits in with the museum's ethos, whether it's worth conserving it.
> (undergraduate)

> I'm going into teaching, and it prompted me to think about learning styles and the value of using objects for learning.
> (third-year undergraduate)

When second and third years were asked in discussion groups about the positive and negative experiences of learning in the museum, students said they appreciated being in a different space. This was for different reasons. One was that there were different power relationships and roles to those on campus. Three students commented:

> ... you come out of the classroom, into a real-life situation like the museum – and going and walking behind the scenes, going behind a closed door and seeing the conservator there, then having a talk with the curator here, it was all part of normal everyday life.
> (second-year undergraduate)

> You are part of the museum experience. You are not a member of the public, not quite staff, you are doing something here.
> (second-year undergraduate)

> Once you're in the museum you feel you're maybe taken away from the more educational lecture side-you're a bit more involved, more equal.
> (third-year undergraduate)

All students here speak positively about being in a space which was not exclusively for study. The first student speaks approvingly of being in a 'real-life situation', while the second student welcomes a partial redefinition of their role, and the third comments on different power relations within the museum compared to the university.

A student also spoke positively of the fact that course tasks were in some cases genuinely useful to the museum (students had to research an object from the collection, and their essays were sent to the museum's curator and kept in the object file if appropriate, as research findings).

In discussion, some of the students said that they saw the museum-based courses as alternatives to more traditional lecture-based courses. This was partly because of the interactive nature of the teaching sessions, but also because the tasks involved analysing objects and spaces and travelling to different museums on and off campus. One student, studying Archaeology along with the museum-based module, commented that more didactic lectures were appropriate for Archaeology but more interactive or self-directed sessions were suitable for tasks where students were practising object-based research skills. She thus recognized that the museum offered the opportunity to learn in different ways to the rest of her courses.

However, a common point raised by students in feedback on the modules was that they did not understand what was required with unfamiliar tasks as much as they would, say, in writing an essay. They therefore needed more help in negotiating these tasks.

Students need forms of teaching and learning which are appropriate or designed for the museum space rather than having a normal lecture or seminar-type session in a museum space, or at the other extreme being invited to browse with no clear objective. Museums lend themselves to fairly unfocused 'leisure-learning' (Hooper-Greenhill 1999) and I would agree that museum display spaces are in my experience not ideal for teaching sessions which need more control, such as focused discussions. For these, classroom-style spaces offer less distraction and a more comfortable sitting and working space. The ideal combination is having a study room near the display spaces so that students can explore the museum environment in a self-directed way, open to the accidental discoveries which are a key part of museum visits, then return to a space in which they can concentrate and focus according to the aims of the session. There is currently an increased interest in the spaces in which students learn (for example, Boys 2011) and more investigation may be valuable here. It is noticeable that museum spaces have received far less attention than virtual spaces in discussing universities' prospective offers to students and they could be made more of a selling point. This does not just apply to universities which have museums, but those which collaborate with museums.

But if it is true that museums bring certain types of learning with them, it is also true that students can also bring to museums their favoured ways of engaging with the environment. Architects can analyse and design spaces and

buildings, creative writing students can write in response to spaces and objects, graphic communication students can focus on text and graphics. This expands the potential of museums as a learning resource beyond the application of the collections to particular subject specialisms. So collections which belong to particular departments – say geology or zoology collections – could be used by other departments and their relevance to the university could thus be renewed and expanded. It is likely that such cross-disciplinary use of collections happens now, but it is not clear how much, or how explicitly such uses are suggested to students or publicized within universities. Research into such applications of collections would contribute to the status, use and even expansion of university collections.

<div align="center">Leanne Manfredi</div>

Models of Collaboration

In this section I draw on my experiences of working in two very different cultural institutions, one a university campus art gallery, the Whitworth in Manchester, the other the Victoria and Albert Museum. Both roles grew out of research into the learning needs of art and design students, the former an acknowledgement of the importance of widening participation for universities in the north-west and the latter research undertaken by staff from the CETLD (2005–10) based in the Learning Department at the V&A. The CETLD research highlighted a number of objectives and activities fundamental to informing students' engagement with the museum (Fisher 2007). These included shaping interpretation and displays, devising events for their peers and general visitors, handling objects, and opportunities for displaying their own work. These student-centred objectives represented a shift away from the institution providing 'HE programming', a 'menu of services to universities', generic resources or study days. Instead it meant that the museum should focus on collaborations with students.

Some models of collaborative engagement projects are outlined below, which highlight the complex interactions between universities and museums. In all three models of engagement both tutor and student adopt a number of roles including researcher and facilitator, practitioner and maker, producer and performer. All three projects were the product of a sustained partnership with one or more universities and were supported by a series of inductions, talks and outcomes. TACTILE culminated in a launch and series of induction sessions for students, the RCA Rapid prototyping project culminated in a student display, and Shakespeare in a Suitcase culminated in a weekend of events and activities entitled 'Designing for Shakespeare'.

Students and Handling Resources

University museums are notable for their valuable teaching collections, offering students the opportunity to extend their subject specialist knowledge through the use of handling and discussion. In recent years case studies and publications on object-based learning, notably Helen Chatterjee's work based on the collections of University College London in particular with respect to health and well-being, and work by Professor Gina Wisker and Christina Reading (formally based at the CETLD) have highlighted the effectiveness of teaching with objects. This work has also highlighted the necessary shifts involved by the museum/gallery and university to make access to collections easier for HE students and incorporate activities such as drawing, observational skills practice, and training in handling objects and in devising strategies for interpretation.

TACTILE, a contemporary textiles handling resource, developed from a recognized need for students to have the opportunity to handle contemporary textiles at the Whitworth to enrich their understanding of the medium. Touch enabled students to engage with collections above and beyond the 'norm' of visiting exhibitions, displays and storage facilities. Contemporary textiles in the Whitworth's collection can be problematic to display and store because of their large size and inherent properties which make handling an issue. Commissioning textile pieces small in scale, easily transportable and 'packaged' through a process of conservation sensitive to the handling practicalities of the objects provided students with a framework to explore the works in greater depth.

Vicki Wheeler, tutor in Textile Design at the University of Manchester, highlights the benefits of direct handling for her students as part of *TACTILE: In touch with the real thing*:

> Learning and appreciation is ultimately more accessible through these bite-sized, tactile works. Students become closer to the works both physically and psychologically through the process of handling. Through the experience of touch students become more aware of the sensibilities of the works. This in turn encourages students to try new processes and experiment with new materials and techniques. This 'hands-on' approach quickly reduces any apprehension associated with traditional gallery visiting practice allowing students to experience these works off the wall, out of storage and away from the practices of traditional display.
>
> (Wheeler 2009)

Students experiencing objects 'away from the practices of traditional display' allows them to encounter the works as makers and not gallery visitors. This is crucial to their understanding of the objects as made artefacts, affording them a multi-sensory experience which enables them to extend their knowledge of materials and technique.

TACTILE can be moved (pieces are contained in plastic storage boxes which are stacked on wheels) and used in gallery spaces next to objects on permanent or temporary display enabling students to create dialogue with collections, referencing both the past and future directions in art and design. Students have at their disposal a rich repository of visual references, techniques and materials supplemented by the working processes of each of the artists contained therein as well as a wealth of research material provided by the individual makers themselves. As a handling collection TACTILE is an example of an integrated HE learning resource at the gallery being informed by curatorial practice, conservation, access and learning.

Students Engaging with Collections

Much research into student barriers to engaging with collections has focused on issues around access to objects. The scale of the V&A and scope of its collections can often act as a barrier to HE groups who have a particular focus for an enquiry or a visit. The project highlighted the complexities of accessing a particular area of the collections with a HE group, the store underneath the building was small, time was limited and as such the visit was carried out with military style organisation. The objects themselves could not be handled because of their age but the opportunity to virtually render them brought into creative interplay a highly specialised area of the Museum's collection, students' application of their making skills and technological innovation in 3-D printing.

RCA/V&A Rapid form examined how the use of rapid prototyping technology could be used to transform a selection of sixteenth-century bronzes from the V&A's sculpture collection. The process brought together a 3-D laser scanner that rendered each of the objects. They were then digitally manipulated using CAD 3-D software and with the use of a haptic device, students used their craft-based skills of hammering, scraping and cutting to alter the appearance of the objects. Digital scans from more than one object were appropriated and meshed together creating strange hybrid forms disassociated from their original museum context.

Steve Bunn, Senior Tutor and Technician in the Sculpture Department at the RCA highlights to students involved in the project the opportunity to encounter these objects haptically through the application of their craft-based skills:

> In itself, this (project) must represent a tremendous opportunity: to see and revise a cultural archaeology with contemporary equipment accessible to the RCA. The range of instruments available with the haptic arm is straight from Howard Carter's tool kit. There are scrapers, dusters, and scribes, gouges, chisels and splitters. We use these tools to tell stories and solve puzzles ...
>
> (Steve Bunn, email correspondence, 2010)

Students were initially asked to choose a bronze from a selection housed in the museum's basement store. They had limited time with the object before it was marked up for scanning and put back on the shelf. The project raised the question of providing meaningful access to objects where curator time was limited and security issues governed the amount of students in the space at one time. However, in this instance the objects simply left the store as virtual copies to be worked on at a later date, the originals left in the basement untouched. In this case a 3-D printer brought these objects back to the physical world and re-situated them as 'prototype' objects, this in itself being problematic as a prototype comes before the finished product. These objects are finished works to which a manufactured process of rapid prototyping has been applied. The project expanded the meaning of the object outside its museum context; the use of the haptic arm by sculpture students pointed to a fixed craft-based tradition extending the term 'handling of an object' to a direct intervention and assault on the object's properties and meaning. This could not have been achieved through a traditional visit to the store or object session.

Students, Spaces and Audience Engagement

Shakespeare in a Suitcase was a collaboration between the Learning Department and Theatre and Performance Department at the V&A, emerging from the exhibition *Transformation and Revelation: Gormley to Gaga* (17 March – 30 September 2012). Staged over a weekend, the project brought together 10 universities from London and the regions which had responded to a project brief to re-stage some of Shakespeare's most enduring plays or create responses to wider themes in the playwright's work through installations, costumes or performance. The project represented the diversity of theatre practice across a range of disciplines. Undergraduate and postgraduate students were asked to respond to a number of museum gallery spaces which formed a dialogue with their own work and evoked the spirit of their chosen Shakespeare pieces.

The result was 16 interpretations of Shakespeare's work happening in different spaces around the museum from the public cafe to more discreet locations such as the Tapestry Gallery. Students were given a framework that enabled them to adopt a multitude of roles encompassing curatorial practice, creative producing, commissioning artist/maker, interpreter, facilitator and evaluator. In many ways they mimicked my role as interpreter but they operated within a defined set of parameters balancing the sensitivities of museum gallery spaces and protocol with the 'spontaneity' of pop-up performances.

Whilst arguably a 'work-based' project where students were exposed to the working environment and day-to-day running of the museum 'behind the scenes', they were also asked to reflect on their practice as part of a film the museum made about the weekend of activities that chartered their processes over the weekend as part of an evaluative tool. Interestingly some of the performances changed shape over the course of the weekend as students either became more self-directed and

confident in the museum spaces or they wished to rework different elements of their practice to reflect our different audiences. In this sense they became 'fixtures' in the museum recognized by staff and semi-adopted by the museum, joined by a sense of belonging and of a wider community of practice.

Generic Learning Resources for HE

Whilst successful museum/HE collaborations can expand museums' approaches to using their collections, those detailed above are time consuming, dependent on the commitment of individuals and may not be replicable beyond certain institutions or without the help of certain staff.

In fact, most HE visits to the V&A are different from these collaborations. Rather than being part of a dedicated project or a period of sustained visiting, they are 'one-offs'. Universities schedule an obligatory visit during term time whereby the whole department visits. In this respect these groups follow the visitor patterns of tourists in huge numbers visiting temporary exhibitions. The fact that a large proportion of these HE groups are visits from London based universities highlights the fact that funding for visits is not the issue, rather a visit to the V&A is perceived as a 'must do', part of the cultural menu of activities that London has to offer. The same may well be true of other large museums. In this case is there any place for special provision for HE groups? With visits from countless courses and institutions how do you ensure that everyone has the provision they need?

One might think that generic learning materials have a role to play here. However, to our knowledge, there are few examples of museum-based learning materials for HE students, as there are for schools for example, in the form of teachers' packs. Evidence as to the usefulness of such resources is mixed. Two CETLD research projects which investigated museum-based learning resources for HE students accessed on mobile learning technology indicated that such resources could contain useful strategies for encouraging object-based learning skills (Reynolds, Walker and Speight 2010, Reynolds 2011) but in this latter project 10 out of 21 students expressed reservations about using such materials, mainly because the content might not be helpful for them or interesting or innovative enough. In addition, some students and tutors may fear having their personal ways of looking pre-empted by interpretation (Fisher 2007).It is also more likely that tutors will appropriate ideas from existing resources and adapt them to their own lessons, rather than transplant completely new material into courses (White and Manton 2011).

One important role of such resources might then be as a light touch, to act as an introduction to museums and to provide a 'way in', which then leaves the student free to carry out their own interpretation of the museum collections and environment. For example, one project evaluated the use of audio files by students in the V&A's permanent galleries with students (Reynolds 2011). Each audio

contained viewpoints on the galleries from designers, curators, design students and others. One student commented on the benefits of using the audios before a visit:

> you are almost preparing yourself for something and it is giving you a snippet of what you are going to see so you are not going to be overwhelmed by it when you are there and you've got a vague idea of what you are going to be experiencing but at the same time it is just opening the door.
> (Art and Design undergraduate)

For this student it is clear that a 'snippet' and a 'vague idea' is enough to open the door to students.

Learning or Study?

Boys has discussed the different ways in which museums and universities frame learning, and argues that these 'have restricted the effective integration of learning activities across both institutions' (2010: 43). We would like to briefly comment on the differences we have experienced in understanding the concept of 'learning'. The V&A has a 'Learning Department' but the activities of the department centre around setting up and maintaining partnerships, programming and event management. This is not the same as 'learning' in HE, where it is a long-term structured process applied to student activity over time; Boys (2010) discusses this in more detail.

In our view a distinction between the terms 'learning' and 'study' would be useful in conceptualizing HE learning in museums, with 'study' implying more pedagogical structure, depth of engagement (including sensory engagement) with the object and the availability of more associated information. This would be helpful since museum learning theory tends to focus on informal museum visits – that is, outside formal courses. We are not arguing for words to be used in the same way in each type of institution, even if this were possible; however, understanding some of the differences between the way institutions operate and use language will help collaboration. Museums staff working with HE may have to 'translate' the museum's ways of working to tutors and students. This may involve explaining the nature and responsibilities of the museum as an institution, clarifying staff roles and administrative procedures. For example, students need to understand that museums as public-facing institutions are less free to tackle controversial subjects than universities are.

Conclusion

Rhianedd Smith describes how museums working with universities can bring together different teaching methodologies, but comments that there is room for

greater 'cross-fertilisation' between them; for example, 'museum learning theory needs to look beyond the school visit to examine models for sustained engagement across collections' (Smith 2010:87). It is our view that such 'cross-fertilisation' is more likely to happen through collaboration between HE and museums, rather than provision of services *for* HE *by* museums.

Museums, unlike many campus spaces, are public domains. They thus provide a place for students to interact with the public through activities such as mounting exhibitions, conducting research with museum visitors, carrying out research which contributes to knowledge about collections and so on. This is a valuable and unusual opportunity for HE students.

Universities are becoming more public-facing and are required to share their knowledge as widely as possible. Working with museums is one way of doing this. Museums, on the other hand, are perhaps more educationally focused than ever before, partly because they have been required to their increase their engagement with the public, in addition to carrying out their custodial role, in order to ensure funding. Both institutions occupy transitionary and sometimes uncertain roles and this enables innovative collaborations that neither institution can offer alone.

References

Boddington, A. and Boys, J. 2011. *Reshaping Learning: A Critical Reader. The Future of Learning Spaces in Post-Compulsory Education*. Rotterdam: Sense.

Boys, J. 2010. Creative differences: Deconstructing the conceptual learning spaces of higher education and museums, in *Looking to Learn, Learning to See: Museums and Design Education*, edited by B. Cook, R. Reynolds and C. Speight. Aldershot: Ashgate, 43–60.

Boys, J. 2011. *Towards Creative Learning Spaces: Rethinking the Architecture of Post-Compulsory Education*. Abingdon: Routledge.

Fisher, S. 2007. *How Do HE Tutors and Students Use Museum Collections in Design?* Qualitative research for the centre of excellence in teaching and learning through design. Unpublished report. [Online]. Available at: http://media.vam.ac.uk/media/documents/legacy_documents/file_upload/41303_file.pdf [accessed: 31 January 2013].

Hooper-Greenhill, E. 1999. *The Educational Role of the Museum*. London: Routledge.

Reynolds, R. 2011. Museum audios for design students: Auditory wallpaper or effective learning support? *Art, Design and Communication in Higher Education (ADCHE)*, 9(2), 151–66.

Reynolds, R. 2012. *Students' Experience of MERL-Based Modules 2010–11 and 2011–12*. [Online]. Available at: http://www.reading.ac.UK/MERL/learnatMERL/MERL-students.aspx [accessed: 31 January 2013].

Reynolds, R., Speight, C. and Walker, K. 2010. Web-based museum trails on PDAs for university-level design students: Development and evaluation. *Computers and Education*, 55(3), 994–1008.

Smith, R. 2010. Student use of a university museum, in *Looking to Learn, Learning to See: Museums and Design Education*, edited by B. Cook, R. Reynolds and C. Speight. Aldershot: Ashgate.

Wheeler, V. 2009. *TACTILE: In touch with the real thing*, presented at the symposium Collecting experiences: Enriching design students learning in the museum, Sackler Centre for Arts Education, Victoria and Albert Museum, London. [Online]. Available at: http://www.adm.heacademy.ac.uk/events/collecting-experiences-abstracts/tactile-in-touch-with-the-real-thing.

White, D. and Manton, M. 2011. *Open Educational Resources: The Value of Reuse in Higher Education*. JISC-funded OER Impact Study. Oxford: University of Oxford.

Whitworth Art Gallery, Manchester University, Manchester. [Online]. Available at: www.whitworth.manchester.ac.uk/learning/post16/tactile/ [accessed: 29 January 2013].

Chapter 10

Enhancing Observational Skills: A Case Study. Collaboration between a University Art Museum and Its Medical School

Linda K. Friedlaender

Introduction

The acquisition of observational skills that distinguish the astute clinician happens after years of clinical experience. A critical aspect of visual diagnosis or 'seeing' is the ability to recognize both subtle and obvious visual details. However, formal teaching of observational skills for medical students is rarely included in their curriculum. In an interdisciplinary collaboration, this study reveals whether the experiential process of seeing such visual details can be enhanced in medical students through systematic visual training using original works of art in a museum setting.

Collaboration

As academic art museums experiment more freely with their role as a resource for teaching in fields as disparate as history, science, English and mathematics, visual literacy has come to be seen as an essential and transferable twenty-first-century skill that promotes cross-disciplinary exchange in new ways (Volk and Milkova 2012, Pickering 2012). Visual literacy is the skill and subsequent process of deriving meaning from a visual object to increase observational skills, the ability to probe, and find a variety of meanings by being open to the unfamiliar (Burnham and Kai-Kee 2011). College and university museums can act as classrooms for the development of visual literacy and observational skills by promoting the ability to look, describe, interpret, negotiate and make meaning from information presented in the form of images. Looking closely at original works of art and deriving meaning and extrapolating ideas from them is a skill that can be taught, a process, which can be actively improved with practice and training, and subsequently transferred to other domains.

Observational skills are the basic tools of a physician. Medical education involves a teacher pointing out to a student a set of facts, observations, or principles that need to be memorized so that the next time they are encountered

and recognized, the problem can be solved. Professors emphasize that one has to look for the details in X-rays, electrocardiograms, biopsy specimens, and so on. Students understand the importance of careful observation, but they do not often know how to look for and identify the details. Visual literacy is an experiential process that is difficult to teach and learn through lecture. Each student must have the experience and practice of close-looking at an object, articulating what they see, and communicating its narrative so that their audience understands their observations and conclusions. The goal is to provide a learning experience for medical students in training for an effective and detailed examination of a patient in a clinical setting.

Art and Medicine: The Yale Center for British Art and the Yale School of Medicine Model

Enhancing Observational Skills is a collaborative museum tutorial now in its fourteenth year between the Yale School of Medicine (YSM) and the Yale Center for British Art (YCBA), both in New Haven, Connecticut. The programme was co-founded by Linda Friedlaender, Curator of Education at the YCBA, and Dr Irwin Braverman, Emeritus Professor of Dermatology at the YSM. Its efficacy was presented in a study published in the *Journal of the American Medical Association* (Dolev, Friedlaender and Braverman 2001), and today its use has been extended by Ms Friedlaender to the Yale School of Nursing; the Yale School of Physician Assistants; the undergraduate curriculum in biological sciences at Mount Holyoke College in South Hadley, Massachusetts; and to the Wharton School of Business at the University of Pennsylvania in Philadelphia, Pennsylvania.

Enhancing Observations Skills is designed to present an equal level of difficulty for each student and faculty by using works of art generally unfamiliar to the participants. The use of representational paintings in the YCBA project capitalizes on the artworks as unfamiliar objects to students; since they have not formed any predetermined bias as to their levels of importance, they attend equally to each of the paintings' details. Additionally, because the students are in a familiar small group with classmates, they are comfortable discussing a subject in which they have no prior training. This provides the opportunity to focus more clearly on the process of looking in a methodical and objective way. Once the painting is inventoried in as much detail as possible, an analytical approach is introduced, using visual cues to draw conclusions about a painting's content. This is analogous to a doctor's clustering of symptoms to draw conclusions about a patient's diagnosis.

In this way, the YCBA project gives practical expression to integrating art and science in education, using fine art as a medium and as a formal training tool for teaching clinical medicine. Dr Braverman's conclusion was that student emulation of attending physicians and house staff alone is often insufficient to develop visual

acuity in a clinical setting. The teaching methodology of the YCBA project uses a student-centred approach to sharpen observational skills and thus accelerate the acquisition and application of visual diagnostic skills (Braverman 1998). One of the core assumptions of this collaborative programme is that the visual tools required to analyse a narrative painting can also be useful in understanding the presence and evolution of patient disease.

The discussion format also serves as an exercise in communication skills. By verbalizing observations, students become more prepared to share diagnostic information about their patients with other health care professionals. This information was gained through anecdotal discussions with students after the exercise.

Once students have completed the visual inventory of details in the painting, they are asked to provide conclusions and/or interpretations of the narrative presented in which several interpretations are possible. In order to narrow down the possible interpretations, students return to the painting to search for other clues to help them form and defend their opinions. This is identical to the process of constructing a differential diagnosis in medicine when working with a patient. For example, is a patient's chest pain related to a cardiac condition (angina), gastic distress ('heartburn'), or plumanary (pleurisy), or a combination of more than one of the above? The internal contradictions in the paintings introduce the doctors-to-be to the problem of contradictory laboratory data in a patient in whom several diagnoses are being considered. Do you just use data that supports the favoured diagnosis and discard the non-supporting data, or do you start over and consider whether the patient may have more than one disorder? You try to make a unifying hypothesis or diagnosis in medicine from all the elements or data that are present, but sometimes that is impossible. Just as in taking a history all the facts may not be related to the same illness, but the patient may have two or more diseases at the same time.

Enhancing Observational Skills in Action

Medical school curricula consistently underemphasize the visual observational skills that are critical to clinical diagnosis, as encountered by our visits to approximately 40 medical centres over the past 10 years. Moreover, methods for teaching these skills have not been found in the academic medical literature. Thus, the objective of this collaboration between the School of Medicine and the Yale Center for British Art was to determine whether medical students enhance their diagnostic visual skills by studying representational paintings.

Each spring, first-year medical students visit the YCBA in groups of 20 and then are divided into five groups of four students each with a facilitator from the museum or medical school. These facilitators are rigorously trained to provide a standardized experience for all students. Facilitators are assigned the same paintings as the students. They must present the object to a small group of

visitors, playing the role of the medical student. Facilitators are then asked to mentor a staff member who is playing the role of the medical student. Facilitators must do this a number of times, finally with the curator of education before they are allowed to work with the students. Staff from the medical school are put through similar training. Students are told they are in the museum to participate in a looking activity to improve their observational skills. Each student is randomly assigned a different painting and has 15 minutes to study it. They may sketch the object and/or take notes on what they see, but this is not required. Students are reminded that this is an exercise about looking and observing and therefore requires no background in art or art history. In addition, object labels on the walls are temporarily covered so that students rely only on the visual information available in the paintings themselves.

After 15 minutes, the facilitators gather their four students together and ask them one by one to report back to the group. Standing in front of the painting, each participant describes his or her object in as much detail as possible without any interpretations, conclusions or opinions. If students begin their presentations with either *I think* or *it appears*, they are asked to use *I see* instead. If they begin to interpret, or use value judgements, they are stopped and asked to use descriptive words to list the painting's visual details. When the student feels he/she has thoroughly inventoried the painting, the others are asked if anything was missed. Learning how to work well collaboratively is a key skill for any health care professional. Then, a student explains what they think is going on in the picture based only on what they see, not what they may know. Any conclusions or interpretations must be grounded in the visual evidence in the painting. Each of the four students has an opportunity to go through this same process with his or her assigned painting.

The first part of the students' presentation is meant to be objective and descriptive. Students are challenged to support any judgements they may make by asking to cite as much descriptive detail for example, to explain 'the person looks sad'. Discussions are structured with open-ended questions, rather than didactic teaching. Direct questioning is used if a specific visual point was not addressed, and often students are asked to elaborate or explain a comment they make. To relate the museum-looking experience to the hospital experience, talking points for paintings were developed that related descriptions of painting to the construction of differential diagnosis, physical examinations and history taking.

Afterwards, all groups reassemble in a museum classroom for a parallel session with Dr Braverman focusing on dermatologic case studies. Students are given enlarged colour photographs of a variety of skin lesions to describe and evaluate as a group.

Following on the heels of the gallery exercise, their language was determined by the moderators to be more extensive, and their descriptions more elaborate and detailed than students who did not work in the galleries. For example, students

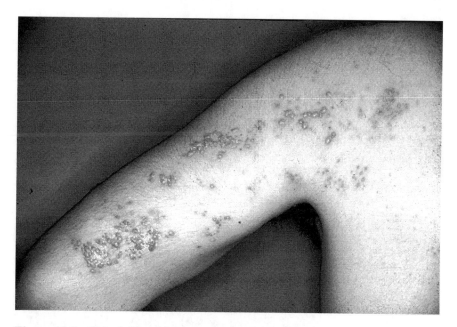

Figure 10.1 Skin Lesion (© Irwin Braverman, MD)

referenced patterns, texture, colour, shapes and repetition while describing a skin rash.

Non-representational or abstract paintings are not currently used for this programme. They require a certain level of experience and informed viewing skills, which are not part of most museum visitors' backgrounds. Many studies of the development of skills in aesthetic appreciation have determined that facility in looking at art is more experientially based than chronologically based (Housen 1987).

Representational painting on the other hand, is painting that seeks to depict the physical appearance of reality. Only representational paintings are used in *Enhancing Observational Skills*. The most effective representational paintings are filled with easily recognizable objects and can be described by a common vocabulary. For example, in 'The Death of Chatterton' (object labels are covered), a figure is draped across a bed, with an arm hanging over the side. Is he comatose? Drunk? Or dead? Paintings with some ambiguity about their meaning were also purposely selected to mirror similar clinical situations where there may be more than one issue going on. We purposely use nineteenth-century English Victorian paintings with strong narratives (Figure 10.2).

However, like many of these paintings, there may be more than one way to interpret what is actually going on using the same visual information. Sometimes, the exact answer just cannot be determined from looking. This is where a medical student would be called upon to find alternate methods of confirmation as to a diagnosis, or may decide that more than one issue may be going on at the same time.

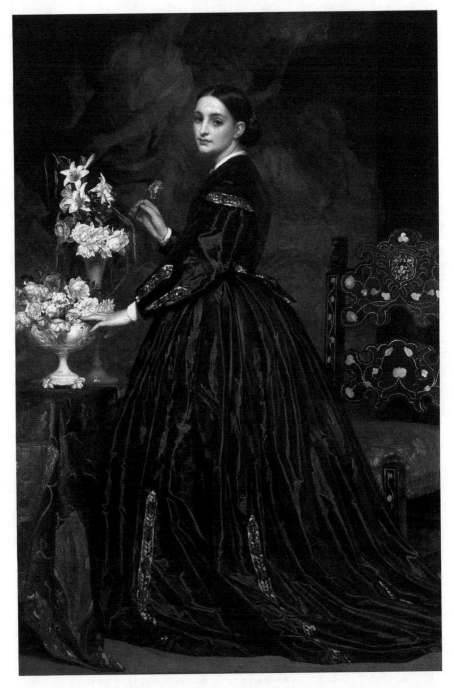

Figure 10.2 *Mrs James Guthrie*, c.1864–1866, by Lord Frederic Leighton, courtesy of Yale Center for British Art, Paul Mellon Collection

The use of representational paintings in the teaching design of the YCBA project capitalizes on the artworks as unfamiliar objects to the students. Viewers attend to all of the paintings' details, since they have not formed a predetermined bias giving weight because they have not given weight to visual details subconsciously deemed 'important'. This observational bias occurs when someone sees a familiar object, like a person's face, and filters out the details. As Conan Doyle's character, Sherlock Holmes, noted, 'Circumstantial evidence is a very tricky thing. It may seem to point very straight to one thing, but if you shift your own point of view, you may find it pointing in an equally uncompromising manner to something entirely different.' Thus, the aim is not only seeing, but flexible, fluid seeing.

Assessing the Museum Intervention

During the first month of the doctor–patient encounter in the first year of medical school, students were encouraged to participate in the YCBA project, which uses a student-centred approach to teaching. In academic year 1998/1999, 90 medical students who expressed an interest were randomized to a control group, an intervention group, or a lecture group. In 1999/2000, 86 students were randomly assigned to either the control group or the YCBA group. A lecture group was not used this year after preliminary data revealed no change in the students' observational performance. By the end of their academic year all students, regardless of group assignment for the purpose of this study, attended the YCBA for visual training as part of the general curriculum.

The control group attended clinical tutorial sessions in which a physician preceptor taught history taking and physical examination skills. The lecture group attended an anatomy lecture that featured abdominal radiographic images related to that week's dissection. The intervention group attended the YCBA programme in which each student studied a preselected painting before describing it in detail to their group of four students.

Sets of photographs (A and B) of persons with medical disorders were administered as a pre-test prior to the groups' sessions and as a post-test after they were completed. Students randomly received either set A as the pre-test and set B as the post-test or vice versa. Students were given 10 minutes to write descriptions of what they observed in each photograph. They were specifically asked not to provide a diagnosis. Students' descriptions were evaluated blindly using a grading key. Grading keys, developed in advance, included 10 points of characteristic features necessary for proper diagnosis for each photograph.

In both years, the students in the group who took part in the gallery activity achieved significantly higher scores in the post-test exam than the control group, and improved their observational skills more often (63 per cent vs 29 per cent) (Figure 10.3).

Our findings suggest that students who received the museum intervention were better observers and were better able to organize both global and detailed

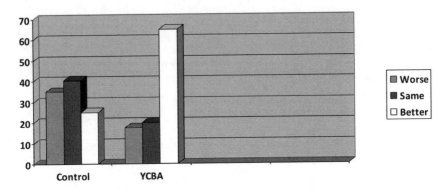

Figure 10.3 Bar graph depicting changes in observational scores between the control and YCBA groups (Dolev, Friedlaender and Braverman 2001)

diagnostic clues. We conclude therefore that medical students can be trained to enhance their clinical visual skills – typically experientially learned – by studying original works of art (Table 10.1).

Table 10.1 Chart breaking down the performance of students in the control and YCBA groups (Dolev, Friedlaender and Braverman 2001)

	Pre-test %	Post-test %	P
YCBA N=81	50.0+0.1	57.0+0.1	0.0001
Control N=65	47.01+0.1	46.0+0.1	0.2

A visit to a hospitalized friend who was a pre-operative patient and visibly anxious and agitated about her impending surgery inspired Friedlaender to design this programme to enhance observational skills. During the visit, the surgical resident checked on the friend but was unable to address her concerns because he missed otherwise apparent behavioural clues, namely that she was agitated and worried. This missed opportunity led Ms Friedlaender to feel that enhancing the observational skills of doctors was important in optimizing the care of patients. With Dr Braverman, who felt medical students were too dependent on tests and machines to gain more information about their patients, they presented to the dean of medical school education the idea that the experience of visually analysing a painting with abundant recognizable detail could be useful in enhancing a medical

student's observational skills. The dean requested proof that this approach did have merit before he was willing to incorporate the programme into an already full medical school curriculum.

The YCBA project gives practical expression to the long-proposed ideals of integrating art and science in education by using fine art as both a medium and a formal training tool for teaching clinical medicine. Currently, medical observational skills often remain hidden within curricula and are frequently transmitted ineffectively to medical students who tend to acquire these skills through emulating the example of consultants/house staff when attending patients. The medical student's approach to learning is a critical factor in determining the quality of their learning outcomes. Learning should enhance self-directed skills, provide a stimulating environment, promote interactions between students and staff, encourage collaboration between disciplines and increase student motivation and enjoyment. Superficial use of visual learning approaches may lead to routine pattern recognition with neither sufficient inspection of details, nor a necessary understanding of the visual clues that compose the global clinical picture. Most often dependent on experience, diagnostic observational skills are challenging to teach. The teaching design of the YCBA project uses a student-centred approach to observational learning in an effort to provide the experience necessary for improved observation and to thereby accelerate and enhance the process of acquiring and applying visual diagnostic skills.

Another Application of a University / Art Museum Collaboration

The most important practical lesson that can be given to nurses is to teach them what to observe and how to observe (Nightingale 1860). Linda Honan Pellico is an Assistant Professor in the Yale University School of Nursing (YUSN) graduate entry pre-specialty in nursing programme. Her programme, *Looking is not Seeing*, is based on the premise of how to educate students to notice what seasoned clinical specialists can (personal communication 1997). Can the process of acclimation to nursing be sped up to improve students' observations and analyses? To find out, a new collaboration was created with the YCBA six years ago.

After following the same procedure as the medical students, Pellico came up with other focused questions for her students in the galleries. Does the painting relate a story, similar to how a patient tells a story, and what does his/her body's story tell us? Helping students become keen observers, recognize patterns, cluster data, and reinterpret observations are fundamental skills needed for diagnostic reasoning (Pellico, Friedlaender and Fennie 2008).

An important aim in training these nursing students is to see how students handle confounders to conflicting data. Do they try to merge them all? Do they ignore pieces that do not fit? Do they see only one issue? The aim is not only fine tuning observational skills but also the development of problem setting skills defined as 'a process in which, interactively, we name the things to which we will attend and

frame the context in which we will attend to them' (Schon 1983). The hope is that this exercise will forewarn nursing students of a potential tendency to self-select observations, categorize too quickly and easily and ignore conflicting cues.

Nursing students who visited the museum as part of the intervention subsequently wrote more about what they saw in post-tests, resulting in significantly more objective clinical findings when reviewing patient photographs (Pellico, Friedlaender and Fennie 2008). In addition, participants demonstrated significantly more fluidity in their differential diagnosis by offering more alternative diagnoses than did the control group.

Conclusion

In summary, our hypothesis is that the experience of visually analysing a narrative painting and having to articulate what you see first without interpretation can be used as an important tool in enhancing observational skills of health care professionals. By adopting this enhancement to the medical and nursing schools' curriculum, observational skills can be strengthened and more opportunities for effective and efficient diagnosis are made possible.

Conan Doyle reminds us that looking is not seeing. In *A Scandal in Bohemia*, Conan Doyle relates this exchange between Sherlock Holmes and his friend Doctor Watson:

> 'You see, but you do not observe. The distinction is clear. For example, you have frequently seen the steps which lead up from the hall to this room.'
> 'Frequently.'
> 'How often?'
> 'Well, some hundreds of times.'
> 'Then how many are there?'
> 'How many! I don't know.'
> 'Quite so! You have not observed. And yet you have seen. That is just my point …'.
>
> (Doyle 1891)

Professor Christiane Nusslein-Volhard was awarded the Nobel Prize in Medicine in 1995 for observing a subtle change in the developing fruit fly egg. Although many investigators had worked with the same material, she was the only one who detected this subtlety. She had a hobby of making jigsaw puzzles based on modern paintings such as those of Mondrian. She cut her own pieces with no two being alike. The pieces were cut along boundaries that did not cross fields of colour or shapes that would assist her in assembling the puzzle. She had to rely solely on the outlines of the pieces and how they fitted together. She credits her work with puzzles as sharpening her ability to find tiny details where others cannot.

Some of the most important attributes medical students need to cultivate are those of curiosity and observation. Keen observation of patients has been the hallmark of the best clinicians no matter their specialty. As de Vinci reminds us 'sapere videre', 'learn to see things'.

Acknowledgement

Thanks to Dr Irwin Braverman and Dr Jacqueline Dolev for their collaborative efforts on this study and continued support of the programme. Thanks as well to Professor Linda Pellico of the Yale School of Nursing for continued support and growth of our collaboration.

References

Braverman, Irwin. 2011. To see or not to see: how visual training can improve observational skills, edited by Philip R. Cohen, *Dermatologic Disquisitions and Other Essays*, Clinics in Dermatology. New York: Elsevier Science Inc. 343–6.

Burnham, R. and Kai-Kee, E. 2011. A brief history of teaching in the art museum, in *Teaching in the Art Museum: Interpretation as Experience*. Los Angeles: Getty Publications, 46.

Dolev, J.C., Friedlaender, L.K. and Braverman, I.M. 2001. Use of fine art to enhance visual diagnostic skills. *Journal of the American Medical Association*, 286(9), 1020–21.

Doyle, A.C. 1891. A scandal in Bohemia, in *The Adventures of Sherlock Holmes*. New York: Harper & Bros, 1.

Housen, A. 1987. Three methods for understanding museum audiences. *Museum Studies*, 2(4), 41–9.

Nightingale, F. 1860. *Notes on Nursing: What Is It, and What It Is Not*. Oxford: Appleton.

Pellico, L., Friedlaender, L. and Fennie, K. 2008. Looking is not seeing: Using art to improve observational skills. *Journal of Nursing Education*, 48(11), 648–53.

Schon, D. 1983. *The Reflective Practitioner*. London: Temple Smith.

Volk, Steven and Milkova, Liliana. 2012. Crossing the street Pedagogy: Using college art museums to leverage significant learning across the campus, in *A Handbook for Academic Museums: Exhibitions and Education*, edited by Stefanie S. Jandl and Mark S. Gold. Edinburgh and Boston: MuseumEtc Ltd 2012, 88–115.

Chapter 11

Object-Based Learning: A Powerful Pedagogy for Higher Education

Leonie Hannan, Rosalind Duhs and Helen Chatterjee

Introduction

The unique power of objects to convey ideas has long been understood by people who work with museum collections. Over the last 40 years, pedagogies that privilege active and experiential learning have become dominant in education. This sea change in teaching methods, from 'chalk and talk' to student-centred approaches, has seen the introduction of object handling to encourage learning in a wider range of educational contexts, notably schools and further education. However, learning from objects has remained a niche activity in HE, generally restricted to students of archaeology or geology – but this is beginning to change. At University College London (UCL), there are three public museums: the Grant Museum of Zoology, the Petrie Museum of Egyptian Archaeology and the UCL Art Museum, alongside a range of departmental collections, including Archaeology, Ethnography, Earth Sciences, Medical Physics, Pathology, and Physiology. By gathering an evidence base for the pedagogical power of OBL, researchers and teachers at UCL have promoted closer connections between their museums and academic departments, and made a contribution to the development of innovative teaching and learning in this sector. Whilst some academic disciplines have always used objects to elucidate meaning, evidence suggests that the principles of object-based learning (OBL) can have a positive influence on students of all disciplines and levels of progression. However, achieving widespread acceptance of the value of this pedagogy has its challenges. Understanding staff and student assumptions about, and expectations of, their teaching and learning can help overcome these obstacles. This chapter will explore experiences of implementing OBL using university museum collections across a range of academic departments at UCL.

The Case for OBL

In the last decade, the Museums and Public Engagement department has made significant progress in its mission to promote the benefits of OBL for teaching and learning in HE (Chatterjee 2008a, Duhs 2010). This drive to establish OBL in the university classroom builds on a broader evidence base for its efficacy in

other educational environments (Durbin, Morris and Wilkinson 1990, Lane and Wallace 2007, Paris 2002). For example, object handling sessions have long been commonplace for school groups and museum visitors, but the acceptance of this technique as beneficial for learning in HE is relatively recent. Notwithstanding this, university museums and collections were formed as learning resources and, as is the case at UCL, often date back to the origin of their respective disciplines within their host HE institutes.

Through successfully engaging a wide range of academic departments, across the arts, humanities, social sciences and sciences, UCL's museums have been able to demonstrate the pedagogical benefits of OBL. In 2010–11, a survey was conducted that recorded students' experiences of this style of learning as compared with more traditional methods and the results were extremely positive (see discussion below). Here the interface of museum and university cultures will be explored in relation to the promotion of OBL as a powerful pedagogy for HE.

In HE, traditional methods of teaching such as the lecture have remained dominant despite the move away from teacher-centred approaches experienced across the education sector (Jones 2007). The longevity of this style of teaching is explained by both the institutional culture of universities and the economic advantage of maintaining large student to teacher ratios. However, with the recent changes to the funding of HE and the new fees regime, there is a heightened emphasis on providing a high-quality student experience of learning. Research-led universities, such as UCL, have had to consider carefully how they will advance an agenda that values excellence in teaching alongside world-leading research. For new academic staff in university departments, the relationship they strike between their research and teaching will be critical to achieving a greater parity of esteem between the two.

Since the 1970s, the advantages of active, experiential and student-centred learning have been promulgated by a large and growing literature on education. In particular, David A. Kolb's (1975) experiential learning cycle had wide-ranging ramifications for pedagogical best practice in adult education. More recent studies, such as Healey's (2010) work on active learning in the context of teaching geography at university level, contribute to the weight of evidence concerning student-centred teaching in HE. The uptake of principles of active and experiential learning has been dependent to some extent on academic discipline and existing teaching traditions. For example, earth scientists and archaeologists have always engaged actively with artefacts of the geological and material world and engineers and mathematicians are highly practised at using problem-based learning techniques to advance student understanding (see for example Prince 2004). Other subjects, such as English Literature or History, have typically pursued highly text-based learning methods in fairly static teaching environments (Hodgson 2011). These traditions in teaching styles are difficult to change, but in a university such as UCL, with such a broad range of academic disciplines, there is a wealth of experience to be shared.

Active learning is strongly focused on what the student does as opposed to what the teacher does (Biggs 2006, Blackie, Case and Jawitz 2010). Learning in this way is effective because it engages students in the process of meaning making (Merriam and Heuer 1996). Instead of passively trying to absorb precepts delivered during a talk or lecture, active learning scenarios encourage students to form their own connections between their existing knowledge and new concepts. This process of making linkages has positive implications for longer-term recollection of knowledge learned. Jack Mezirow (1991) has emphasized the importance of both reflection and dissonance in the learning process. As Illeris explains:

> Transformative learning is about being conscious of, considering and reviewing one's meaning perspectives and the habits of mind that follow from them. This typically occurs when one discovers in one or other connection that the meaning perspectives do not fit with what one experiences or does. Then dissonance or a dilemma arises ... and this takes place first and foremost through reflection, leading to revision or transformation of the meaning perspectives.
>
> (Illeris 2007: 63)

One strategy for encouraging student engagement with a particular dilemma is enquiry or problem-based learning. Objects can be used to provoke enquiry, especially when students have not previously encountered the artefact or specimen and have to apply learned principles to the diagnosis of an object's features, material composition or provenance (Ballantyne and Knowles 2007). The benefits of enquiry-based learning have been explored in detail in recent research (see for example Deignan 2009, Healey 2010, Spronken-Smith and Walker 2010, Wood 2003).

In line with current thinking on active and experiential learning, UCL has adapted its strategies on teaching to reflect a student-centred approach. As previously mentioned, these changes will have important implications for the enhancement of the student experience of learning at UCL. The institutional learning and teaching strategy includes in its 'Vision' the aspiration to 'provide a research-led and student-centred learning experience to students from across the world in a context of innovation, dynamism and inclusivity' (see http://www.ucl.ac.uk/teaching-learning/strategic_priorities/ILTS). Moreover, the strategy values the contribution to be made by the university's museum collections – stating that 'UCL has an outstanding resource in its Museums and Collections and departments are strongly encouraged to exploit the potential of object-based learning in their teaching' (ibid). Through careful advocacy for the tangible benefits of OBL, it has become recognized that university museums can facilitate not only the successful acquisition of subject-specific knowledge, but also the development of research, communication, and critical thinking skills – all of which help to make UCL students more employable. Gaining formal recognition of OBL as a part of UCL's approach to teaching and learning has been an important step forward for the Museums and Public Engagement department.

University Museums

University museum collections in the UK were largely established in the eighteenth and nineteenth centuries during a time when pioneering archaeologists, zoologists and collectors hoped to capture the world's knowledge, categorize and codify its contents for the benefit of future generations. These collections were explicitly intended for use in academic research and teaching. However, in the second half of the twentieth century, use of these collections – outside strongholds of object-based study such as archaeology – declined. Museums that had once been seen as repositories of contemporary knowledge came to be viewed as old-fashioned cabinets of curiosity, lacking relevance to modern university curricula.

Like many HE institutions, UCL's museums comprise a series of atomized collections, many of which were historically lodged in academic departments. Over the last 10 years, these disparate collections have been drawn together under one departmental jurisdiction and this has allowed staff to establish common goals for the care and use of these objects. This change has been important in terms of establishing an overarching policy for the use of objects in teaching and learning at UCL. In the past, collections were acquired, curated and used for teaching and research in discipline-specific environments and it is still the case that scientists engage with objects in very different ways to humanists. However, by synchronizing activities under one department, it has been possible to promote much wider use of the collections and to make an argument for an educational value that transcends subject-specific criteria. Increasingly, lecturers are finding ways to use objects from a range of collections to help students learn new ideas and skills. Examples of this more experimental use of objects in learning have informed the design of an object-based core module for the new interdisciplinary undergraduate degree, launching at UCL in 2012–13 (see http://www.ucl.ac.uk/basc).

Increased use of collections in the university's teaching has occurred in the context of an equally dramatic upsurge in the public museums' engagement of wider audiences and the general public. But whilst public programmes play a crucial role in making universities relevant to their local communities, university museums cannot overlook the valuable role they can play within their own institutions. With a vast population of students, staff and visiting researchers – making the museum collections relevant to these audiences is essential. Moreover, university museums offer the potential to bring researchers together, from different disciplines, around themes of mutual interest. In this way, exploiting the use of collections and museum spaces to initiate novel lines of enquiry can consolidate a central role for museums in both teaching and research.

OBL: Why it Works

The pedagogical power of OBL is closely linked to the success of active and experiential learning techniques. At UCL researchers have collected information

on the specifics of how this method can achieve desired results for university students. In 2005, Meyer and Land identified the specific need to help HE students master 'threshold concepts' and overcome blocks around 'troublesome knowledge'. Research on OBL at UCL has shown how this strategy can help students to negotiate such difficult areas in their learning and make important conceptual leaps (Chatterjee 2008a, Chatterjee and Duhs 2010, Duhs 2010).

In 2010–11 a survey was conducted with 154 students about their views of the value of using objects for teaching and learning. Students from a range of disciplines, including biology, geology, anthropology and medicine, were asked to complete a questionnaire immediately after an object-based teaching session. The questions covered issues such as positive and negative aspects of the session, the kinds of skills that were used, the relative value of OBL as compared with more traditional methods, and the overall improvement in understanding resulting from the session. The survey found that 61 per cent of students either agreed or strongly agreed that OBL is a more effective way of learning than listening to a talk or lecture (40.4 per cent agreed and 20.6 per cent strongly agreed).[1]

In terms of positive features of OBL, students emphasized the interactive, hands-on and visual learning experience and also the way the session had engaged their attention, been inspiring and enjoyable. Comments included: 'it's visual, tangible and fun'; 'you are involved in learning so can learn better, can ask questions and discuss'; 'fun, exciting, thrilling'; and you 'know how to apply rather than just imagining, (leads to a) better understanding'; and results in a 'good visual impact, practical application'. Students said that they expected the session to improve their understanding of subject-specific knowledge, but results also confirmed that the technique helped students to develop transferable skills. For these groups of students, the development of teamwork, communication and observation skills ranked extremely highly in their learning experience. A comparable survey, undertaken with students from the arts and humanities, showed that observation and analytical skills came out most strongly from their engagement with art objects.

Throughout, student answers to the survey commented on the 'hands-on', 'interactive' and 'engaging' qualities of the activity – stressing the importance of learning by doing to long-term understanding. This finding is supported by research that explores the importance of kinaesthetic activities to memory retention (see for example Baddeley 1992, Clark and Paivio 1991, Craik and Lockhart 1972 and Paivio 1986). Moreover, scholarship is beginning to show that the engagement of multiple senses (including sight and touch) aids the acquisition and retention of new concepts, knowledge and ideas (see Chatterjee 2008b, Romanek and Lynch 2008). Translating this principle into a different realm, Thomson et al. (2012) have shown the positive therapeutic outcomes for patient welfare resulting from the handling of museum objects in a hospital environment. Taking this growing evidence base and applying it to teaching strategies in university classrooms has

1 30.9% neither agreed nor disagreed, 6.6% disagreed, and 1.5% strongly disagreed.

the potential to improve students' ability to acquire and retain subject knowledge, overcome barriers to difficult areas of learning, and improve transferable skills and employability. Moreover, they could accomplish all of this and actually enjoy the experience.

Overcoming Barriers

Despite the compelling evidence base demonstrating the pedagogical efficacy of OBL, there are still barriers to its acceptance amongst teaching staff in HE. The student survey results highlighted that where students felt that OBL sessions needed improvement, it was around the quality of facilitation and the hands-on access to objects. For example, a biology student complained that his/her learning was hampered by there being 'too many people in the class, not enough demonstrators'. A geology student commented that 'you may have to wait' some time for a facilitator to be able to answer specific questions. These concerns about the running of object-based sessions focus strongly on the logistical difficulties of facilitating small group, hands-on activities and point to the need for such sessions to be well resourced with teaching staff. They also highlight a continuation of traditional approaches whereby learners depend strongly on the teacher (demonstrator). Students feel more secure when teachers lead from the front of the learning space or intervene in students' practical work, in this case OBL. Active learning systems where OBL sessions are designed to fit transparently into courses' intended learning outcomes have the potential to create a sense of purpose and direction for students (see for example Biggs 2012). Students need to become independent self-directed learners (Knowles 1975) to engage fully with objects.

Joe Cain (2010) has elucidated the obstacles to using objects in teaching from the lecturer's perspective. Cain describes OBL in a HE context as 'a tough sell', explaining that:

> Most tutors have strong incentives to not change their curriculum and to avoid spending time developing diversions that seem mere curiosities. Demands on our time are crushing, and our reward systems are quite specific. Time spent on curriculum re-design is time away from things that are better rewarded.
>
> (Cain 2010: 197)

But even once a lecturer has decided to re-design some teaching, there are challenges. For example, enhancing a teaching session with digital images of objects in a PowerPoint presentation or handout might seem a lot easier than taking students to visit a museum. In fact logistical difficulties are some of the most significant barriers to staff use of museum objects in teaching. As Cain details, issues as varied as the spatial arrangement of the teaching room, the timing of the lesson, student access to a limited number of objects, the novelty of the session and need for preparation, all conspire to discourage a lecturer from planning an object-

based teaching session. At UCL, the museum curators have worked hard to make their museum spaces available for teaching and to facilitate access to objects; in 2010–11 UCL museums recorded over 5,000 student uses of their collections from 135 different modules. In reality, however, most university teaching takes place in the traditional environments of seminar room, laboratory and lecture theatre.

Despite all these concerns, it is possible to 'sell' OBL to university teachers. In the first instance, it is important to focus on what OBL can offer the lecturer quickly and efficiently. For example, most teachers want their students to be engaged and enthusiastic about their topic – museum objects can provide novelty, intrigue and hands-on activity. Lecturers often worry that students are too dependent on the perceived 'answers' contained in a lecture and are, consequently, not making the transition to becoming curious, critical, independent learners. Facing students with an unknown object and asking them to deduce what they can from its physical form, encourages just the sort of analysing and hypothesizing that are the life force of scholarly enquiry. Moreover, recent generations of university students have grown up in a highly multimedia environment and expect departures from textbook and whiteboard in their experience of education. However, to appreciate all of these points, teachers have first to understand something of contemporary pedagogies, which points to the crucial role of staff training in the improvement of HE.

Cain's argument, that it is important to understand the lecturer's perspective in order to promote the use of OBL, is borne out by experiences at UCL of proliferating the use of collections in teaching. Although websites, leaflets and emails all help to disseminate information, nothing is more effective than talking with individual teachers about their practice and the ways they might wish to incorporate museum collections in their teaching. By engaging with lecturers' goals and interests in a specific, rather than generic, way – working partnerships can be formed and confidence built.

The learner's perspective is also worth considering. It is helpful if teachers explain the many advantages of active learning. If students are accustomed to sitting quietly listening in a lecture theatre, hands-on learning may prove challenging. They will be more likely to get fully involved in OBL activities if they understand the rationale for student-centred approaches. Clear instructions and carefully articulated core learning outcomes for sessions provide much-needed structure.

Also, as museum professionals, it is important to acknowledge the use of collections digitally and encourage this form of engagement alongside more traditional collections-based teaching. Speaking with teaching staff individually, tailoring provision to their needs, and providing much-needed practical support has proved a successful strategy for promoting the use of collections in teaching at UCL. This teaching spans a broad cross-section of academic subjects, from the arts to the sciences, and includes undergraduate and postgraduate students. The appointment of an Object-based Learning Teaching Fellow at UCL has accelerated the promotion of collections-based teaching and helped to ensure it is widely embedded in practice. There is, of course, still much more to be done.

Conclusion

Experiences of promoting OBL for teaching and learning at UCL have been valuable for their exploration of staff and student views on this subject. The process has also helped develop an evidence base for the pedagogical power of OBL for HE. Whilst museum professionals have always understood the value of contact with artefacts and specimens, articulating the specifics of this benefit in educational terms has sometimes proved more of a challenge. Moreover, the language of 'active', 'hands-on', 'interactive' education has traditionally been considered the preserve of early years, rather than a legitimate mainstay of learning in HE. These views are changing, but slowly, and university museums can play an important role in the development of a new and improved approach.

References

Baddeley, A.D. 1992. Working memory. *Science*, 255, 556–9.
Ballantyne, N. and Knowles, A. 2007. Enhancing student learning with case-based learning objects in a problem-based learning context: The views of social work students in Scotland and Canada. *MERLOT Journal of Online Learning and Teaching* 3, 363–74.
Biggs, J. 2006. *Teaching for Quality Learning at University: What the Student Does*. Maidenhead: Society for Research into Higher Education/Open University.
Biggs, J. 2012. What the Student Does: Teaching for enhanced learning. *Higher Education Research & Development*, 31(1), 39–55.
Blackie, M.A.L., Case, J.M. and Jawitz, J. 2010. Student-centredness: The link between transforming students and transforming ourselves. *Teaching in Higher Education*, 15(6), 637–46.
Cain, J. 2010. Practical concerns when implementing object-based teaching in higher education. *University Museums and Collections Journal*, 3, 197–201.
Chatterjee, H.J. 2008a. Staying essential: Articulating the value of object based learning. *University Museums and Collections Journal*, 1, 1–6.
Chatterjee, H.J. (ed.) 2008b. *Touch in Museums: Policy and Practice in Object Handling*. Oxford: Berg.
Chatterjee, H. and Duhs, R. 2010. Object Based Learning in Higher Education. *CETLD Learning at the Interface Conference Proceedings*. [Online]. Available at: http://arts.brighton.ac.uk/__data/assets/pdf_file/0010/18649/01-Object-based-learning-in-higher-education.pdf. [accessed: 29 May 2013].
Clark, J.M. and Paivio, A. 1991. Dual coding theory and education. *Educational Psychology Review*, 3, 149–210.
Craik, F.I.M. and Lockhart, R.S. 1972. Levels of processing: A framework for memory research. *Journal of Verbal Learning and Verbal Behaviour*, 11, 671–84.
Deignan, T. 2009. Enquiry-based learning: perspectives on practice. *Teaching in Higher Education*, 14(1), 13–28.

Duhs, R. 2010. Learning from university museums and collections in higher education: University College London (UCL). *University Museums and Collections Journal*, 3, 183–6.

Durbin, G., Morris, S. and Wilkinson, S. 1990. *Learning from Objects: A Teacher's Guide*. London: English Heritage.

Healey, M.J. 2010. *Active Learning and Student Engagement: International Perspectives and Practices in Geography in Higher Education*. London: Routledge.

Hodgson, J. 2011. *The Experience of Joint Honours Students of English in UK Higher Education*. The Higher Education Academy: English Subject Centre Report Series, 26.

Illeris, K. 2007. *How We Learn: Learning and Non-Learning in School and Beyond*. London: Routledge.

Jones, S.E. 2007. Reflections on the lecture: Outmoded medium or instrument of inspiration? *Journal of Further and Higher Education*, 31(4), 397–406.

Knowles, M.S. 1975. *Self-Directed Learning: A Guide for Learners and Teachers*. New York: Association Press.

Kolb, D.A. and Fry, R. 1975. Toward an applied theory of experiential learning, in *Theories of Group Process*, edited by C. Cooper. London: John Wiley, 35–6.

Kolb, D.A. 1984. *Experiential Learning: Experience as the Source of Learning and Development*. Englewood Cliffs, NJ: Prentice-Hall.

Lane, J. and Wallace, A. 2007. *Hands On: Learning from Objects and Paintings. A Teacher's Guide*. Glasgow: Scottish Museums Council.

Meyer, J.H.F. and Land, R. 2005. Threshold concepts and troublesome knowledge (2): Epistemological considerations and a conceptual framework for teaching and learning. *Higher Education*, 49(3), 373–88.

Merriam, S.B. and Heuer, B. 1996. Meaning-making, adult learning and development: A model with implications for practice. *International Journal of Lifelong Education*, 15(4), 243–55

Mezirow, J. 1991. *Transformative Dimensions of Adult Learning*. San Francisco: Jossey-Bass.

Paivio, A. 1986. *Mental Representations: A Dual-Coding Approach*. New York: Oxford University Press.

Paris, S.G. 2002. *Perspectives on Object-Centered Learning in Museums*. London: Lawrence Erlbaum Associates.

Prince, M. 2004. Does active learning work? A review of the research. *Journal of Engineering Education*, 93(3), 223–31.

Romanek, D. and Lynch, B. 2008. Touch and the value of object handling: Final conclusions for a new sensory museology, in *Touch in Museums: Policy and Practice in Object Handling*, edited by H.J. Chatterjee. Oxford and New York: Berg, 275–86.

Rowe, S. 2002. The role of objects in active, distributed meaning-making, in *Perspectives on Object-Centered Learning in Museums*, edited by S.G. Paris. Mahwah, NJ: Lawrence Erlbaum Associates, 19–36.

Spronken-Smith, R. and Walker, R. 2010. Can inquiry-based learning strengthen the links between teaching and disciplinary research? *Studies in Higher Education*, 35(6), 723–40.

Thomson, L., Ander, E., Lanceley, A., Menon, U., Noble, G. and Chatterjee, H.J. 2012. Quantitative evidence for well-being benefits from a heritage-in-health intervention with hospital patients. *International Journal of Art Therapy: formerly Inscape*, 1–17. DOI: 10.1080/17454832.2012.687750.

Wiley, D.A. (ed.). 2000. *The Instructional Use of Learning Objects*. Bloomington: Indiana Association for Instructional Technology and Association for Educational Communications and Technology.

Wood, W.B. 2003. Inquiry-based undergraduate teaching in the life sciences at large research universities: A perspective on the Boyer Commission Report. *Cell Biology Education*, 2, 112–16.

Conclusion
Opportunities for the Future

Jos Boys, Anne Boddington and Catherine Speight

In our introductory chapter we outlined a series of opportunities that the contemporary moment offers for museums and HE to work together – realizing the possibilities for new hybrid models and practices, new kinds of dialogue, and harnessing the potential of new digital opportunities. In their different ways, the contributors to this volume have engaged with, informed and questioned just how such 'openings' might be developed that could transform future collaborations and learning processes. The objective of this volume was primarily to outline potential opportunities for exploring a more joined-up use of our cultural resources as well finding ways to deal effectively and creatively with the impact of reductions in public spending. This concluding chapter will aim to summarize and reflect on the sections of the book and then offer a series of potential ideas that might shape future policies and practices in HE and museums.

Strategic Alliances, Knowledge Exchange and Opportunities

All four contributors in Part II 'Strategic Alliances, Knowledge Exchange and Opportunities' begin from an understanding of learning as a hybrid activity that occurs in different forms and in many specialist as well as public locations. Within this context, each contributor examines how to construct effective frameworks for learning that are designed to help position both the learner and the different institutions. In so doing each chapter confronts both the changing nature and shifting purpose of HE as well as the changing use and role of museums. Juxtaposing these two different but scholarly types of institutions also highlights how different and divergent views of the relationships between learning and education are held by museum professionals and academic institutions. Each of the four contributors has identified challenges in how best to cultivate and progress strategic partnerships between different museums and universities that include: what constitutes the appropriate assessment and evaluation of learning that occurs; how it could be more explicitly evaluated; and how to value and embrace knowledge and expertise beyond the conventional divisions between teachers and learners.

Curating, Collecting and Creative Practice

In Part III 'Curating, Collecting and Creative Practices', the three contributors examine the specific characteristics of learning within the museum. Their central interests are the nature and content of display and the role of collections and objects in understanding 'meaning-making' within the wider world. Writing predominantly from an art and design perspective, the authors reflect on current attitudes and approaches to curatorial authority and how this has shifted over time from one of emulation of masterpieces to that of – as Ganz Blythe describes it – practices of 'appropriation and intervention'. The contributors raise questions and reveal assumptions about how academics in HE not only demand 'services' from museum professionals but also desire recognition of a scholarly partnership. However, they also wish to retain a critical and questioning role that enables subversion of the perceived orthodoxies of public display. Central to such debates are a series of questions not only about the locus of curatorial authority and expertise in framing our collective cultural and social histories; but also the importance of universities and of museums maintaining a degree of political detachment and independence. Together they leave us with questions as to who interprets, who creates new narratives and who, when these interventions aim to disrupt perceived conventions, are the intended audiences? Similarly, if such interventions are permitted, what are the risks if such practices fail to connect with more conventional and popular understandings of what museums are for?

Expectations, Assumptions and Obstructions

Part IV 'Expectations, Assumptions and Obstructions' explores the gap between the internalized and more rarefied dialogues between museum and university experts, and the more popular expectations as to what museums and universities might offer to HE. For example, Winstanley's research (Chapter 8) reveals some of the basic anxieties her students have about even entering the museum, let alone engaging with some of its more esoteric activities. Importantly, the other contributors to this part examine in detail the kinds of experiential and 'non-verbal' aspects of learning that museums offer through engagement with collections and objects. Here, we suggest, is a vital point – that what museums and universities could share more effectively is their expertise in experiential and OBL that extends beyond the lecture theatre and seminar room and builds on the idea that visual and haptic learning offer different ways of applying knowledge to understand the world. Museums and universities have a wealth of knowledge and expertise, but have yet to commit to developing a series of shared values and a common language that could transform the way learning and teaching are perceived by both sectors.

Facing Up to Current Challenges

In our introduction we raised the challenges that publicly funded museums and HE institutions now face across the world in demonstrating their value, resource-effectiveness and their social and cultural roles particularly in times of severe economic constraint. For UK universities, the significant rise in tuition fees and the marketization of HE have fuelled academic concerns that students will be forced to become educational consumers so changing the motives for learning. This could arguably lead either to more radical forms of educational innovation or increasingly reductive educational experiences, as all public institutions are forced to achieve more with less or generate new sources of income.

For universities that already host museum or archival collections, such resources have the potential to complement and extend the disciplinary culture of HE by creating learning spaces that can offer alternative perspectives on disciplinary forms of knowledge and stimulate opportunities for interdisciplinary dialogue and public engagement (Chatterjee 2008a, 2008b, Duhs, 2010). However, it has been argued (Cook, Reynolds, Speight 2010) that in contrast to university-based facilities, public museums find it difficult to respond directly to the needs of HE, because it is harder to design or develop resources in the same way that they can for more prescribed topic-based primary and secondary school curricula. In addition there are misconceptions by museums and universities about the ways in which public displays in museums may be used for effective teaching and learning in HE. The assumption is that their displays will be used, as they are in schools, as didactic, knowledge-based support for the teaching of specific subjects, an approach that inhibits a more lateral and creative use of the different forms of knowledge on display and the learning opportunities these suggest.

As we noted in the introduction, current museum-university collaborations remain, as represented by the case studies in this volume, predominantly individual, one-off projects that have been independently funded and hence tied to the institutions that produced them. Such targeted resources and activities – while positive for their participants and offering much local value – have tended to limit the forging of more strategic relationships as suggested by Hannan, Duhs and Chatterjee (Chapter 11). Our proposition is that enriching and expanding the range of strategic educational and scholarly activity between museums and universities could refresh ways of learning and thinking differently. However, we would also argue that this requires a realignment of shared values and a different understanding about the way in which partnership is conceived, one that is not driven by short-term funding.

This conclusion is structured into three sections. First, we examine – by focusing on the values and relevance of object and collections-based learning as a public good – how museums and universities can better understand and promote collaborative activities as a vitally important form of learning. Second, we consider the issues that museums and universities need to address when working in partnership; this includes the 'public engagement' context, the impact of digital

technology, the different kinds of spaces for learning and how to show impact through effective evaluation. Finally, we propose that museums and universities need to develop shared communities of practice, through which experts from both sectors can come together to build and sustain long-term, robust and influential collaborations through debate, projects, partnerships and campaigning.

Promoting the Value and Relevance of OBL as a Public Good

Essential to examining learning in the context of museums is the need to understand the value and relevance of object-based and experiential learning, and how this might be more broadly and strategically applied and promoted in museums and other contexts. Our research has only just begun to shape responses to these questions by offering examples of good practice, of working across sectors and by contributing to emerging debates as they arise. While Part III offers evidence of the value and relevance of object-based study, it remains challenging to see how these arguments might be directly translated into something more persuasive at a national policy level. Simply suggesting that these ways of learning are 'visual, tangible and fun' is unlikely to have much impact in generating support for more comprehensive, robust and longer-term museum-HE partnerships. The contributors to this volume have begun to articulate compelling and interdisciplinary examples of effective OBL, as a means to understand how knowledge is constructed.

In looking forward we need to examine how museums and universities can build persuasive and compelling cases for strategic collaboration, by outlining what possible changes could be made to achieve the goal of working together more effectively and how this might contribute to the enrichment of creative, social and cultural public learning.

A key question is how we can contribute to and affect strategic and governmental policies across HE in general, and museum–university partnerships in particular. In the current financial climate, partnership activities need to focus on creating maximum educational value for minimum effort and on ensuring that what is developed is replicable in different contexts and disciplines. Our goal is to expand the arguments about the contributions museums and universities can make collectively to education in its broadest sense. To achieve this we must promote and provide evidence of the critical importance of creativity as vital to being human, and as core, rather than peripheral, to workplace knowledge, related skills and to personal fulfilment (Robinson 2011, Collini 2012). Our argument underlines the development of a culture of learning and inquisitiveness as a fundamental public good, and such that we teach communities how to engage with local and national museums as effectively as possible.

Strategic collaborations with museums or with other cultural agencies present opportunities to develop new hybrid pedagogies and curricula that support the 'shaping (of) a democratic, civilised and inclusive society' (Dewey 1997: 72). From 1997 to 2010 museums in the UK have received increased investment and

contributed to the social inclusion agenda. Universities in turn could learn from the successes museums have achieved in this area. However, it is the potential combining of such scholarly resources that is most potent; for example, museums present and shape forms of knowledge through their curation of objects and public displays that can help to contextualize the predominantly disciplinary learning that occurs within universities.

Central to our proposition is the need to ensure that students benefit from the kind of demonstration of context which museum-university partnerships potentially could facilitate. As a combination they offer the potential for enhancing both specialized and applied learning in a more sustainable manner. To achieve such goals however, we must recognize the importance and relevance of the different aspects to learning (in the John Dewey sense) that help us to understand how knowledge is constructed and how we can read and understand the world through objects and images as well as through texts.

These challenges may appear modest but have significant implications and pose fundamental questions about the changing role of universities and museums and how they are likely to transform. While there is little space or time here to dwell on the implications of such fundamental changes for the roles and responsibilities of researchers, curators, teachers, museum educators and institutional managers, there are many questions that will emerge as the impacts of austerity and shifts in the global economy take their toll. The examples included in this volume from University College London and the Yale Center of British Art can be added to others (Jandl and Gold 2012a, 2012b) as exemplars from which to build strategic contemporary arguments about the need for learners to experience different ways of knowing. This is essential in a world that is increasingly mediated through technology and that often prioritizes text and image over the physical, tactile and visual presence of objects and spaces. Yet we have so much to gain from our encounters with material objects.

Expanding on OBL

Research into how learning takes place has been broadened in recent years to examine the unspoken interactions of learning. These include, for example, both the hidden agendas in relationships between students and their teachers (Austerlitz 2009) and the centrality of learning attitudes as well as the formation and development of subject knowledge and skills (Lave and Wenger 1991, Wenger 1998). Many scholars and educational researchers are attempting to gain a better understanding of how best to explore and theorize the non-verbal aspects of the visual, material and experiential worlds (Pink 2006, 2009, 2012, Infold 2011, 2013, Rose 2011), and creativity more generally (Hallam and Ingold 2008, Sennett 2009). This has been termed in contemporary theory as the 'practice turn' (Knorr Cetina, Schatzki and von Savigny 2000), which emphasizes the role of objects and our responses to them as central and is having a significant impact on research

across subjects such as anthropology, ethnography, cultural theory, visual and material culture and the social sciences. However, these innovative new forms of engagement have yet to permeate pedagogic theories or learning and teaching methods. It is therefore important to develop a critical framework that can help to shape what we mean by OBL, and to find a shared language that enables effective communication and demonstration of its value and relevance.

The following are aspects of object-based scholarship through which museums' collections, enable particular and important kinds of experiential learning to take place:

1. What the Artefact or Collection Brings

Each artefact in a museum provides a potential learning 'portal' and embodies multiple, and often, contradictory ideas and narratives. This could provide a vehicle for understanding the fragile and complex conditions that occur in order to create even the simplest artefact. Demonstrating this with an array of objects, illustrates in a very tangible and visual way, how different aspects of knowledge intersect within any entity. OBL offers a complementary approach to the type of disciplinary learning that occurs within universities which might best be described as thinking about things. OBL on the other hand provides opportunities for thinking through experiencing things that engage learners in visual and haptic ways and thus embodies learning and extends their critical and creative skills.

An example of this approach is the renowned economics essay 'I Pencil: My Family Tree as Told to Leonard E. Read' (1958, reprinted 2006) written by the American economist Leonard Read, which reflects on the inherent complexities that underlie the modest wooden pencil. It uses the idea of OBL, albeit described in essay form, and applied to a familiar everyday object. This offers perhaps a more holistic and embodied form of learning that extends beyond the traditional positioning of museum learning in the arts and humanities by using OBL to learn about other fields of knowledge or disciplines, in this instance materials science, business and economics.

2. The Context of the Object

In addition to the value of OBL, as outlined above and in detail by Chatterjee et al. (Chapter 11), the context in which an object is encountered and understood is equally critical. Context provides opportunities for more complex and nuanced readings that extend beyond the intrinsic nature of the object and which address questions about the interrelationships of objects in both time and space. These contexts may include, for example, examining curatorial authority within the museum, including how museums are challenged by the 'wisdom of the digital crowds' or by the creation of 'contact zones' that stimulate and encourage other voices and positions to be represented and heard (Pratt 1992). Examples of curatorial disruption are documented by Ganz Blythe, Williams, and Mackenna

and Janssen (see Chapters 5, 6 and 7) in this volume. These raise questions as to how public audiences might better understand the authorities located within museums that are broadly responsible for the curatorial and critical narratives central to constructing public histories.

Context stimulates new pedagogic possibilities – not only through the means by which learners encounter objects but also through the practices of educators and curators. Both are already deeply engaged with how objects and collections are framed, and the ways in which narratives are affected by how and where objects are located, as well as their relationships to each other, and to the stories that are woven around them. The artists and designers writing in this book often struggle with the effects of context on the 'reading' of work in the museum. From a different perspective, Bautista and Balsamo (see Chapter 3) explore how the blurring of the boundaries between digital and physical forms of representation also establish new kinds of contexts and raise questions as to how we understand not only real but digital artefacts. Each of these perspectives has implications for how such encounters are managed and how we engage with, and understand objects.

3. What the Learner Brings

If the first aspect of an object is its intrinsic nature understood through different forms of experiential and textual analysis, and the second, the idea of context and the reading of objects within time and space, then the third aspect is what prior skills and knowledge each learner brings and applies to their learning experience as considered by Falk and Dierking (1992). Their application will draw on their preconceptions, senses, verbal and non-verbal engagements as well as their more conventionally understood background knowledge and skills. As Winstanley (Chapter 8) identifies there are many practical barriers to the use of public learning spaces including museums from the suitability of spaces that can accommodate different forms of learning to timetables. In addition there are also the preconceptions that students bring to the museum about what their involvement and experience is likely to be and therefore explicit enabling practices are required by both teachers and curators.

Each of the three aspects outlined above also imply different levels of engagement, knowledge and skills. In universities, learning is structured and sequenced into levels and modules; in museums, learning is generally defined as open-ended and has been accompanied by new modes of interpretation which may include different visitor responses or multiple perspectives. The different aspects of OBL outlined here suggest there are a series of thresholds for assessing knowledge of OBL in HE that could inform a learning framework for use across both sectors.

A potential structure is outlined in Table C.1, with the aim of informing a tiered framework for beginners, intermediate and advanced level learners. For museums, the framework could inform the design and evaluation of OBL activities; for universities it could reveal the use and value of museum collections for HE

audiences and how this can best be embedded into HE courses. For learners of all kinds, the framework provides a palette of opportunities that enables choice from immediate and sensory learning (sight, touch, scent) through to more abstract and conceptual ideas.

Table C.1 Outline diagram of education 'levels' and learning objectives across museums and universities

Level	Learning objectives
Basic: Understanding what is there	Learning to look: developing powers of observation, curiosity, attention to detail, descriptive abilities, visual literacy, object/spatial/visual analysis
	Haptic learning through touch: developing awareness of tactile and tacit knowledge through senses, feelings and memories
	Engaging with materials, objects and spaces thorough hand, eye and body: developing drawing, making, performing, story-telling as forms of recording and expression
Intermediate: Building from what is there	Generating inspiration: developing abilities in lateral thinking, creativity and the exploration of both emotional and intellectual ideas
	Providing a reference point: offering models and patterns (material, form, colour, structure, interrelationships) as sources of further enquiry
	Learning complex analysis across multiple variables: understanding the connections between material things and their processes of production and consumption, within specific historical, geographical, political, economic, social and cultural contexts
	Designing sequences and narratives: selecting and combining elements for specific purposes, curating, exhibition, events organization
Advanced: Integrating what is seen with what is known	Engaging with alternative perspectives: undertaking and understanding complex interpretations, dealing creatively and critically with the unfamiliar, developing second order thinking, making persuasive arguments
	Imagining alternative scenarios: exploring translational and transformational changes through making and remaking ideas, texts, things and spaces
	Doing applied research: developing ideas, hypotheses, undertaking investigations and evaluations, drawing conclusions, making recommendations
Professional: Transforming what is there	Generating new propositions: challenging existing knowledge, creatively and critically disrupting existing assumptions, designing improvements, understanding and managing complex change, innovation, creative entrepreneurship

The learning framework described above demonstrates the opportunities that OBL and learning from museum collections offer museum and university personnel when working together. It is our proposition that there are considerable and as yet, untapped learning opportunities that have the potential to transcend traditional disciplinary boundaries.

In the next section, we consider some of the different contexts of these opportunities including the 'public engagement' context, the impact of the digital, the different spaces for learning, and how to show impact through effective evaluation.

Museums, Universities and Public Engagement

While museums have long and chequered histories of successful engagement with the public, relationships between universities and their local and regional communities in the UK have been more variable. More recently, factors such as policy commitments to widening participation and access (Hart, Maddison and Wolff 2007), and to business and community engagement are having a significant impact on HE. In the context of recent changes in the UK, the National Coordinating Centre for Public Engagement (NCCPE) makes three distinct cases (moral, business, academic) for universities considering the value and methods of public engagement. These are outlined below:

- The moral case – universities are accountable to the public for the funding they receive.
- The business case – universities need to generate additional income, enhance their reputation, motivate their staff and students, contribute to their professional development, improve the quality of their teaching and research, and improve the recruitment and retention of staff and students.
- The academic case – public engagement enables universities to contribute positively to society through the co-production and building of knowledge that inspires learning, and empowers individuals.

(NCCPE 2012 in Oakley and Selwood 2010: 15)

The contribution universities make to regional, social and cultural capital, and the 'moral' and 'academic' cases underpinning university engagement are all familiar through, for example, providing support to create new knowledge or new insights, collaborative ventures or activities with external organizations. Increasingly familiar is the growing civic role universities play within their local and regional communities. Many have responded imaginatively to government policies and reports that have long promoted the need to increase universities' contribution, engagement and economic development in various different ways. However, despite these efforts the making of a business case is generally less familiar and less palatable to university and museum audiences and the arguments, and consequently the evaluation tools, tend to be predicated on basic and outmoded models of knowledge transfer and transmission, rather than evaluating the extended

agency of universities to stimulate creative, cultural and social environments, generate regional prosperity and enhance the quality of life through their public, cultural and business activities.

Museums are regularly acknowledged for their educational and civic roles in participating-in and supporting public and social life but a 'business' case based on explicit and measurable knowledge transfer 'from' the museum to the external organization or individual is not so obviously achievable. Museums tend to have much less instrumental aims. They are actively engaged in demonstrating, promoting and sharing their knowledge, collections and expertise with others as a way of increasing access but also in becoming more responsive social organizations (Sandell 2003, Janes 2009).

A collaborative or participatory museology (Were 2010, Schultz 2011) emanates from the ideas surrounding social activism and social inclusion that have positioned the museum within a perceived moral framework of inclusivity (Sandell and Conaty 2005). Within the field of Museum Studies, while some have embraced this role as a way of reviewing the value and purpose of museums (Sandell 1998, Janes 2007) others have argued that it has drawn museums away from their traditional purposes and placed them at the whim of instrumental government agendas, where they are at risk of being employed for the delivery of politically motivated social and cultural agendas that threaten their perceived objectivity (Houlihan 2001).

Some of the authors in this volume have examined ways in which the two sectors have worked together, more or less productively, to enhance their public engagement and from different historical and cultural locations. The Beacons for Public Engagement programme in the UK for instance, see Watermayer (Chapter 4) was established with the broad aim of building capacity for public engagement across the UK university sector. The initiative (2008–2011) was made possible by large-scale investment supported by the UK Higher Education Funding Councils, the UK Research Councils and the Wellcome Trust. It comprised the National Coordinating Centre and six collaborative centres or 'Beacons' across the UK, each consisting of a number of universities and partnership organizations with a remit to foster a 'culture change' in universities. One of the initiative's successes, as outlined by Watermayer, was the opportunity to establish relationships with the creative and cultural sectors and in particular museums and galleries. But, despite the success of many museum-university partnerships in the programme, the experience also raised concerns about some of the cultural differences between the two sectors:

> In the last few years we've run a number of events where we've brought university and museum professionals together to explore partnership. What we've heard from museum professionals is that university academics don't always respect their expertise in engagement and see the museum as a 'quick fix' to reach the public with quite old fashioned kinds of dissemination activity: they don't recognise that the culture of museums has changed quite dramatically and

that they could really benefit from museum professional's expertise in creating really engaging experiences for visitors.

(Manners 2012, Director of NCCPE)

Underpinning these observations is the challenge to find ways of establishing resilient and sustainable partnerships that recognize the differences between museums and universities (as outlined in the introduction) but also have clear shared goals and values. Here we are suggesting that there is a need to 'de-centre' collaboration as the assumed imperative and instead concentrate on the development of shared and complementary learning experiences, that have public engagement as a central theme. This means teasing out what is particular and important to learning from objects and collections to HE audiences. Such clarity would enable more explicit negotiations to occur around the framing and precise nature of shared learning objectives as the central activity of museum–university partnerships. It would also enable universities and museums to be more explicit about the value and relevance of museum and university education to contemporary culture and society, creating a shared purpose within which multiple, creative and life-enhancing forms of learning can be devised and accessed at different levels (e.g. informal workshops to stimulate imagination, to structured and accredited HE) can demonstrate the purpose and value of museums and universities working together as part of the broader continuum. For example, part of a long-term goal could be to inculcate through school and university, an educational experience that enables all students to recognize the use and benefit of public resources such as museums to inform their lifelong learning. The centrality of objects and spaces to our daily lives and the importance of creativity, non-verbal communication and visual literacy are, we believe, critical work-related competencies that have a role in fostering social and cultural capital and are increasingly recognized in the workplace by employers (Sennett 2009, Robinson 2011).

Responding to the Digital

It is vital that OBL is positioned within the context of social and cultural change in particular the interweaving of physical and virtual environments. There remains considerable research to be undertaken in this field, but in this volume Bautista and Balsamo (Chapter 3) introduce and outline the transformations created by the interweaving of the physical and the virtual, through the re-framing of knowledge and the impact of social media on contemporary learning. As they highlight, recent decades have seen a blurring of boundaries between different types of institutions and the forms of representation and displays that museums present to their visitors. In contrast to other contributors Bautista and Balsamo conclude that museums are no longer tied solely to the physicality of objects, but can also offer digital surrogates that provide alternative portals for visitors of all kinds to museum collections.

They raise issues about the purpose and value of intersections between virtual and physical forms of encounter. Although digital surrogates provide effective memory triggers and introductions to objects, we believe physical encounters remain essential in embedding different forms of experiential knowledge rather than relying wholly on the digital learning encounters (Carr 2011).

In recent years, the expansion of the online educational resources (OER) movement through the development of reusable learning objects has been one of the most consistent examples of how an online presence can be achieved.

As Roy Clare acknowledges in his preface, museums, (and arguably universities) need to reconsider the nature of their online presence. It is no longer enough for any educational or scholarly institution to merely host a website. Instead the virtual environment is a distinctly different but complementary space with a set of roles that have yet to be fully defined and examined. Museums and universities, both independently and collaboratively are just beginning to develop educational resources that are aimed more specifically at HE level learners. For example, University College London offers support for tutors developing OERs including those related to OBL as one of its core teaching and learning methods and based on the use of its own museums (see Chatterjee et al., Chapter 11, http://www.ucl.ac.uk/teaching-learning/teaching-learning-methods/object-based-learning).

Learning as a Different Kind of Space

So far we have espoused the value of advancing OBL as the form of shared educational provision between museums and universities but we also need to examine the value and experience for students of 'being in a different space' and what this lack of familiarity brings to their learning experience (Boys 2008, Austerlitz 2009). Winstanley notes in (Chapter 8) that there are three aspects to helping students and academics share discursive spaces, in which the safety and authority of the lecture or the seminar formats are destabilised: Winstanley presents a practical focus on stimulus, establishing the 'right frame of mind', and providing both motivation and support as essential starting points. To achieve these, however, requires a rethinking of educational practices and the development of learning models that complement these different physical, virtual and hybrid environments.

Many authors have explored how learners require a 'safe' and familiar place from which to begin their learning (Boys 2008, 2009b, Sagan 2009). However, such spaces should not just provide a comfort zone for learners but instead create what the psychoanalyst and paediatrician Donald Winnicott has termed a 'holding environment'. This is a transitional space designed to stimulate both empathy and imagination. For example, in the context of OBL our overarching goal would be to nurture within every student the ability to demonstrate their knowledge and understanding through multi-sensorial engagements with objects and spaces and to understand the context in which they are learning.

Chapters 8 and 9, from Winstanley and Reynolds and Manfredi respectively, both address the physical spaces of the museum and their impact on visitors, from their intimidating facades to the interrelationships between study-spaces and the collections. Their questions raise more critical concerns about the fitness for purpose of many standard types of spaces across both universities and museums. Many assumptions still remain about the nature of the museum and university experience, for example it is not clear why we continue to view objects in galleries standing up or why we continue to create lecture and seminar spaces in both institutions in the traditional theatre style, given the significant shifts in both pedagogy and technology. Is it possible to provide comfort and the opportunity for visitors to get up close to objects alongside the need for security and protection? How can museums and universities create spaces that allow for in-depth scholarly activity with more self-determined or free-choice learning? What is the contemporary 'space' of object display in a world that is increasingly blurring the boundaries between physical and virtual environments?

James Clifford (1997), drawing on the work of Mary Louise Pratt, has argued that museums might be considered 'contact zones' – permeable spaces that can bring together dispersed and fragmented forms of knowledge but also sites of potential discord and conflict where different demands are played out. Gere (1997), like Bautista and Balsamo in this volume, suggests that this idea owes much to the Internet's communication model but suggests that such spaces of exchange, negotiation and communication can be far more problematic than might first appear, raising issues of mediation, access and control.

Defining and Evaluating Impact

There has long existed an expectation that museums and universities will measure the impact of their activities as a way of demonstrating and justifying the public funding they receive. The need to justify public funding, balanced with the demand for articulating how the sector contributes to the local and national economy, has been a source of some difficulty for both sectors. The thorny issue of accountability and measuring the value and impact of their activities is an area that attracts a great deal of criticism from those working both in and outside the sectors, particularly when evaluation is done mechanistically (for example, through attendance figures or satisfaction surveys). Stephen Weil in his essay 'Making Museums Matter' (2002) talks instead about what constitutes a museum's 'worth'. As he put it, in another paper: 'the awkward fact still remains that for a variety of reasons, the museum field has never really agreed, or at least until recently, has scarcely even sought to agree on some standard by which the relative worthiness or merit of its constituent members be measured' (Weil 2000: 1). This issue of how to measure the impact of cultural activities is critical but also problematic, further exacerbated when providing evidence of cost and value in times of financial difficulty. Stanziola (2008), writing on behalf of the now defunct

Museums, Libraries and Archives Council (MLA) has argued that it is essential for museums to demonstrate their purpose and value to the sector as pre-requisite for their sustainability: 'For measuring and articulating the value and impact of the sector is more than an academic exercise, given the policy, financial and business structures in which most cultural organisations operate in England' (2008: 320).

So, what ways of thinking about this problem does Weil offer? First, he proposes differentiating between means and ends:

> 'Ends' will be used to describe those positive differences in – those ultimate impacts on – the lives of its community and the community's members that a museum is deliberately trying to bring about through its activities. 'Ends' are the objectives for the sake of which it does everything else that it does. In tandem with that definition, 'means' will then refer to everything else - all of the money, staff, collections and other things that a museum has to have; all of the exhibitions, scholarship, conservation and other things that it has to do in order to achieve its ends.
>
> Ultimately to be argued is that the comparative worthiness of any museum must be determined, first, by reference to the particular ends it seeks to accomplish, not to the means it employs toward those ends, and, second, that such a determination must take into account both the significance of those particular ends and the museum's relative success in their achievement.
>
> (Weil 2000: 2, emphasis in original)

Thus the museum's mission, and its evaluation, (despite the many complications and distractions in understanding this that Weil goes on to list) must ultimately be about making a difference: 'When the day was over, the sun had set and the crowds gone home, what had you accomplished? What difference had you make? In what ways had the world been improved? How had somebody's life been made a little better?' (Weil 2000: 10–11)

Both museums and universities then, (together with other UK public institutions and creative and cultural industries) urgently need to find ways of arguing for, and measuring the impact of, these kinds of social, cultural and public good. When it comes to learning, whilst universities can offer comparative recruitment, retention and achievement statistics, most academics share a commitment to similar 'ends' to those described above, to more vague and complex concerns with improving people's opportunities and lives. As Falk articulates this with regard to learning in the museum (but it is equally applicable to university education):

> The overwhelming majority of earlier investigations of museum learning were predicated on historical, primarily behaviorist views of learning. In this traditional view, individuals were assessed to determine whether they learned specific, predetermined information, much as someone would test learning in a traditional classroom. Although well-thought-out exhibitions and programs

can facilitate visitor learning of predetermined topics, the inherent complexity and choice offered by the museum environment, coupled with the widely varying experiences and knowledge levels of museum visitors, yields a far greater range of possible learning outcomes than can be accommodated by the assessment strategies created for the older absorption-transmission model. In addition ... significant conceptual change is unlikely to occur within a single visit. It may take days, weeks, or months for the experience to be sufficiently integrated with prior knowledge for learning to be noticeable even to the learner himself, let alone measurable.

(Falk 1999: 260)

It is the richness and longevity of these kinds of learning, and their value and relevance to individuals and to society as a whole that should ultimately be the aim of museum–university collaborations.

Towards Communities of Practice

Finally, in considering how such strategic collaborations could be achieved, there is a need for a responsive framework for knowledge exchange shaped around learning, skills and resources.

Useful in this context, as Beckmann (Chapter 2) also concludes, is Etienne Wenger's communities of practice model (Wenger 1998).

He suggests three key elements are needed to develop a 'community of practice':
1. a domain, which defines the area of shared enquiry;
2. a community with relationships between members and a sense of belonging;
3. a body of knowledge, methods, stories, cases, tools and documents that he refers to as the 'repertoire'.

Wenger's model has its limitations that are important to acknowledge from the outset. First, it tends to assume stability as the (preferred) norm in a community of practice, rather than valuing the tensions, contradictions and transformations that occur; second, it is implicitly about reinforcing the boundaries between insider and outsider, rather than envisaging the more permeable boundaries that are likely to be essential in strategic relations between public sector organizations. Third, Wenger does not really explore how individuals manage the joining of different communities of practice simultaneously. Despite these limitations, the idea of 'communities of practice' has been taken up within HE in particular, because it appears to express something essential about the nature of complex disciplinary and professional learning, as a vital and underlying process in the development and interaction of bodies of knowledge, beliefs, attitudes and activities. Thus if we are to develop and embed learning across both sectors, whether academics, researchers, curators or museum educators, we need to revisit the roles and responsibilities we have long assumed within our respective disciplines. This

would enable us to articulate more explicitly both our creative differences (Boys, 2009a) and to understand what it is we share and the potential value of collaboration for enhancing learning.

Stanziola (2008), writing on behalf of the former MLA pointed to the importance of developing a more sophisticated system for measuring the impact and value of the museums' sector and in particular how this approach could help increase and improve the museums' (libraries and archives) sector relationship with HE:

> Through the development of new knowledge exchange forums and reviewing our funding timetables, the MLA is looking forward to increasing our ties with the HE sector. We will support and promote more proactive partnerships between academics, policy makers and practitioners, where our practical knowledge of the sector and understanding of the policy and political landscape, and academics' understanding of and experience in modelling, theory building, and their healthy scepticism are powerfully combined to promote innovation and support the development of the museums and galleries sector.
>
> (Stanziola 2008: 320)

In this passage Stanziola suggests that one of the incentives for museums to work with universities is the exchange of knowledge between one and the other – with museums learning about systems of governance and understanding theories of research and innovation, helping both sectors to understand one another and by implication what their experience of working together is likely to be. For example, all museums face common challenges in the way they deliver educational experiences, make the most of their collections, develop their workforces and reflect and sustain a sense of community, in addition to working with partners inside and outside the sector (DCMS 2006). Universities too, face similar challenges in the way they nurture skills development and provide professional training but also in identifying their contribution to economic prosperity (Oakley and Selwood 2010).

In examining these two parallel scholarly sectors, a key challenge in the development of a new 'community of practice' is how disruptive of the 'conventional' idea of a museum or a university such a community might be, what it might look like and whether it would still define itself through its traditional ways of working. Both the designer-led contributions in this volume centre on the perceived problem of museum experts perpetuating given histories over contested or alternative narratives. Although many museum curators and educators wrestle daily with this issue, the value of outsiders' views is in opening up the potential for ways of rethinking curatorial and educational practices in the museum, and in the university.

In their various ways Ganz Blythe, Williams and Mackenna and Janssen are all arguing for a different kind of space where objects and exhibitions are themselves acts of critique about the world. As outlined in the Part IV, developing direct visceral relationships with objects (through handling and making, alongside

interpretation) is central to the value of museums for experiential learning and may offer additional and powerful forms of expression to the participatory museum. We would therefore argue that this level of using objects as a form of critique must be explicitly understood as one form of engagement among many others and that alternative voices and spaces can be created and curated both physically and digitally.

Central to this debate is the underlying issue of power and who has control over the making of meaning at both the local level, as well as in constructing the public narratives made official in museums. In their different ways Williams, and Mackenna and Janssen, attempt to claim a place in museum-led narratives about designed objects, particularly by re-centring the (radical) intentions of the artist or designer. They refuse to ignore questions of power relationships, and contest the meanings themselves as those more normatively constructed within museum collections. Such challenges raise two wider issues: what constitutes authoritative expertise (and who has it); and how should this power be exercised in relationship to diverse understandings of the world?

A great deal of this volume is informed by contemporary discourses within the fields of art and design, so it is important that we question whether such practitioner-led discourses are in fact introspective and therefore fail to engage with other subjects or the history of their own disciplines. Returning to Ganz Blythe's central point: whilst there has been a shift over time from seeing museums as enabling the emulation of great artistic works (Classicism), to generating innovation through understanding (Arts and Crafts), to creative disruption (Avant-garde), none of these relationships is better or more 'correct' than any other. As Ganz Blythe notes:

> Following the gambit from authority of the past over the producer in the present, to the autonomy of the individual to construct irrespective of the past, we appear to be left with a choice between polarities. But what if we were to see the education of artists and designers as a complex progression through several coexisting models of 'keeping good company'? As such, the museum offers the physical and conceptual space for what Jean-Luc Nancy has called the 'co-appearance' of simultaneous paradigms of being and learning.
>
> (Ch. 5, this volume)

This suggests that there is a need for a broader and more critical self-reflection on these relationships, and their ability to contextualize both historically and across disciplines. This is helpfully and specifically articulated by Beckmann (Chapter 2) in her detailed analysis of these partnerships and the three parties involved.

While we would argue, as Ken Robinson does (2011), that learning – and life more generally – demands the creative and critical combining of emotion and rationality simultaneously, there is a long and contested history of difference between ways of knowing in the arts and the sciences, such that this has generated artificial divisions in the ways we learn. Over time this has required educators to formulate innovative ways to bridge these divisions and to support both the depth

of disciplinary learning and the ability to contextualize and situate knowledge through non-conventional study techniques. In attempting to construct a more holistic model of learning that is, in the Dewey sense, embedded in the practices of life itself, Etienne Wenger's communities of practice model (1998) offers a way of situating learning in a world in which building communities of practice may be the most innovative, productive and effective way to learn. See also Beckmann (Chapter 2) for a museum's perspective of this model.

What Would a New Community of Practice Look Like?

Below we suggest a loose framework and a possible list of the processes that such a community of practice across museums and universities might agree to as a domain of shared enquiry. Constructing such a domain (with its associated community and repertoire) could form a strong alignment of interests across the two sectors as distinct from individual and isolated collaborations. Here we aim for a framework that facilitates stability and cohesion in order to maintain the boundedness of a group, but also allowing space for creative differences, distinctiveness and non-aligned overall objectives. Our proposition is a community of practice that could underpin future museum and university collaborations and that is built upon the core values of object-based and creative learning, that is:

Creatively disruptive

> Learning elsewhere in the world such that the 'academy' is conceived as a network physically as well as virtually engaged not only with other scholarly environments but where 'going somewhere else' in order to have different conversations is a vital as part of the creative learning process.

Sensorial

> Bringing together analytically and through systematic, creative experimentation, non-verbal, haptic investigation as well as textual and verbal analysis using visual and physical media (images, objects and spaces) as the means both to disrupt the centrality and authority of the spoken and written text as the main form of knowledge exchange, and to share and improve the precision and detail of descriptive and analytical language through closer and shared encounters.

Dialogic

> Sharing a dialogue through social learning and through a range of shared interpretations and mediated devices that compare authoritative views and other layers of meaning – i.e. drawings, images, objects, discursive learning.

Embodied

> Constructing meaning through creative acts, making and remaking.

Creative misreading as a means of learning or re-learning to play.

Developing skills in making lateral connections, to reveal unexpected gaps and opportunities to create and ask good and refined questions.

Interconnected

Creating the narratives of objects as a means of bringing together and revealing many different types of knowledge – the object as a portal.

Demonstrating, in a structured way, the interconnections between different kinds of knowledge and skills: e.g. economics, history, materials science, aesthetics, engineering and industrial production.

Situated

Exploring and understanding the effects of context.

Engaging with what constitutes authoritative knowledge, and issues of power, meaning and control.

Conclusion

This book has been written at a difficult time for many public-funded institutions globally, and when HE – particularly the arts and humanities – has been perceived to have been under some attack in the UK.

In conclusion, our proposition is that out of these difficult times comes the potential for some creative thinking of what learning can be, where and how it can take place. We see, as does Beckmann (Chapter 2), new opportunities for hybrid and cross-institutional sharing which can benefit not just learners but also scholarship, society and culture more generally.

The various contributors have explored and reviewed good practice examples of museum–university partnerships, as well as opening up for debate both the successes and problems in these relationships. We have argued that there is still much to do in terms of developing collaborative pedagogies and scholarship, especially in object-based learning; and in articulating the kinds of roles, responsibilities and spaces that might enable more effective, resilient and long-term partnerships in the future. Most crucially we have proposed that to enable creative and sustained growth in this area, we need to develop and implement better strategies in three key areas – resource-effectiveness, value and relevance, and partnering in learning (through shared definitions of, and campaigning for, the special kinds of learning that museums offer, and by building communities of practice across sectors).

Ultimately this is about how museums and universities together could develop and promote their learning activities and spaces, such that difference is celebrated, dialogue and debate are stimulated and learning is promoted as

an active rather than a passive proposition, as part of all our diverse everyday experiences. Within the current social, cultural and political context in which we find ourselves, such models of creative learning can and must demonstrate the value and use of our public resources. We must also continue to promote the essential role of the arts and humanities in exploring what it means to be human, in stimulating the development of our public and personal imagination, creativity and innovation, and in enriching people's lives through education.

References

Cook, B., Reynolds, R. et al. (eds). 2010. *Looking to Learn, Learning to See: Museums and Design Education*. Farnham: Ashgate.

Hallam, E. and Ingold, T. (eds). 2008. *Creativity and Cultural Improvisation*. Oxford: Berg.

Ingold, T. 2011. *Being Alive: Essays on Movement, Knowledge and Description*. Lodon: Routledge.

Jandl, S.S. and Gold, M.S (eds). 2012a. *A Handbook for Academic Museums: Exhibitions and Education*. Edinburgh: Museums, etc.

Jandl, S.S. and Gold, M.S. (eds). 2012b. *Academic Museums: Beyond Exhibitions and Education*. Edinburgh and Boston: Museums, etc.

Knorr Cetina, K., Schatzki, T.R. and von Savigny, E. (eds). 2000. *The Practice Turn in Contemporary Theory*. London: Routledge.

Lave, J. and Wenger, E. 1991. *Situated Learning: Legitimate Peripheral Participation*. Cambridge: Cambridge University Press.

Lave, J. and Wenger, E. 1998. *Communities of Practice: Learning, Meaning and Identity*. Cambridge: Cambridge University Press.

Pratt, M.L. 1991. Arts of the contact zone. *Profession*, 91, 33–40. [Online]. Available at: http://writing.colostate.edu/files/classes/6500/File_EC147617-ADE5-3D9C-C89FF0384AECA15B.pdf [accessed: 31 January 2013].

Pink, S. 2006. *Doing Visual Ethnography: Images, Media and Representation in Research*: London: Sage.

Pink, S. 2009. *Doing Sensory Ethnography*. London: Sage.

Pink, S. (ed.). 2012. *Advances in Visual Methodology*. London: Sage.

Rose, G. 2011. *Visual Methodologies: An Introduction to Researching with Visual Materials*. London: Sage.

Sennett, R. 2009. *The Craftsman*. Harmondsworth: Penguin.

Wenger, E. 2011. Social learning capacity: Four essays on innovation and learning in social systems, in *Reshaping Learning: A Critical Reader. The Future of Learning Spaces in Post-Compulsory Education*, edited by A. Boddington and J. Boys. Rotterdam: Sense, 193–210.

Winnicott, D. 1965. *Maturational Processes and the Facilitating Environment: Studies in the Theory of Emotional Development*. London: Hogarth Press.

Afterword

Many years ago, when working at the National Maritime Museum in Greenwich, I developed a temporary gallery for young children aged three to eight years to accompany the museum's exhibition on the Spanish Armada. The gallery was highly participative, with a reconstructed section of a sixteenth-century ship for children to explore, and a storytelling corner in the form of a rocky outcrop.

The success of the activities depended on the recruitment of temporary staff for the school summer holidays who had the knowledge and skills to support young children's learning. I decided to approach the early childhood teacher training course at Goldsmiths College, who advertised the four paid posts to their students. I had very few applicants, but fortunately the four students I did recruit were all very able, and willing to adapt to work in a museum, which for them was an unfamiliar learning environment.

At the end of the project, I invited the students out for a meal to thank them for their work, and asked them what they thought of their experiences. What they told me surprised and even shocked me.

First, they said that most of their fellow students on the early childhood course had not wanted to work in a museum because of bad experiences they had endured on visits to museums when they themselves had been children. They told me some fellow students said they preferred to work as stackers in the local supermarket than work for better pay in the museum. Remember these students were among the better educated and more committed young adults of their age group! And they would be the teachers who would guide the learning of the next generation of children in schools.

I then asked the four students if any of them would now consider a career in museums, as a result of their experience. They all said they had really enjoyed the job and were glad they had decided to apply. But they also detected a widespread ignorance of the nature of learning, and even hostility to educators and audiences, especially children, on the part of many other staff at the museum.

Three said they would never want to work in such an environment. Just one said she was inspired by the project and the potential of museums for learning that she might want a job in the sector after she finished her training, despite these challenges.

It would be easy to dismiss this conversation over a meal as unscientific and the students as atypical. I would also like to think that things have changed over the quarter of a century that has elapsed since my conversation. And I do believe that children and young people, whether in or out of schools and colleges, are generally more welcome than they were then, and have better experiences.

And yet ... Carrie Winstanley's research in this volume shows that many among the present cohort of students hold the same negative feelings about museums as their predecessors did a generation and more ago. She also suggests some reasons for these feelings, as well as strategies for change.

A few years after the exhibition on the Spanish Armada, I attended a conference on the future of the decorative arts. The majority of those attending were either design historians from the HE sector, or museum curators. It quickly became apparent that the two groups might share a common discipline, but they understood the discipline in very different ways. The design historians used theoretical frameworks, whereas the curators often spoke from first-hand engagement with the collections.

One senior curator from the V&A even said that she learnt more by sensing the object through touch and smell than she ever could from written sources. This appeared to be scarcely comprehensible, and certainly not academically valid, to many of the design historians attending the conference. The divide between the two professional groups seemed deep. It is a generalization to say that they had different ways of knowing, but it seemed that many curators struggled to match the design historians in the language of academic discourse, and seemed to find it hard to articulate a theoretical rationale for their distinctive approach.

All this was, however, two decades ago. There is no doubt that, for many reasons (not least the development of joint research posts, as well as changes in government policies on research funding which has allowed some national museums in the United Kingdom to have Independent Research Organisation (IRO) status, and has required HE institutions to develop a more sophisticated approach to impact), national museums and HE institutions have developed closer relations in many significant areas. These and other collaborations have changed the landscape of partnership between the sectors.

But, if joint academic research projects and commitment to public engagement have drawn museums and HE together, we should acknowledge that there also are forces that are working to separate the sectors.

One is the continued lack of understanding on both sides at an institutional level of how the other operates. This can lead each sector to assume that the other 'has more to learn from us than we have to learn from them'.

A second is that, despite apparently having a common mission implied by the commitment each sector has to 'education', in practice each uses the word to mean something different, and really does have a fundamentally different educational purpose. Of course there are overlaps, but museums, for example, also share common goals with local authority children's services, schools, charities, community organizations and think tanks, not to mention libraries, archives and heritage bodies. HE institutions have their own, mostly different, networks. Let us be clear: there is no special relationship.

To see the fundamental difference between sectors, it is only necessary to look at the spaces that institutions in each sector create to fulfil their public purpose.

HE institutions mostly use formal teaching and learning spaces; museums create galleries and open-air sites. These really are very different.

The abolition of the Museums, Libraries and Archives Council in 2011, and the transfer of many of its sectoral responsibilities to Arts Council England (ACE), is likely to widen the gap between the sectors. ACE's focus on the interests of artists, its commitment to an elitist definition of excellence, and its apparent unwillingness fully to embrace inclusion and community engagement as core functions, are all pulling museums away from their fundamental responsibility to the whole public on a basis of equality.

Reductions in public funding are gathering pace. A recent survey of private funding of the cultural sector showed that over 80 per cent of money from private individuals in the UK goes to London – and, in practice, probably to a small number of very large national organizations. Even Trusts and Foundations in the UK, which have clear public charitable purposes, give over 60 per cent of their funding to London institutions. As some private funders have pointed out, this breath-taking inequity only replicates the imbalance of distribution of public funding for the cultural sector, where large national institutions in London again get a disproportionate share of the money available. Public and private funding for HE is also unequally allocated. The funding cuts we now experience are widening the gap between rich and poor institutions in both sectors still further.

There are two likely consequences of this. First, there may be a disproportionate reduction in provision in both sectors to support those least able to pay. Second, the greatest decline in collaboration may be between museums and HE institutions located in areas of economic disadvantage, because it is these institutions that will probably be hardest hit financially.

Looking to the future, our greatest challenge will be to find ways to overcome these financial obstacles, and work together for public good in communities in greatest need. It is an obstacle that the two sectors can unite to address, and the need for us to do so has never been greater.

<div style="text-align: right;">
David Anderson

20 November 2012
</div>

Index

Abasa, S. 40, 44, 47
abstract paintings 151
academic models 85, 86
academics 4, 16, 46, 160, 164–5
 artists as 116
 and public engagement 73–4
 critics of 75, 77
 role of 183–4
access xix, xx, 14, 17, 28, 65, 67, 103
 mobile 64
 problems 140, 141, 164
accountability 45
accreditation 15
action 29, 33, 43, 112
active learning 31, 116, 117, 160, 161, 162–3
activities 33–4, 55, 59, 62ff., 76, 189
 closed 59, 64–5
 open 59, 64–5
 social 76
actors 87
adaptive media 32, 33
'Adjective Task' 125
Adobe Museum of Digital Media 62
adult learning 3, 47
aesthetics 75, 76
'affinity spaces' 58
agency 12, 88, 116
alternative platforms 107
ambiguity 151
analogue practices 59, 60, 66, 68, 100
analysis 32, 35, 55, 59, 65, 66, 68, 86, 89, 106, 122, 135, 137, 163, 165, 175, 176, 186
 visual 121, 122, 148, 149, 154, 156
Anderson, David 5, 9, 20, 189
Anderson, Keith 62
anxiety 71, 126, 128, 129
apprehension 31, 32
apprenticeship 45, 73

appropriation 17, 76, 81, 84, 109, 140, 170
archaeology 137, 159, 160
architecture 61
archives 6, 190
Arnold-Foster, K. and Speight, C. 11
art 81, 96
 conversations in 110–11, 112
 discourses of 185
 and science 99–100, 148, 155
 terminology of 117
art colleges 107
art education 84ff., 107
 new forms of 112–15
art galleries 3, 7, 9, 58, 60, 61–2, 86
 interventions 108ff.
 and new design works 100
 participatory 88
 university 138
 see also art museums; works of art
art museums 84–7
 and modern art 87–9
Art on Call 64
art schools 84, 85, 88, 90
artefacts 139, 174 *see also* objects
articulation 31, 32
artists 81, 84, 93, 95, 191
 as curators 88, 106–7
 education of 84–5
 as educators 112–15
 as mediators 107
 and new learning 114
 and research 108, 111–12
 as visitors 106–7, 108, 110
art-making 60, 81
Arts Council of England (ACE) 6–8, 10, 44, 191
arts sector 9
ARTstor 58
art students 138–9
assessment 10, 47, 73, 126, 153–4

attending 31, 32
attitudes 17, 29, 73, 123–32, 136, 163, 173, 176, 189, 190
　research study 124–6ff.
　see also negative attitudes
audiences xxii, 4, 8, 9, 14, 15, 41, 65, 92, 136, 170, 175ff., 189
　and artists 107, 108, 117
　diversity of 27, 28, 75
　engagement of 76, 82, 141ff.
　new 103, 105, 162
　youth 123
audio 61, 64, 87, 142–3
augmented reality 59, 62–3
Austerlitz, N. 4, 173, 180
Australia 41, 44, 45, 46, 74
authority 18, 26, 66, 82, 88, 89, 107, 185, 186
　curatorial 170, 174
avant-garde 86, 87, 185
awareness 43, 47, 73, 75, 77, 176

Baddeley, A.D. 163
Ballantyne, N. and Knowles, A. 161
Barker, E. 75
barriers 3, 11, 19, 74, 140, 164–5, 175
Baudrillard 75, 100
Bauhaus 87
Bauman, Z. 74
Bautista, S.S. 68
Bautista, S.S. and Balsamo, A. 15, 18, 55ff., 67, 175, 179
Beacons for Public Engagement 73–4, 77, 178
beauty 111
Becker, Carol 89–90
Beckmann, E. 16, 17, 25, 39ff., 183, 185, 186, 187
behaviour 29, 75, 154
behaviourism 31
beliefs 128, 129, 183
belonging 130, 183
Benjamin, W. 112
Bennett, T. 56
Berger, John 111
best practice 43, 46–7
bias 153
Biggs, J. 47, 161, 164

binaries 55, 59ff.
Black, G. 76, 123, 126, 127
Blackie, M. et al. 161
blogs 60, 61, 97
Bloom, B.S. et al. 29
Blythe, Sarah Ganz 5, 17, 81, 83ff., 170, 174, 184, 185
body 114, 115, 155, 176
body language 124
Bond, R. and Patterson, L. 74
BOP 9
Boston 85
boundaries 11, 15, 16, 40, 59, 82, 108, 156, 175, 177, 179, 181, 183
Bourdieu, Pierre 89n
Bourriard, N. 76
Bowen, A. 48
Boys, J. 15, 137, 143, 180, 184
Braverman, Dr Irwin 148, 149, 150ff., 154
Bronx Museum of Art 61
Brooklyn Museum 62, 65
Brown, Stephen 16, 17, 25, 27ff., 29, 40
Brown, S. and Cruikshank, I. 32
Brown, S. et al. 29, 32
Bruner, J. 31
buildings 131
Bunn, Steve 140
Burnham, R. and Kai-Kee, E. 147
business case 10, 177
Buxton, W. 29
Byatt, Lucy 115

cafes 75, 76
Cain, J. 164, 165
Camenson, B. 39
Canada 41, 42
canons 91, 92, 101
Cardiff University 73
career development 40, 41
Carr 180
Castells, M. 57
Centre for Excellence in Teaching and Learning through Design (CETLD) 12, 13, 14, 15, 17
de Certeau, M. 57
CETLD 135, 138, 139
　research projects 142–3
Cézanne, Paul 84

Index

change 11–13, 41, 43, 47, 57, 66, 81, 106, 169
charities 190, 191
Charlotte Museum of History, NC 64
Chatterjee, H. 139, 159, 163, 171
Chatterjee, H. and Duhs, R. 163, 174
Chatterton, P. 5
Chen, Y.C. 39, 41, 50
Chicago Art Institute 85
children 123, 189
China 93, 96
choice 16, 30, 128, 129
citizenship xxi, xxii, 76
civic role 177, 178
Clare, Roy 17, 19, 180
Clark, J.M. and Paivio, A. 163
Clarke, P. 28, 29, 30, 31–2
Clifford, James 181
closed activities 59, 64–5
Coalition Government 6
co-creation 71, 89
collaboration xxii–xxiii, 3–4ff., 66, 128, 144, 178–9
 artist-led 103–6ff..
 costs 10
 digital 18–19, 172
 framework for 186–7
 and funding 7, 171, 177
 incentives for 184
 informal 13
 and internships 47–8
 and learning 3–5
 limits of 3, 4, 5
 observational skills 147–8ff.
 opportunities 16–19
 and policy 6–7, 9–10
 problems of 9, 10, 11–14ff., 19
 scholarly 4, 12, 17, 171, 173
 scientific 72ff.
 and universities 8–10, 138–9, 141ff., 177
collecting xix, 19, 41, 66, 81, 101, 111
 notions of 108
 philosophy of xxi–xxii
 policies 100
collections xxiii, 28, 84–5, 91, 105–6ff.
 dialogue with 140
 digital 165

environmental standards xx
experimental 106–7
interventions 108–15
and mobile access 64
and object handling 139
online 61–2
university 138, 162
 in teaching 165
collective identity 76
colleges 3, 107 *see also* universities
Collini 172
Collins et al. 40
Combs, A.A. 124
commercial interests 14, 75
common goals xxiii, 13, 77, 162, 170, 190
Common Wealth: Museums and Learning in the United Kingdom, A. 5, 20
communication 26, 107, 124, 138, 148, 149, 174, 179, 181
 skills 35, 149, 161, 163, 179
communicative media 31, 32, 40, 47, 57, 61, 64, 75
communities xxi, xxii, 5, 57, 59, 74, 177, 182
communities of interest 59, 65
communities of practice 47–8, 50, 77, 142, 183ff.
 critique of 183
 framework for 186–7
competences 43, 44, 46, 179
competitions 61
computers 57, 59, 60, 91
concepts 163
conceptual art 101
conferences 10, 17–18
conservation xix, xx, 14, 58, 107, 139, 182
constructivism 31, 33
consumer culture 75, 99
'contact zones' 174
Contemporary Art Society 115
contemporary artworks 115, 117
content 15, 17, 19, 64, 92
context xxii, 15, 43, 92, 96, 109, 124, 156, 173, 176, 177, 179, 185, 186, 187
 and OBL 174–5, 180
 and pedagogy 175
Contextual Model of Learning 128
contradictions 149, 151, 156

control 128, 129
controversial subjects 143
conversations 128
 in art 110–11, 112, 115
 see also dialogue
Cook, B. et al. 4, 10, 14, 171
core functions 14–15
costs xix, xx, 6, 10, 45, 181
 see also funding
Couture, Thomas 84
Cox, S.G. 6
'creative capital' 89
creative inventory 65, 66
creative sector 73, 141
creativity 29, 55, 84, 86ff., 92, 98, 107, 141, 172, 173, 179
 disruptive 185, 186
critical debate 17, 75
critical thinking 161, 165, 185
critique 82, 89, 92, 96, 99, 116, 184–5
cross-disciplinary approach see interdisciplinary approach
'cross-fertilization' 144
cross-sector relationships 47
cultural change 11, 57, 74–5, 178
cultural context 128, 130, 177
cultural debate 112, 116
cultural heritage institutions 29, 66
 and GLOs 29–30
 internships 45
 and measurement 29
 role of 81
Cultural Learning Alliance xxi
cultural pursuits 76, 107
cultural sector 5, 6, 9–10, 66, 67, 68, 91, 107
 and universities 7, 73, 178
cultural skills 43
curation 88, 91–101
 by artists 88, 103ff.
 by designers 91–3ff.
 disruption of 82, 116, 174–5
 online 61
 radical 82
curators xix, xxi, xxiii, 3, 4, 40, 44, 81, 115, 117, 143, 173, 175, 183, 190
 and OBL 165

curricula 42, 43, 46, 47, 58, 118, 135, 147ff., 153, 155, 156, 162, 164, 171, 172
Cutts, P. 6

D'Arcy Thompson Zoology Museum 105–6
data xxi, 8, 124, 125ff., 149, 155
Davies, M. 49
Davis LAB 60
Dawson, J. and Gilmore, A. 5, 9, 10
DCMS 5, 6, 8, 9, 10, 76, 184
de Duve, T. 85
Deakin University, Australia 45
death 108, 109, 111, 115
debating 31, 32, 33
deconstruction 89
decontextualisation 97, 99
deep learning 4
Deignan, T. 161
deinstitutionalization 74–5
dematerialization 74, 76, 117
democracy 75, 107, 172
Department for Business, Innovation and Skills 12
Department for Culture, Media and Sport 12 see also DCMS
departments 4, 138, 159, 162
description 30, 147, 150, 153
design 81, 82, 89, 91–101
 canons of 91, 92, 101
 discourses 94, 101, 185
 education 85, 138
 see also industrial design
Design Academy, Eindhoven 92
design historians 190
design process 96, 97, 100
designers 81, 84, 91ff., 98
development xxii, xxiii, 10
Dewey, John 4, 115, 172
diagnosis 147, 148, 149, 161
 differential 149, 151, 156
 medical 148–9, 151–2
 visual 147–8, 149ff.
dialogue xxii, 3, 12, 16, 17–18, 82, 140, 169, 170, 171, 187
 and academics 74
 framework 186

Index

public 72
scientific 74, 76–7
with visitors 110
student 128
Dickerman and Bergdoll 87
Dickinson Brothers 83
differences 9, 12, 13, 14ff., 143, 178–9, 182, 190–91
 in interpretation 149, 151
 knowledge 185–6
 in learning outcomes 27, 28, 29, 143
 in training 42
digital images 59, 62, 67
digital labels 60, 62
digital objects 15, 18, 59, 165, 175
digital technology xx, 14, 15–16, 28, 32, 33, 47, 75–6, 107, 179–80
 collaborative 18–19
 and distributed museum 58–9, 62, 66
 and expertise 66
 learning activities 33–4
 mapping 66–7
 new design works 91–2ff., 97
 and OBL 165, 172–3
 skills 140–41
disabled students 124
disciplines 13, 40, 107, 136, 137, 138, 141, 159, 160, 174, 183, 185, 190
discourses 71, 73, 88, 94, 101, 108, 185, 190
discursive learning 186
discursive sites 112, 114, 118, 180
discussion 31, 32, 66, 150
disease diagnosis 149, 150–51ff.
dispersal 57, 58
display 84, 87ff., 136, 137, 181
disruption 81, 82, 116, 118, 121, 170, 174, 176, 184
 creative 185, 186
dissonance 161
distributed museum 55–68
 challenges 65–6
 concept 56, 57–8, 59ff.
 and digital learning 58–9, 62, 66
 dimensions 59–60ff.
 interactive map of 66–7
diversity 27, 28, 43, 73, 75
doctors 148, 153, 154

Doherty, C. 76
Dolev, J.C. et al. 148, 154
domain 183, 186
domestic space 111
Dorner, Alexander 87–8
Doyle, A.C. 153, 156
drawing 97, 111
Duhs, R. 159, 163, 171
'dumbing down' 75
Duncan of Jordanstone College of Art and Design 103, 106, 109ff., 116
Dundee 103ff.
Dunne, Tony 98
Durbin, G. et al. 160

earth sciences 159, 160
economic change 5–6, 11
economic constraints 5, 6, 8, 16, 171
 and training 43–4, 45
economic development 10
Ed and Ellis in Schiedam 103, 104
Edson, G. 44
education xxii, 3, 4, 5–6, 16, 28, 107, 172
 of artists 84ff.
 concept of 113
 design 92, 98
 differences 190–91
educators 4, 81, 82, 128, 175
 artists as 103, 112–15
effectiveness 16, 27, 28, 35, 139, 171, 187
elderly people xxi
electronic publishing 59
elitism 191
Ellenbogen, K. 28
emails 33, 76, 98, 124, 165
embodied learning 86, 87, 88, 101, 111, 174, 186
emotions 76, 129, 131, 176, 185
empirical research 50
employers xxii, 42, 46, 179
emulation 81, 84, 85, 87, 89, 122, 148, 155, 170, 185
ends 182
engagement 141ff., 165, 176
 public 71–2ff., 77, 177–8, 190
 scientific 71, 73ff.
 student 127–8, 163, 165
England 5–8

Enhancing Observational Skills 148–9ff.
enjoyment 29, 30, 129, 163, 164
enquiry 161, 165
 shared 183, 186
entertainment 66, 67, 75
entrances 131
environment 31, 96, 106, 108ff., 114, 117, 124, 135, 141, 155
environmental standards xx, xxii
ephemeral works 91, 97, 100, 101, 106
Esche, C. 117
ethics 111, 177
ethnic minorities 123, 126
Europe 41, 85
evaluation 12, 141, 153–4, 177, 181–3
events 34, 60, 61, 64, 66, 75, 91, 110, 114, 115, 122, 128, 135, 138, 176
everyday products 97, 109
exchange 10, 107, 112, 117, 184
exhibitions 82, 87–8
 and making 115
 new design works 91–101
 virtual 61
expectations 15, 19, 27, 48, 50, 74, 77, 84, 170, 181
 students 126, 128, 129, 159, 170ff.
experiences 76, 87, 88, 108, 109, 113, 150
 fixed 59, 62, 64
 measurement of 30
 mobile 59, 62, 64
 students 126–7ff., 136, 163, 164, 189
experiential learning 4, 13, 39, 48, 148, 151, 159, 160, 162–3, 185
experimentation 31, 32, 33, 59, 61, 68, 82, 97, 186
 by artists 106–7
 and public engagement 73
expertise xix, xxii, xxiii, 6, 7, 8, 11, 13, 16, 26, 73, 75, 76, 169, 170
 nature of 66, 185
 scientific 71
 shared 170, 180
experts 74, 184
exploitation 49
exploration 31, 32
expression 31, 32
Exquisite Corpse; a Contemporary Unfolding 113, 114

Facebook 60, 64, 68
facilitators 10, 116, 138, 141, 149–50, 164
factory production 93, 95
Falk, J. 182–3
Falk, J. and Dierking, L. 4, 6, 28, 124, 126, 128, 175
Falk, J. et al. 28
familiarity 153
Featherstone, M. 75
feedback 31, 137
female students 125, 126
fetishism 107, 117
films 96, 97, 111, 141
Fiorino, D.J. 72
Fisher, S. 142
fixed experiences 55, 59, 62, 64
Flickr 58, 60, 65, 68
fluidity 26, 115, 153, 156
formal learning 4, 15, 16, 55, 58, 113
 student attitudes to 126
frameworks 8, 25, 29ff., 43, 50, 55, 73, 106, 141, 169, 175, 176ff., 186–7
'free-choice learning' 124
Freer Sackler Galleries 61
Freire, P. 112
Friedlaender, Linda K. 122, 148ff., 154
function 4, 56ff., 64, 75, 82, 108, 191
funding xx, 6–7, 10, 12, 28, 160, 171, 177, 178, 18–2
 inequities 191
 internships 45
 opportunities 7, 11
 reductions 191
 sources 12, 191
future 5, 76, 81, 113
Futurists 86

games 32, 33, 60–61
 augmented reality 62–3
 tagging 65
'generative site' 81, 84, 90
Gere 181
Generic Learning Outcomes (GLOs) 27, 29–30ff.
 formal/informal 29, 31
 problems of 30
generic learning resources 142–3
geocaching 64

Getty Museum 60–61
Gibson, L. 8
Glamorgan University 73
Glaser, J. and Zenetou, A. 39
global financial crisis 3, 5, 6, 19, 43
 see also economic constraints
globalization 6, 43, 75, 155
goals xx, xxiii, 12, 13, 15, 28, 46, 162, 173, 179, 190
governments 5–6, 9, 46, 72, 172, 177
graduates 39
Gray, C. 5, 12
groups 72, 73, 114, 128, 129, 130–31
 identity 130
 medical students 149–50, 153, 154
guidelines 43

Hallam, E. and Ingold, T. 173
handling xxii, 136, 139, 159, 163
 problems 140, 164
Hannan, Duhs and Chatterjee 12, 122, 159ff., 171
haptic learning 140, 141, 174
Harland, J. and Kinder, K. 123, 126
Hart et al. 177
HASTAC 18
HCCB 62, 63
Healey, M.J. 160, 161
health 139
HEFCE 7, 8
Hein, G. 4, 28
hierarchies 50, 58, 72, 74, 78
high-resolution images 67
Higher Education (HE) xxii–xxiii, 143, 144, 172, 183
 and artists 107, 116, 118
 changes 6, 177
 and collaboration 4–5ff., 142–3
 and differences 190–91
 in England 5–8
 funding 6–7, 10, 190
 and internships 46–7
 limited role 3, 4
 and new design works 92, 99
 and OBL 159–61ff.
 barriers to 164–5
 and public engagement 73–4ff., 177
 and skills mismatch 42
 student visits 123ff., 132
 see also collaboration; universities
Higher Education Funding Councils (UK) 178
Higher Education Innovation Fund (HEIF) 10
Hinchcliffe, M. 47, 50
historical sources 33–4
historical works 110, 115, 117
history 11, 81, 84ff., 89, 91, 107, 111, 114, 189
 in exhibitions 87, 105, 107ff.
Hodgson, J. 160
Holden, J. 43
holistic approach 78, 118, 127, 174, 186
Holmes, K. 43, 44, 49
Hooper-Greenhill, E. 4, 28, 29, 75, 76, 113, 123, 126, 137
Horlock, N. 126
hospitals 150, 163
Houlihan 178
Housen, A. 151
Hoving, Thomas 77
Hoy, M. 39, 44, 46, 47
human identity 94, 96
human life 108, 109, 111, 115
humour 129, 130, 132
hybrid practices 13, 15, 16, 18, 19, 20, 106, 140, 169, 172, 180, 187

ICTOP 41, 42
ideas 9, 114, 159, 163, 174
identity xxi, 94, 96, 97, 130
Illeris, K. 161
image databases 58–9
imagery 115, 128
imaginary museum 111
imagination 87, 89, 132, 179, 180, 188
independent learning 4, 121, 123, 126, 129, 132, 164, 165
Independent Research Organisation (IRO) 190
Indianapolis Museum of Art 60, 65
individuals 13, 46, 88, 89, 130
industrial design 92–100
 critique of 96, 99, 100
 discourses 94
 new works 93–101

limited editions 92
industry 45, 73
informal learning 4, 15, 16, 27, 28, 29, 113
 and digital media 55, 58, 65ff.
 measurement of 30
 student attitudes to 129, 130
information 131, 150, 154
Ingles, E. et al. 42
Ingold, T. 173
innovation xxiii, 3, 4, 6, 7, 10, 17, 19, 43, 57ff., 66, 67, 78, 81, 85ff., 92, 99, 140, 142, 159, 161, 171, 176, 184ff.
 technological 71
inspiration 15, 29, 30, 61, 84, 85, 163, 176, 177
Inspiring Learning for All xxi, 29, 35
Institute of Museum and Library Services 28
institutions 7, 9, 12, 29, 40, 50, 57, 74ff., 84ff., 107, 112, 190
 critique of 88
 funding sources 191
instrumental rationales 72
intentions 13, 30, 58, 99, 100, 185
interactions 4, 13, 31, 32, 59, 62, 74, 75, 76, 107, 137, 163, 173
interactive map 66–7
interactive media 32, 33, 59, 60, 62–3, 97
interdisciplinary approach 13, 84, 138, 147ff., 162, 171
interests 128, 129
International Council on Museums (ICOM) 41, 42, 43, 47
Internet 128, 131, 181 *see also* websites
Interns Anonymous 49, 50
internships 39–51
 ambiguities of 44
 benefits of 48–50
 collaborative 47–8
 costs 45
 definition 44
 diversity of 44–6, 47
 function of 39, 40
 and learning 39–40, 46, 47, 50
 paid 45
 strategy for 46–7

interpretation xxii, 66, 82, 88–90, 91, 92, 96, 97, 99, 100, 101, 106, 139, 141, 170
 and critique 185
 and paintings 151
 and visual literacy 147, 149
interventions 19, 71, 81, 84, 99, 141, 153–6, 170
 artist-led 103–6, 108–12, 115
 and students 114
 medical 153ff.
investigation 31, 32
iPads 60

Jameson, F. 75
Jandl, S.S. and Gold, M.S. 4, 13, 173
Janes 178
Janssen, Edwin 109–10
Jasanoff, S. 72
Jen Hui Liao 93–7
Jenkins et al. 58
Jensen 123
jigsaw puzzles 156
joint research posts 190
Jones, S.E. 160
Journal of the American Medical Association 148
judgement 91, 93

kinaesthetic activities 163
Knorr Cetina, K. et al. 173
knowledge xxii, xxiii, 4, 5–6, 9, 29, 30, 32, 76, 112, 161, 163
 anxiety about 126
 community of 183 *see also* communities of practice
 construction 33, 71, 76, 173
 and deinstitutionalization 74
 differences 185–6
 and guidelines 43
 interactions 174
 and learning outcomes 31, 32
 mismatch of 42
 public 73, 75
 relational 17
 scientific 71, 72, 76–7
 transfer 10
Knowles, M.S. 164

Kolb, D. 4, 160
Koret Visitor Education Center 60
Kotler, N. 76
Kwon, M. 112

labels 136, 150, 151
　see also digital labels
laboratory 32, 71ff., 86, 94, 165
Lambert, R. 6
Lane, J. and Wallis, A. 160
language 143, 150, 166, 16, 190
Lauraillard, D. 31–2, 33
Lave, J. and Wenger, E. 173
Lawley, I. 28
leadership 9, 10
learners 13, 15, 16
　and learning construction 31, 33
　and measurement 29
　and OBL 164, 165, 174, 175
learning xxi, 12, 13, 14, 113–14, 123–4, 143, 173–4, 182–3
　and artists 114
　collaborative 3–5, 7, 179
　contextual 128
　differences 143, 185–6, 190–91
　digital 58–9, 61ff., 75–6
　effective 4
　and internships 39–40, 46, 47, 50
　levels of 176
　measurement 29–30, 182
　　problems 30
　mobile 64
　networked 57–8ff., 75
　new forms of 12, 15–16, 17, 18, 58ff., 75–6, 114, 121, 135–6ff., 160–61, 180
　　and critique 184–5
　map of 67
　and OBL 173–4
　prescribed 31
　see also active learning; deep learning; experiential learning; formal learning; informal learning
learning activities 33–5, 47, 136, 137
　assessment of 30, 47
learning methods 32, 136–7
learning objectives 176

learning outcomes 15, 16, 27–35, 46, 47, 91, 155
　concept 28–9, 30
　convergent 31
　divergent 31
　measurement of 29–30
　in museums 27, 29–30ff.
　and OBL 155, 164, 173
　in universities 27
learning resources 17, 142–3
learning styles 136
Learning 2.0 58, 66
lecture theatre 165
lectures 97, 132, 137, 148, 153, 160, 181
Leicestershire 33, 34
leisure 76, 137
libraries 6, 32, 42, 57, 67, 190
life, practices of 186
Life, Death and Beauty 109–11
LIFE IS OVER! 108–11ff.
lifelong learning 39–40, 179
linear methods 32
Lisjst 0 103, 104
Lissitsky, El 87
locations 59, 112, 131
　physical 59, 60ff.
　virtual 59, 60–62
logistical problems 164
London 131, 141, 142, 191
looking 84, 142, 147, 148, 150, 151, 155, 156
loss 109, 114
Louvre 83, 84, 86

Macdonald, S. 28
machines 93–4, 96
Mackenna, Tracy 110, 116n., 174
Mackenna, T. and Janssen, E. viii, ix, 17, 82, 103ff., 174, 184, 185
McLellan, A. 78
Macleod, S. 47
Mager, R.F. 29
making 33, 55, 60, 81, 82, 84, 89, 97, 106, 108, 111, 117, 140, 176, 177, 184, 186
　and exhibitions 115
Malraux, A. 74
management 40, 43, 46

Manchester 8, 135, 138
Manfredi, Leanne 135, 138–43
Manners, P. 179
Marinetti, F.T. 86
marketing 77
mass production 91, 92, 98
masterpieces 81, 84, 85, 86, 89, 170
materials 97
meaning 141, 147, 151, 185
meaning-making 81, 122, 147, 161, 170, 185, 186
means 182
measurement 6, 8, 10, 16, 27, 28–30, 35, 73, 85, 181–2ff.
media forms 32, 33, 111
mediation 107, 128
medical education 147–8
 and observational skills 149–53
 collaborative project 147–9ff.
meeting-place 76
memory retention 163
mentors 150
Merriam, S.B. and Heuer, B. 161
Meyer, J. and Land, R. 163
Mezirow, J. 161
Microsoft Tags 62, 63
Milan 97
Miller, Daniel 107
minerals 97
mission 14
Mitchell, W. et al. 58
mixed-reality spaces 61
mobile phones 14, 57
mobile tours 64
mobility 55, 57, 59, 62, 64
models 10, 13, 14, 17, 32, 43, 128
modern art 86–9
modular systems 16
Monet, Claude 86
moral case 177, 178
Moran, Pam 18
Morris, William 85, 86
motivation xxi, 127, 128
Moussouri, T. 28
multiple sites 18
multipliers 11
museology 43, 44, 74ff., 178
 see also new museology

Museum of Modern Art, New York 60, 61
museum professionals 66
museum shops 75
museum staff 40, 64
 costs xix, 44
 education of xxii
 and medical students 150
 and visits 131, 150
museums
 and art schools 84, 86ff.
 business case for 178
 changes in xix–xx, 11–13, 41, 57ff., 75–6
 collaborative role 3–5ff.
 see also collaboration; universities
 core mission 14, 28, 182
 criticism of 107
 digital 15–16, 18–19
 educational role 3, 4, 5, 28
 functions of 4, 58, 82
 funding of xx, 6, 7, 10, 12, 28, 181
 and training 43–4
 and HE xxii–xxiii, 3–5ff.
 history of 11, 85, 87–8
 and industrial design 91–2, 99–100
 and internships 49
 and learning 15–16, 135–8, 182–3
 differences 143
 outcomes 27, 29ff.
 spaces 181
 measurement of 6, 10, 29, 181, 184
 and OBL 13–14, 162
 and public engagement 71–2ff.
 and scientific knowledge 72
 traditional role of 5, 17, 40, 56, 57ff. 65, 66, 86, 91
 and universities 5–13, 162
 worth of 181–2
 see also collaboration; distributed museum; university museums
Museums Association xix, 41
Museums Australia 50
Museums, Libraries and Archive Council (MLA) 6, 9, 28, 29, 30, 42, 182, 191
Museums 2020 xix

Nagy, M. 87

Nancy, Jean-Luc 185
narrative media 32
narratives xxi, 81, 82, 107, 115, 174
 of the past 87–8
National Coordinating Centre for Public Engagement (NCCPE) 177, 179
National Gallery of Art, Washington, DC 61
National Museum Directors Conference 28
negative attitudes 31, 46, 121, 123, 124, 136, 163, 189–90
 data on 125–6, 129, 131
Netherlands 103, 104, 105
networks 55, 57–8, 67–8, 186
new design works 91–101
new institutionalism 74–7
 criticism of 75, 77–8
new knowledge 76, 177
New Labour government 5–6, 9
new meanings 89, 112
new museology 74–7, 178
 and artists 107
 criticism of 75, 77–8, 81, 178, 181, 183
New York 60, 61
Nightingale, F. 155
non-experts 72, 74
non-linear methods 32, 58
non-verbal learning 173
North West England 9
note-making 112
notice-board 75
nurse education 155–6
Nusslein-Volhard, C. 156

Oakley, K. and Selwood, S. 9–10, 177, 184
object labels 150, 151
object-based learning (OBL) 3, 12, 13, 14, 137, 139, 142, 159–66, 172–80
 barriers to 164–5
 benefits of 160, 162–4
 and context 174–5, 180
 and digital technology 165, 179–80
 in HE 159–61
 and learners 164, 165, 175
 and learning 173–4
 and policy 172
 and public good 172–3
 research on 163
 student attitudes to 163
 and university museums 159, 162ff., 165
objectives 5, 11, 28, 31, 58, 138, 176, 179, 182, 186
objectivity 29, 46, 148, 150, 156
objects 84–90, 110, 111, 174, 181, 190
 access to 140, 141
 and art education 84–8
 cached 64
 and critique 184–5
 development of xxii, xxiii
 digital 14, 59, 64
 tagging 65
 interpretation of 88–90, 151, 153
 and learning 4, 84ff., 136, 139–41
 new design 91–2ff., 96ff.
 and decontextualisation 97
 social role of 82
 see also handling; object-based learning (OBL); works of art
observational skills 139, 147–57
 definition of 147, 148
 difficulties 149, 151, 155–6
 evaluation 153–4
 in medicine 147–8ff., 155
 and paintings 151–3, 156
 and student performance 148–53ff.
On Growth, and Forms of Meaning 105, 106
online educational resources (OER) 180
 see also digital technologies
online-only experiences 61–2
open activities 55, 59, 64–5
open culture 67
opportunities 3ff., 9, 19–20, 64, 65ff., 169ff.
 career 42, 44ff.
 collaborative 40
 dialogue 17–18
 digital 18–19, 55, 75
 funding 7, 11, 171
 for museums 91ff.
 for new learning models 17, 25ff., 55ff., 122ff., 130ff.
 scientific 72
 for students 140ff.
organizations 9, 10

others 31
outreach 58, 73, 75, 132
outsiders 183, 184

paintings 88, 89, 148, 149, 151–3
 representational 148, 151, 153
Paris, S.G. 160
participation xx, xxii, 64, 71ff., 77, 84, 88ff., 112, 117, 125, 138, 150, 153, 177, 185, 189
partnerships xx, xxii–xxiii, 103, 138, 178
 cross-sector 7
 funding 10, 11
 limits of 3, 4, 5
 and policy changes 6
 university/public 73–4, 178, 190
past xxi, 76, 84–6, 89, 185
patients 149, 153, 154, 163
Patrick, C. et al. 40, 46
patterns 151, 155
PDAs 14, 57
pedagogy 4, 15, 86, 88, 112, 159, 160, 165, 172
 and context 175
peers 58, 59, 66, 114
Pellico, L. et al. 155, 156
people xx, xxi, xxii, 5, 7, 18, 28, 57, 107, 124, 129, 182
Peoples, S. et al. 39, 44, 45, 46, 47, 49
perception 87, 115
performance 29, 30, 35, 74, 95, 96, 122, 141
 measures 6, 7, 30, 73
 observation by students 153ff.
performative works 91, 93, 95, 96, 98, 100, 112, 114
personal context 128–9
Phillips, A. 111–12
photographs 33, 65, 110, 111, 150, 153, 156
 digital 60
physical context 128, 131–2, 175
physical museum 15, 18, 19, 55
physical space 55, 59, 60ff., 181
Piaget, J. 31
picture-making 33
Pink, S. 173
place 56, 57, 58, 67, 68, 115, 131

see also locations
play 33, 35, 60, 61, 64, 115
podcasts 61
policies 4, 5, 6–7, 9–10, 71–2, 172, 177, 190
politics 5, 6, 9, 43, 75, 103, 105, 107
pop art 96
popular culture 75
portrait galleries 97, 104, 105
portraits 96
 machine-made 93ff.
postcards 111, 128
postgraduate courses 41, 165
postmodernism 57, 75, 88
'post-museum' 76
power 9, 56, 78, 81, 82, 136, 137, 185, 187
practices 4, 9, 13, 17, 39, 40, 43, 44, 47ff., 50, 55, 56, 57ff., 91, 111–12, 116, 136, 186
 closed 64–5
 collaborative art 108–9
 digital 60, 61, 62
 mobile 62, 65
 open 64–5
Pratt, M.L. 174, 181
preconceptions 121, 125, 126, 175
prescriptive outcomes 30, 31
present 88, 89, 185
presentation 91, 96, 97, 101, 103, 105ff., 112, 114, 115, 117, 164
 'closed' 64
preservation 14
 digital 59
Prince, M. 160
prior knowledge 128, 129, 175, 183
private activities 57
private funding 12, 191
private sector 15
problem setting skills 155
problem-based learning 161
process 8, 11, 14, 16, 43, 47, 65, 72, 74, 76, 77, 82, 84ff., 89, 92, 96ff., 100, 105, 112, 115
 and community of practice 186
 model 43
productive media 32, 33
professional development 10, 40, 41, 44
programmed learning 31

progression 29, 131, 159, 169, 185
projects 4, 9, 14, 15, 46, 114
 collaborative 138–9
 design 92–3ff.
prototyping 29, 140, 141
public xix, xx, 67, 71, 81, 108, 144
 engagement of 71ff., 108, 117, 171, 177–8, 179, 190
 criticism of 75, 77
 motivation of xxi
 satisfaction of xxi
 and science 71–2ff., 76–7
 understanding of 71, 72
 see also audiences; visitors
public consultations 72
public events 114
public good 172–3, 182
public sector 5
public space 57, 65
publications 9
purposes 5, 13, 14, 16, 28, 30, 58, 81, 82, 164, 178, 179, 182
Pyle-Vowles, D. 48

QR codes 62, 63
qualifications 126
quality 7, 8, 46
questionnaires 136
questions 30, 150

Raid the Icebox I 83, 88
Rams, Dieter 97n.
rationales 72, 165, 190
rationality 185
RCA/V&A Rapid form 140
RCMG 29, 30
RCUK 73
Read, Leonard 174
Reading, Christina 139
reconfiguration 76, 91
recontextualization 103
recreation 66, 67, 75, 76
re-curation 105–6
Redler, Helen 99–100
reflection 18, 47, 141, 161
re-imagining 107
re-inforcement 31, 117, 128, 130, 183

relationships 11, 15, 16ff., 47, 76, 81, 86, 97, 103, 107, 115, 173, 178, 190
re-learning 187
relevance 4, 16, 39, 76, 77, 113, 116, 138, 162, 171, 172ff., 179, 187
 social 88
remaking 84, 176, 186
reminiscences 33
repositioning 103, 105, 108
re-presentation 103, 105, 116
research xxii, xxiii, 14, 99, 124, 135ff., 161, 162, 190
 and artists 108, 111–12
 fellowships 45
 funding support for 10
 and OBL 163, 173–4
 projects 12, 15
 and public engagement 72, 73
 social value of 8
 student projects 137
Research Excellence Framework 73
researchers xx, 33, 46
reserve collections xix, xx
resource-effectiveness 187
resources, learning 33–4, 65, 124
Rettig, M. 29
Reynolds, J. 84
Reynolds, Rebecca 135–8
Reynolds, R. et al. 142
Rhizome and Digital Art Source 58
Rhode Island School of Design (RISD) 83, 85, 86, 87, 88, 89
Richardson, Craig 103
risk-based approach xx, xxii
Robert, Hubert 83
Robinson, K. 172, 179, 185
Roehampton University 123
Rogoff, Irit 110, 116
role-playing 141, 150
Romanek, D. and Lynch, B. 163
Rose, G. 173
Rotterdam 105
Rowe, Earle 86
Royal College of Art (RCA) 12, 93, 97, 140
Royal Institute of British Architects (RIBA) 12

Sagan 180
San Francisco Museum of Modern Art 60
Sandell, R. 4, 5, 28, 178
Sandell, R. and Conaty 178
satisfaction xxi, 129
Savin-Baden, M. 4
scanning 140, 141
scepticism 75, 77, 81, 88, 184
Schaller, D.T. et al. 28
scholars 4, 71
scholarship xix, 4, 165
 collaborative xxii, 4, 12, 17, 171, 173
Schon, D. 156
schools 3, 5, 33, 57, 58, 61, 160, 190
Schultz 178
science 71–9, 148, 155, 185
 and ethical issues 71, 72
 and public 71–2ff., 76–6
Science and Technology Studies 71
Science Museum, London 99
Sciencewise 72
scientists 71
Scott, C. 6
Scottish National Portrait Gallery, Edinburgh 104, 105
Screen Yorkshire xxi
scripted events 110
sculpture 140
sector-wide approach 46–7
seeing 87, 122, 132, 147, 150, 153, 155, 156
Seely Brown, J. 58
self-directed skills 155
self-expression 130
Self-Portrait Machine 92, 93–7, 100–101
 curation of 96–7, 101
 interpretation of 96, 101
Selwood, S. 8, 28
seminars 181
Sennett, R. 173
sensory experience 118, 122, 139, 143, 163, 176, 180, 186, 190
sequencing 15
'Shakespeare in a Suitcase' 141–2
Shanghai 93, 96
sharing xix, xxi, 3–4ff., 6, 11, 106, 117, 130, 179, 187
 online 61

see also collaboration
Shotgun Wedding 104, 105
silos 11, 12, 77
Simpson, M. 47
simulations 32, 33, 34, 100
skills 29, 30, 40, 42, 43, 49, 89, 112, 137, 155, 161, 163
 digital 140–41
 and learning outcomes 31, 32
 mismatch of 42
 observational 139, 149–53, 155
 range of 42–3
slide projections 109, 115
smart objects 59
smart phones 61, 62
Smith, C. and Blunkett, D. 28
Smith, Rhianedd 135, 143–4
Smithsonian American Art Museum 62
social activism 178
social change 11, 75–6
social context 11, 43, 45, 57, 58, 71, 72, 74, 76, 88, 96, 112, 124, 128, 176, 188
social criticism 82, 96
social dialogues 122, 186
social histories 82, 92, 170
social inclusion 28, 173, 178
social interaction 31, 62, 68, 75, 76
social learning 186
social media xx, 61, 64, 66ff., 90, 107, 112, 179
social tagging 65
social value xix, xxi, xxii, 4, 8, 9, 28, 43, 55, 57, 61, 65, 67, 73, 74, 86, 171, 179, 182
society 8, 10, 11, 40, 57, 71, 81, 82, 91, 107, 113, 117, 121, 172, 177, 179, 183, 187
software 95, 140
South Kensington Museum 85
spaces 3, 4, 15, 17, 19, 55ff., 76, 82, 87, 106, 135–8
 concept of 57
 creative 107
 dispersed 57
 and new learning 58–9ff., 137, 180–81
 networked 57–8
 physical 55, 59, 60

public 56, 57
 university 164–5
 virtual 55, 60–62
Spronken-Smith, R. and Walker, R. 161
stability 57, 183, 186
staff *see* museum staff
staged events 115, 141
stakeholders 46, 48, 71
Stanley, J. et al. 30
Stanziola 181–2, 184
Stedelijk Museum Schiedam 103, 104
Steve: the Museum Social Tagging Project 65
stories xxii, 33, 64, 115
 see also narratives
strategies 17, 47, 88, 172, 187
structure 11, 12, 15, 32, 165, 175–6, 186–7
student placements 7, 25, 39, 44
 see also internships
student-centred approaches 160–62
students 14, 46, 89, 141, 179
 anxiety of 126, 128–9
 art 84–5, 107
 assessment tasks 46, 47
 attitudes of 123, 125–32, 136
 and costs 45
 engagement of 127–8, 138ff., 163
 and internships 47, 48–9
 and learning 4, 16
 experiential 39, 41, 43ff., 163
 and new design works 91, 97
 and observational skills 147–8ff., 163
study 143
'stuff' 107, 108, 109, 111
Sturgeon, K. 41
subject knowledge 126, 163, 171
subjectivity 33
'substantive' rationale 72
suicide 109, 115
supervisors 45, 46, 47
surprise 129
surveys 160, 163
Swain, H. 7, 8
symbiosis 93, 97

TACTILE 138, 139–40
'tagging' 61, 65
tasks 137

Tate Museum, London 61
taxonomy 31, 32, 78
teachers 4, 30, 58, 89, 164, 165
 university 127, 131, 160, 161
teaching 12, 46, 108, 113, 114, 136
 barriers 164–5
 funding 7
 medical 149, 151–2
 with objects 139, 159ff., 165
teaching methods 47, 136–7, 149ff., 160
 student-centred 160–61
teamwork 163
Techniquest 73
technology 6, 46, 55, 58–9, 74, 99–100, 106, 140
 critique of 96, 99
teenagers 61
Ten Climate Stories display 99
tertiary students 45, 46
textiles 89, 139
theatrical spaces 87, 141–2
themes xxii, xxiii, 61, 108, 111, 114, 115
theory 39, 44, 48, 50, 88, 129, 136, 144, 173, 190
therapeutic outcomes 163
thinking 43, 174
Thomas, J. 39
Thomsen, L. et al. 163
3-D printing 140, 141
Thwaites, Thomas 97–100
time-based works 91, 95, 97
Toaster Project 92, 97–100
 curation of 99–100, 101
touch 139, 163, 176, 190
tourists 75, 129, 142
trade fairs 97
traditional learning 181
training xxii, 10, 41–2, 58, 92, 139
 art 86
 economic constraints 43–4, 45
 medical 148ff., 155
transferable skills 163
transformation xx, 6, 11, 16, 17, 57, 75, 76, 78, 112, 122, 140ff., 176, 179
 of learning 161
Trant, J. 42
travel 57, 62, 64, 68, 74, 137
Travers, T. 9

tuition fees 6
tutors 4, 126, 128, 130, 164, 180

UK 28, 41, 42, 44, 72ff., 85, 107, 172, 178, 190, 191
 see also England; Wales
undergraduate courses 15, 40, 41, 42, 123–4, 135–6, 148, 162
understanding 29, 30, 33, 39, 43, 48, 50, 67, 98, 100, 101, 107, 122, 123, 136, 139, 143, 149, 155, 160, 163, 170ff., 176, 182, 184, 185, 187
 public 71, 72
universities xxii–xxiii, 137
 and business case 177
 collaborations 138–9, 141
 collections 138
 core mission 14
 criticism of 75, 77–8
 in England 5–8ff.
 funding 6–7, 10, 12, 77, 160, 177, 181–2
 strategic change 6
 history of 11
 internships 39–40, 44–51
 benefits of 50
 costs 45
 and learning 15–16, 137, 190
 moral role 177
 and OBL 159–60ff.
 and partnerships 138
 and public 71–2ff., 77, 144, 177–8
 and social change 76
 training courses 41–2
 and value 8, 181–2, 184
 see also university museums
University College, London (UCL) 8, 12, 139, 173
 museums of 159, 161, 162, 165
 and OBL 159–66
 and OERs 180
 university museums 7–8, 12, 81, 135–6
 and OBL 159, 162ff., 165
University of Brighton 12, 13, 14, 17
University of Dundee 103, 106, 108ff.
University of East Anglia 15
University of Reading, Museum of English Rural Life 135–6

'upstream' activities 71, 72
Uruguay 62
USA 28, 40, 41, 44–5, 55, 58, 60ff., 74, 85ff.

value 5ff., 12, 16, 18, 25, 39, 57, 72, 77, 97, 110, 117, 123, 136, 162, 181–2, 184, 187
 see also social value
value-judgements 150
values xxiii, 29, 41, 57, 75, 160, 170, 171, 179, 186
Van Dijk, J. 78
Van Kittensteyn album 105
Vasari, G. 84
Victoria and Albert Museum (V&A) 12, 13, 14, 83, 85, 96, 135, 138
 and barriers 140
 and differences 14
 and learning 140–41, 143
 visits to 140, 142
 see also CETLD
video 32, 60, 65, 105
Virilio, P. 75
virtual copies 141
virtual exhibitions 61
virtual museums 62
virtual spaces 55, 59, 60–62ff., 107
virtual tours 61
visitors 27–8, 66, 142, 150
 artists as 106–7, 108, 110
 dialogue with 110–11, 112
 experiences of 127, 129
 measurement of learning 29–30
 numbers of xix–xx
 and open activities 64–5
 and post-museum 76
 prior knowledge of 128, 129
 and student attitudes 124ff.
 see also audiences; public; students
visits 115, 123ff., 128, 131, 132, 142, 143, 149, 189
 data on 125–6
visual arts 9
visual diagnosis 147, 149
 and medical students 153–5
 and nurses 155–6
 see also observational skills

visual learning 163, 174
 see also observational skills; visual diagnosis
visual literacy 147, 148, 150ff., 155, 179
Volk, S. and Milkova, L. 147
volunteers 29, 44, 49
Vygotsky, L. 31

Wales 73
Walker Art Center, Minneapolis 61, 64
Wallace-Crabbe, M. 46
WAR AS EVER! 105
Warburg, A. 111
Warhol, Andy 83, 88, 96
Watermeyer, R. 26, 71, 72, 74, 75, 76, 178
Web 2.0 75
websites xx, xxiii, 28, 32, 41, 55, 58, 60, 62, 64, 67, 180
 and geocaching 64
 mobile 64–5
 open tours 64
 tagging 65
 teen sites 60–61
Weil, S. 12, 181–2
well-being xxi, xxii, 139
Wenger, E. 47–8, 77, 173, 183, 186
Were 178
Wheeler, Vicki 139
White, D. and Manton, M. 142
Whitworth Art Gallery, Manchester 135, 138, 139

Whyville 60–61
Williams, Gareth 82, 91ff., 185
Winnicott, D. 180
Winstanley, C. 17, 121, 122, 123ff., 170, 175, 180, 181, 190
Wisker, Gina 139
Wood, W.B. 161
work 43, 48, 49
working class 57, 96
'work-integrated learning' 40, 46
workplace 43, 45, 46, 47, 50
work-related competences 179
works of art 61, 82, 83, 84ff., 115, 185
 display of 87–8
 location of 112
 mobile access to 64
 and observational skills 147, 148ff.
 repositioning 108, 116, 117
 responses to 110
 virtual 62
writing 112
Wyman et al. 65

Yale Center for British Art (YCBA) 148–9, 173
 observational skills project 148ff.
Yale School of Medicine 148
Yale School of Nursing 148, 155
Young, L. and McIntyre, D. 46
young people xxi, 123, 189
YouTube 64, 68